The
Architecture
Chronicle

Design Research in Architecture

Series Editors

Professor Murray Fraser
Bartlett School of Architecture, UCL, UK

Professor Jonathan Hill
Bartlett School of Architecture, UCL, UK

Professor Jane Rendell
Bartlett School of Architecture, UCL, UK

and

Professor Teddy Cruz
Department of Architecture, University of California at San Diego, USA

Bridging a range of positions between practice and academia, this Ashgate series seeks to present the best proponents of architectural design research from around the world. Each author combines innovative historical and theoretical research with creative propositions as a symbiotic interplay. In offering a variety of key exemplars, the book series situates itself at the forefront of design research investigation in architecture.

Other titles in this series

Transitions: Concepts + Drawings + Buildings
Christine Hawley
ISBN 978 1 4724 0909 6

Digital Poetics
An Open Theory of Design-Research in Architecture
Marjan Colletti
ISBN 978 1 4094 4523 4

Marcel Duchamp and the Architecture of Desire
Penelope Haralambidou
ISBN 978 1 4094 4345 2

The Inhabitable Flesh of Architecture
Marcos Cruz
ISBN 978 1 4094 6934 6

Design Research in Architecture
An Overview
Editde by Murray Fraser
ISBN 978 1 4094 6217 0

The Architecture Chronicle

Diary of an
Architectural Practice

Jan Kattein
University College London, UK

Published by
Ashgate Publishing Limited
Wey Court East
Union Road
Farnham
Surrey, GU9 7PT
England

Ashgate Publishing Company
110 Cherry Street
Suite 3-1
Burlington, VT 05401-3818
USA

www.ashgate.com

British Library Cataloguing in Publication Data
A catalogue record for this book is available from the British Library

The Library of Congress has cataloged the printed edition as follows:
Kattein, Jan.
 The architecture chronicle : diary of an architectural practice / by Jan Kattein.
 pages cm -- (Design research in architecture)
 Includes bibliographical references and index.
 ISBN 978-1-4094-5186-0 (pbk.) -- 1. Kattein, Jan--Diaries. 2. Architects--Great Britain--Diaries. 3. Architectural practice. I. Title.
 NA997.K35A35 2014
 720.92--dc23

2013050282

ISBN 9781409451860 (pbk)

MIX
Paper from
responsible sources
FSC® C013985
www.fsc.org

Printed in the United Kingdom by Henry Ling Limited,
at the Dorset Press, Dorchester, DT1 1HD

Contents

List of Illustrations

Introduction

I.1 In his article 'St. Catherine's College, Oxford', John Carter quoted Dr Allan Bullock, master of St. Catherine's on the negotiations with his architect Arne Jacobsen during the design and construction of the college

1 Diary of an Architect

1.1 Collection of tools of the architect-activist. The tools that I took to Munich were chosen for their versatility. Most of these can be used for more than one purpose: (a) electrical screwdrivers; (b) disc with essential computer programmes comprising photo-editing, desk-top publishing and CAD software; (c) self-made, large-radius compass – particularly useful for 1:1 drawings; (d) well-used scraper – a scraper's edge sharpens with age and the initially sharp corners are worn round; (e) universal hammer; (f) pipe wrench; (g) junior hacksaw for small engineering jobs – in spite of technological innovation the best quality engineering is still done by hand; (h) combination pliers for cutting, holding, tightening and loosening; (i) long-nose pliers; (j) technical drafting pens with 0.18mm, 0.25mm and 0.5mm thick nibs; (k) precision pencil sharpener; (l) rubber with narrow end for detailed erasing; (m) precision drafting pencils with medium and hard leads; (n) precision compass with attachment for pens or pencils; (o) handy-sized Leatherman multi-tool with saw, screwdrivers, knives, drills and file – particularly useful on scavenging trips; (p) Stanley knife for rough cuts and cutting thick materials; (q) medical scalpel for precision cutting; (r) multi-purpose scissors for heavy duty cutting with screwdriver attachment and bottle opener; (s) precise paper scissors; (t) 5m measuring tape; (u) metal ruler for use as cutting edge; (v) scale ruler; (w) combination set square and protractor; (x) transluscent adhesive tape; (y) drafting ink; (z) universal glue for a variety of materials

1.2 Cover page of the first edition of *Kabale & Liebe* by Friedrich Schiller. The play is classified as a *Buergerliches Trauerspiel* (popular drama). It was banned in some parts of Germany because it was considered to be too critical of the aristocracy. The play became extremely popular in other parts of the country. Audience reaction is a useful gauge for the success of a work. Success is not solely a matter of universal praise, controversy amongst the audience is an indicator of critical engagement. A good work will be hated by some and loved by others. It is a poor work that is often treated with indifference

1.3 Front Cover of Goldman paperback edition of *Kabale und Liebe* with photograph by Felicitas Timpe showing actors Jan Niklas und Dietlinde Turban in a TV adaptation of the drama. The

historicizing 1996 Goldman cover gives an indication of the Munich audience's past exposure to *Kabale und Liebe* and hence their presumptions about the nature of our production

1.4 Photograph of *Kabale und Liebe* model stage-set with illuminated refrigerator. The theatricality of the refrigerator light in the model that switched on when the tiny door was opened enticed the actors to adopt the stage-set proposal. Their trust in the architect was founded upon his ability to deliver a stage-set that communicated a sense of magic even at its reduced scale

1.5 Colour sample of carpet tiles from the *Kabale und Liebe* model. The sample is dyed using hand-mixed acrylic paint to achieve the exact colour required

1.6 Fax sent to Herr Lange (Munich City Council Recycling Department) describing, in detail, the refrigerator required for the *Kabale und Liebe* stage-set. The material acquisition process has two approaches, material-led and design-led. Either a material is identified, found and integrated into the design or an idea develops while designing that directs the architect-activists' search for a particular material. Most designs are the result of the combination of both methods; the use of the refrigerator followed the latter

1.7 Front and reverse side of the original pattern used as a template for the *Kabale und Liebe* wallpaper. Regular patterns like this are usually designed as tiles that are then multiplied across a large surface. Through careful investigation, a tile can be identified and isolated. An isolated tile is the key for scaling and then re-creating a large patterned surface

1.8 *Kabale und Liebe* wallpaper sample. The self-invented printing technique gave us an unexpected result. The blurry edges accentuate the impact of the pattern and every rose is slightly different from its neighbour. Inaccuracy in this instance is desirable and contributes towards the liveliness of the pattern. An even and sharp print applied across the large expanse of the walls of the set would have looked monotonous and lifeless. With the *Kabale und Liebe* wallpaper, a happy accident that occurs during the printing process became a key design parameter. The wallpaper was designed by both drawing and making

1.9 Sugar pot and milk pitcher from teatime. Furniture and crockery for teatime were carefully selected with the stage-set in mind so that the other team members could familiarise themselves with their material qualities

1.10 View of workshop with scattered stage elements. Carpet tiles and stage-set elements are spread out in the workshop to improve drying of paint and dye, but also so that they are prominently visible to guests at teatime. Familiarity with the material will make it easier for the end-users to adapt to the stage-set once it is assembled on stage only four days before the premiere

1.11 Audience seating for *Kabale und Liebe*. The seating furniture from teatime is moved into the auditorium. Teatime provided a useful opportunity

to compose the chair collection and to rehearse the assemblage that would become the audience seating. In most theatres the audience seating is a permanent fixture of the building that is bolted to the ground for safety reasons. The design of the auditorium and its seating is the responsibility of a specialist sub-contractor or, in older theatres, the architect of the theatre building. In *Kabale und Liebe* the auditorium and the stage-set are designed at the same time and by the same architect

1.12 Note from dramatic advisor dated 3 February 2004 praising the architect-inventor, thanking the architect-arbitrator for organising teatime and applauding the architect-activist for constructing the set

1.13 *Kabale und Liebe* stage. The photograph was taken from the top of the lighting gantry above the audience seating. This overall view cannot be perceived by the audience. To achieve maximum spatial engagement, the audience is seated amongst and below the massive inclined walls of the room. Without theatre lighting and void of occupation, the architectural theatre set lacks theatricality

1.14 Luise standing and Miller coming out of his door during dress rehearsal. The leather coat next to Miller's door is borrowed from the previous production and is illuminated bright red every time Miller's dialogue refers to the coat. The red lamp has not yet been directed accurately. One can see the illumination of the rear wall above Miller's door. The stage designer's job in the theatre is mute; it must not interfere with the dialogue. Any critical interaction with dialogue or action on stage occurs spatially. On this occasion, the illumination of the red coat accentuates Miller's all-words-no-action attitude towards his daughter's pleas for help

1.15 The stage-set extending into the main fire-escape corridor behind the stage. The rear section of the set had to be built onto a trolley that could be folded up and rolled away to clear the fire-escape route

1.16 King Ludwig's dining room in Herrenchimsee from *Gebaute Träume: Die Schlösser Ludwig II van Bayern* by Achim Bunz and Michael Petzet

1.17 The sub-stage mechanism to raise and lower the table into King Ludwig II's service quarters from *Gebaute Träume*

1.18 Watercolour detail by Heinrich Breling showing the king awaiting the ceremonial raising of his dining table from the service area below from *Gebaute Träume*. The king's early arrival in the dining room while meal preparations are still ongoing can hardly be attributed to his anticipation of the unappetising meal that is being assembled by his staff in the service quarters below. Instead, the king has come to witness the theatrical raising of his dining table with a mechanism that was designed especially by the technical crew of the Munich Residence Theatre. King Ludwig II used modern stage machinery to animate the everyday domestic activities in his castles and mansions, creating spaces with a curious theatrical domesticity. *Kabale und Liebe* is sited in the theatre, but it uses everyday objects, spaces and materials to link the theatre to the domestic. The reason behind Ludwig's actions

was to escape from his despised domestic life as king into a fairy-tale world like Richard Wagner's operas. *Kabale und Liebe* seeks to escape wonder and detachment of the theatre by association with the domestic context, a context familiar to the audience. This way, we thought we could make the play as relevant to our audiences lives as it was to the contemporary audience when first published

1.19 King Ludwig's Venusgrotto at Linderhof complete with swan-shaped royal barge, animated light effects and artificial waterfall, was conceived and constructed by stage technicians especially brought in from the Munich Residenztheatre

1.20 Hunding's Hut and Gurnemanz Hermitage are the architectural expressions of an increasingly solitary life-style adopted by a king who gradually lost the ability to distinguish between drama and reality

1.21 Gurnemanz Hermitage

1.22 Schloss Herrenchimsee

1.23 Park Herrenchimsee. King Ludwig's final work, Herrenchimsee, a lonely palace was sited on an island in the Chimsee, with only a group of neighbouring monks sharing his solitary existence. The palace, a miniature Versailles decorated with paintings of the French kings did not have a kitchen, the king's swimming-pool sized bath tub was too large ever to be filled with bath water, the innovative air heating system too complex ever to be put into use and the south wing was left unfinished due to lack of funds. During the one occasion in 1885 when the king stayed at Herrenchimsee, the palace served as a mere stage-set representing the king's imperial ambitions. An enormous firework display designed to eclipse the shortcomings of the architecture entertained the king during his brief visit and food was delivered on carriages from the nearby monastery

1.24 Plan of the *Kabale und Liebe* stage-set. The plan shows the blurring of the boundary between auditorium and stage: the raking walls of the decoration and carpet tiles continue into the auditorium and the auditorium seating is integrated with the stage-set

1.25 Occupied refrigerator. The refrigerator is actually powered by the plug socket attached to the stage decoration. There is a light inside the refrigerator that turns on when the door is opened. This effect was very difficult to achieve, due to stage safety regulations, but it helped to identify the stage space with a familiar domestic setting

1.26 Plug socket. The features, including the surface mounted power cable, were copied from a plug socket in my grandmother's kitchen

1.27 Set photograph of the penultimate scene from *Kabale und Liebe*. The plan (Figure 1.24) is dated 2 December 2003, but it was in fact, drawn months after the premiere, in March 2004. This representational drawing is a make-believe construction drawing that appears in a report on the production used by the technical department of the Prinzregententheatre to present to other stage designers as an exemplary stage design submission. The *Kabale und Liebe* set

was designed by making. The conviction drawings that were submitted were not used for construction, and drawings for construction were never issued. Instead, the architect-activist directed the design in the workshop and acquired materials as the design progressed

1.28 The lemonade salesperson in the foyer intruding into the audience-only space. Three audience members look towards the floor or hide behind their copies of the programme booklet in embarrassment. Even though lemonade can be bought in most theatre foyers, the fact that it is done in a performative manner in *Kabale und Liebe* is unsettling to the audience because it undermines the traditional theatre experience

1.29 Detailed drawing of the ramp trolley

1.30 Detailed drawing of the doors, drawn after the completion of the set. The lines in this drawing only reveal some aspects of the architecture, most of its qualities remain hidden. To enliven the drawing and to add theatricality, I drew the hinged door flap even though it was never built. The medium used for representation is an important design parameter. A design represented with the use of a computer will be very different from a design represented with watercolours

1.31 Small print from the Wagner Forum competition brief. The ten lines of small print put into question the tightly typed three-page document of the competition conditions, by allowing the organisers to intervene at any stage and in any manner of their choosing.

1.32 Pages 304–5 of Franz Blei, *Geist und Sitten des Rokoko*. *Geist und Sitten des Rokoko* served as an important reference to understand the historical context of *Le nozze Di Figaro*. Perhaps even more interesting than the historical information the book provides, is its format. *Geist und Sitten des Rokoko* is a collection of letters, personal accounts and reports that the editor has carefully woven together to create a captivating narrative with little need for further explanation. The book gains its historical authority by reproducing original sources which simultaneously makes it an informative and entertaining read. The editor relies on his reader to make connections, discover patterns, find reasons and identify key events. The format of *Geist und Sitten des Rokoko* aids understanding of *Le nozze di Figaro* as a collection of contradictory and opposing situations and musical compositions producing an entertaining and delightful comedy where the outcome is what the audience makes it to be

1.33 The Countess' room. Detail photograph of *Le nozze di Figaro* model

1.34 The Countess' room. Detail photograph of *Le nozze di Figaro* model

1.35 The entrance. Detail photograph of *Le nozze di Figaro* model

1.36 Post Office receipt for the competition documents

1.37 Reverse sides of the pages of the summary concept with cut-out dolls

1.38 Reverse sides of the pages of the summary concept with cut-out dolls

1.39 Competition submission for the 2005 Ring Award

1.40 Competition submission for the 2005 Ring Award

1.41 *Herr Gevatter: Bühnenbild zum Selbermachen*. The *Herr Gevatter: Bühnenbild zum Selbermachen* was designed to engage the reader. The drawing cannot be clearly understood until its individual elements are cut out and assembled. The reader of the drawing engenders a closer understanding of the intention of the design when he or she becomes the maker of the model

1.42 Pages 8–9 of *The Doubtful Guest* by Edward Gorey

1.43 Textures used in the Herr Gevatter Design. Clockwise from top left: wall texture from *The Doubtful Guest*, wall texture from the drawing-model, wall texture in the actual stage-set, wall texture in the stage-set model.

1.44 Pages 678–9 of *The Theatre of the Stuart Court* by Stephen Orgel and Roy Strong

1.45 Pages 584–5 of *The Theatre of the Stuart Court*

1.46 Notre Dame du Haut Zhengzhou, China. Notre Dame du Haut is arguably one of the most iconic buildings ever built. The original was completed by Le Corbusier in Ronchamp in 1954.

An identical copy appeared in Zhengzhou, China in 1994. The photograph shows that construction methods have 'improved' since 1954 giving the new Ronchamp an immaculately smooth facade and patent glazing. The replica artwork at the pavement edge appears to have been placed there to justify the incongruous appearance of the building on its new site, excusing its presence by association with the world of sculpture. To copy the shape of a building without understanding its philosophy is likely to make it inferior to the original. Notre Dame du Haut Zhengzhou was recently demolished, apparently following intervention by the Fondation Le Corbusier

1.47 Original umbrella stand. The development of the drawing-model established a working method that was used for the entire *Herr Gevatter* design. The disadvantage of this working method is that the design is only ever as good as the architect's drawing and that the maker's skill and craftsmanship in the workshop remain unexploited

1.48 Template drawing of cardboard umbrella stand

1.49 Template drawing of cardboard chandelier

1.50 Template drawing of cardboard rocking horse

1.51 Model of performance space

1.52 Model photographs from our submission for the first stage of the Ring Award 2005

1.53 Lighting script for the micro-processor controlled lighting circuits. The model could be

animated with lights and scenes were set using scale paper figurines. The model was not site specific, nor did it respond to the budgetary or operational realities of a contemporary theatre production. The model was our theatre; it was complete in itself and, in that sense, was more like a puppet theatre than a stage-set model

1.54 Maquette with Magdolna Parditka's costume design on exhibit in Graz

1.55 Model theatre exhibit in Graz

1.56 Slide made for our presentation advertising the good team spirit in our group. In reality it had been impossible to organise a team meeting for a group photograph so this slide is a collage that was made from individual photographs of team members digitally processed and pasted onto a background photograph of an opera auditorium

1.57 Promotional pencil advertising *Der Standard* newspaper

1.58 Ring Award semi-finalists on the makeshift stage holding their bouquets. From left to right: Orpha Phelan (Ireland), Leslie Travers (UK), Anna Malunat (Germany), Magdolna Parditka (Hungary), Jan Kattein (Germany), Elena Artioukhina (Russia), Etel Ioshpa (Russia), Christoph Rodatz (Germany), Marcus Droß (Germany) and Michael Wolters (Germany)

1.59 *Herr Gevatter* cardboard set assembled on stage for the first rehearsal after the technical set-up

1.60 Vent Axia fan in Bartlett lavatory that informed the design of the cardboard fan

1.61 Snow in Saarbrücken. Hollywood Snow is sifted through purpose-made snow dispensers from the lighting gantry and gently settles on the first rows of audience seats during the final scene of the opera. When the audience leaves the opera house the streets of Saarbrücken are covered in a thin layer of white because it has started to snow for the first time this year. The transition from fake snow inside to real snow outside has caused the theatre space to seamlessly melt into the city space, blurring the boundary between inside and outside

1.62 Hollywood Snow under the cardboard chandelier

1.63 Hans on cardboard rocking horse

1.64 Mother switching on the cardboard fan. The operational cardboard fan was modelled on the Bartlett lavatory fan. It not only played an important role as a detail of the stage-set, its function was first and foremost to manifest to the team the architect-arbitrator's conviction of the design and to encourage interaction with the set. The architect-activist had to manufacture the fan himself. Limiting the design input of the workshop staff to cutting out and assembling ready made templates, meant that no-one at Staatstheater Saarbrücken had acquired the expertise to fabricate an operational cardboard fan

1.65 Marcellina's chair. Front Elevation, 1:5. The chair wobbles. One of the front legs is short by 1cm.

The seat is covered with worn black, shiny leather, the wood is stained yellow

1.66 Figaro's chair. Figaro's chair can be dragged. Four white, wooden or pressed metal wheels with solid, black rubber tires are fixed to the end of two axles that run through the chair legs. Thus the chair can roll backwards and forwards. It squeaks. The legs of the chair are cut down to 26cm from the top of the seat surface. The wood is painted gloss, light blue (RAL 5024). The seat is not covered but also painted blue. A rope with white and red stripes serves to drag the chair

1.67 Cherubino's chair. Cherubino's chair can bounce. The legs of the chair are shortened and fitted with a brass plate on which a mattress spring is fastened (or two twirled into each other if the spring resistance is too low). The wood is painted pink, high gloss (RAL 3015). The seat is covered in salmon coloured velvet

1.68 Bartolo's chair. Bartolo's chair can be folded apart in the centre. On the back side of the back rest and on the back side of the seat is a brass hinge. To strengthen the seat, a section of moulding is fitted to the underside on either side of the cut. A curved metal track with a slot keeps the two halves of the chair together in the front. Wheels are fitted to the front legs so that the two chair halves can be rolled apart. The seat is covered in worn faux leather in light blue, washed-out (not vibrant), the wood is stained yellowish and worn. Each character has their own chair. The chairs each have an added function related to the personality that we associate with the character. This added function is designed to encourage the creative use of the piece of furniture

1.69 Construction and conviction drawing. The entire stage-set is represented in one drawing that provides construction details and engages through its massive size, a variety of scales, sequential drawings and the textual descriptions

1.70 Email with CV as edited by Wagner Forum Graz (left) and original (right)

1.71 CV as finally printed. The CV edited by the Wagner Forum Graz omits many references to my background in architecture. Instead, three references are inserted to emphasize the fact that I live in London. My background in architecture has a critical significance to my practice in stage design. Innovative design solutions can occur at the boundary of two disciples, and, hence, I insist that my qualification and practice as an architect features prominently in the CV. The Wagner Forum puts undue emphasis on the fact that I live in London because they want to advertise the international status of the competition

1.72 Model of the revised stage-set for *Le nozze di Figaro*

1.73 Model in plan before disassembly

1.74 Model in plan after disassembly

1.75 Detail of swivelling chair

1.76 Rolling chair

1.94 Act 2 of *Le nozze di Figaro* at Schauspielhaus Graz on 25 June 2005

1.95 Act 2 of *Le nozze di Figaro* at Schauspielhaus Graz on 25 June 2005

1.96 Ticket for Ring Award finals

1.97 Certificate for participation in the finals

1.98 Certificate for the Styria County Award

1.99 Certificate for winning the Ring Award

1.100 Article '2020 Vision' by Tanya Gold from *The Guardian* 'Travel Section', 10 September 2005. The article mentions the *Zero Emission Luminaires*. The piece conveys an atmosphere of decay and melancholy, failing to recognise the beauty and the romance of the town. Many readers will share this desolate view of Blackpool. Building upon prejudice, however, can cloud one's view and often fails to engage with the actual site or subject matter

1.101 Overall drawing of the methane-powered *luminaire*. The original drawing was at 1:2 scale and contained substantial technical detail. The detail was made up by the architect-inventor without the architect-activist testing or verifying the efficacy of the ideas. Even though the drawing looks like a detailed construction drawing, it was never intended to inform construction, but used by the architect-arbitrator to convince the client of the technical feasibility of our proposal. Its vast scale (2.2×1m approx.) was to convey the energy and conviction behind the project

1.102 Water collector

1.103 Detail of fermentation vessel inlet

1.104 1:2 Lamp detail

1.105 Email titled 'Call for Artists' from Blackpool Council, forwarded by the Royal College of Art press officer. The email vividly advertises the prospect of working in the context of the Blackpool Illuminations. However, when looking at the detail – little prospect for funding, no workshop facilities and little support from the council for the installation of work – the architect-activist would have to take on much greater responsibility then in all previous projects.

1.106 Project programme dated 15 July 2005

1.107 Findings list. The programme clearly structures the construction process, but the deadline for completion is immovable. This means that, in reality, the contingency strategy is to simply make fewer *Luminaires* if we are to run late. Even though working to a programme implies strict management and tight organisation, imposed management and organisation were the practices that I was trying to avoid. The findings list was the first attempt to hand responsibility to the volunteers. The descriptions of items were specific and vague at the same time; functionality was clearly defined, whereas appearance was left intentionally imprecise so that a degree of creative input would be required

1.108 Detail of letterhead

1.134 *Luminaire no. 5* on site in Caroline Street. The end-user was engaged as soon as the architecture was installed on site as was the press. Figure 1.134 was edited to show the *Luminaire* illuminated. Even though the *Luminaire* was not lit when the photograph was taken, the fact that the lamp had been shown to work during the lamp test justifies the editing of the photograph

1.135 Original project description issued to the press

1.136 Online article from *BBC News*

1.137 Article from the *Liverpool Daily Post* dated 18 October 2005

1.138 *The Guardian* press review dated 20. Oct. 2005, quoting the *Liverpool Daily Post*

1.139 Online article from *The Daily Mirror* dated 18 October 2005

1.140 *Luminaire no. 5* on site in Caroline Street. This picture was originally not published by the council for child protection reasons. Instead the council published the picture with the girl on the bicycle (Figure 1.133), because her face is concealed. This book is published almost a decade after the photograph was taken, hence child protection is no longer an issue

1.141 *Luminaire no. 1* at Woburn Square Studios. To investigate the urban implications of the project, we had to manufacture several *Luminaires* to install along the entire length of Caroline Street. If there had been only one it would have been all too easy to categorise it as a piece of art. When the *Luminaires* were later exhibited, they were shown in the context of the whole project alongside a video showing their operation, large scale photographs, press clippings, drawings and text

1.142 *Luminaire no. 2* at Woburn Square Studios. The *Luminaires* were all slightly different. This was for a number of reasons: (1.) the availability of materials, (2.) aesthetic considerations, (3.) the fact that we were designing while making and learning as we went along

1.143 *Luminaire no. 3* at Woburn Square Studios

1.144 *Luminaire no. 4* at Woburn Square Studios

1.145 *Luminaire no. 5* at Woburn Square Studios

1.146 Letter to Jörg Kossdorff. To establish transparent and well-ordered working conditions before starting a new job is as essential as the arranging, by the architect-activist, of his or her tools prior to beginning any work. Inappropriate tools, a vague brief and a disorganised environment can spoil the final product

1.147 Email from Anna Malunat to Jan Kattein dated 29 July 2005

1.148 Email from Anna Malunat to Jan Kattein dated 5 August 2005

1.149 Model view from lower auditorium level with projection screen in the background

1.167 Final drawing of chandelier issued to Opernhaus Graz

1.168 Email from Anna Malunat to Jörg Kossdorf dated 21 January 2007. The email is the response to a physical clash between Hanna Eimermacher and Anna Malunat on the rehearsals stage. The composer intentionally interrupted the rehearsals by walking on stage. Hannah Eimermacher was the least engaged composer because her composition had been introduced at the last minute, just before rehearsals started. The inability of the composers to comprehend and respect disciplinary boundaries led to physical violence

1.169 Rehearsal photographs of the game with paper

1.170 Rehearsal photographs of the game with paper

1.171 Rehearsal photographs of the game with paper

1.172 Rehearsal photographs of the game with paper

1.173 Rehearsal photographs of the game with paper

1.174 Rehearsal photograph during scene 4. Paper was everywhere and had informed every scene of *Opernreigen*. Removing the printed music from the scene damaged the performance to such a degree that it could not be repaired within the limited rehearsal time which now remained before the premiere. To have the singers read from sheets without scenic justification would make them look unprofessional and the composers inadequate. Thus, insisting on the elimination of the scenic use of the paper, the composer made her composition appear unfit for operatic performance

1.175 Collection of tools and materials for the chandelier maker: (a) revolving punch pliers for piercing edges of water bags; (b) scissors to cut string; (c) zip-up plastic bags constituting crystals once filled with water; (d) strong cotton thread for beading; (e) bucket with clean water

1.176 Detail photograph of sound tape cutting table with projected opera curtain in the background

1.177 Actors at the cutting table

1.178 Chandelier being strung with water beads

1.179 Sound tapes being poured into the opera-house model

1.180 When the lights come on a disillusioning occurs as the opera curtain reveals itself as a projection onto a white screen

2 The Characters of the Architect

2.1 Elevation of the architect's desk. *S,M,L,XL* by OMA, Rem Koolhaas and Bruce Mau is an essential constituent of every architect's library. Because of its size it is especially useful as a screen prop giving an entire 72mm viewing height advantage. Even the colour scheme of the book cover is co-ordinated with that of the monitor stand

Acknowledgements

Thank you to my wife, Chrysanthe Staikopoulou, whose pertinent ideas have contributed to all the projects in *The Architecture Chronicle* and who has taken many important photographs that have allowed me to reconstruct all the detailed stories around the projects that would otherwise have been forgotten. Thank you to Professor Jonathan Hill at the Bartlett School of Architecture who has patiently read and re-read almost innumerable drafts of the book and whose comments were invaluable for me to understand what I wanted to write. Thank you to Anna Malunat who has directed all the plays and operas in *The Architecture Chronicle* and who has introduced me to the magic of theatre. Thank you to Dr Penelope Haralambidou at the Bartlett for her useful comments and for lending me an important book. Thank you to Rachel Collings whose comments were invaluable when putting this document together. Thank you also to all the people who have contributed to the projects described in *The Architecture Chronicle*: in particular, Michael Bauer at Staatsoper, Munich; Anna Bell; Josephine Callaghan; Lena Gaetjens; Chris Leung at the Bartlett; Traudel Malunat; Girgl Nagel and Stefan Wintersberger at Prinzregententheatre, Munich; Veronika Niederhauser; Philip Oakley; Magdolna Parditka; Heini Philipp; Samara Stott; Christiane Tombrink; Heinz Weyringer at Wagner Forum, Graz; and Emi Yamada.

INTRODUCTION

When he disagreed with the committee he had a way of saying, 'I will do it your way, gentlemen, but I think you will regret it.' That convinced them he was right.

This book has been with me since I set up Jan Kattein Architects some ten years ago. It evolved as I devised a corporate identity, as I received my first commission and as I completed my first project on site. Writing became a means to navigate the labyrinthine landscape of conflicting ideas, discordant agendas and jarring opinions that mark the architectural process. While maturing as an architect, writing became a means to an end. It provided an invisible sounding board for design decisions, the omnipresent dialogue partner when rehearsing tricky client meetings and the paternal master ensuring excellence during the construction process. When writing and re-writing sections of this book over the years, I have come to understand that writing and designing have one common peculiarity which sets them apart from many other disciplines, they are never finished. A good writer or architect knows when to sum up one's intentions, tie up lose threads and come to an interim conclusion. *The Architecture Chronicle* is my interim conclusion on the subject of architectural practice.

The book started life as a PhD thesis at the Bartlett School of Architecture in London. The doctoral programme at the Bartlett combines design work and text with each component having equal importance. This working method reflects my practice as an architect and a writer where one discipline helps to make sense of the other. A new way of doing things evolves at the junction.

ARCHITECTS

During the last 30 years technological, social, economic and environmental changes have brought about the most dramatic evolution to architectural practice that has taken place since the profession emerged during the Italian Renaissance.[1] Architecture has attained a new status in a global market. New technologies have opened up opportunities for collaborative working methods, and environmental changes bring with them the potential for architects to become leaders in sustainability. At the same time some of the traditional responsibilities of architects are taken on by other members of the design team in a drive for greater specialisation and to apportion design liability. While these changes are taking place, few practising architects engage in the debate about the future of the profession. Whilst the strength of the profession is its vast diversity, it is also a priority that architects develop a common voice to defend their profession. This is particularly important in an economic environment where good and sustainable design is easily considered a dispensable add-on to a building project. *The Architecture Chronicle* sets out to define the role of the contemporary architect in light of these changes and strives to initiate a discourse about the profession.

BOOKS

Most books on architecture start when a building is complete, carefully editing out any evidence of the design and production process. Dissemination occurs as an afterthought, and the completed building stands as evidence of the architect's achievement. Architecture as a result is often seen

I.1 In his article 'St. Catherine's College, Oxford', John Carter quoted Dr Allan Bullock, master of St. Catherine's on the negotiations with his architect Arne Jacobsen during the design and construction of the college

as a product rather than a process. The obfuscation of the architectural process prevents wider public scrutiny and hinders progress. Architectural practice at its most basic results in the construction of a building; at its best it helps to engage people and create cohesive communities.

DIARY

The Architecture Chronicle is organised into two chapters. Chapter 1 is written as a diary starting on 16 December 2003. It is divided into five sub-sections reporting on the design and realisation of four stage designs and one urban intervention over a four-year period. Chapter 2 reflects on the diary, post-rationalising the activities of the architect and contextualising his practice.

The diary reveals how design decisions are made, it identifies the members of the team that help realise each project and it analyses how the designing and building process can engage the user and the maker. Where appropriate, the diary digresses to discuss other references. Digression in this context is intentional and contextualises the content of the diary.

CHRONICLE

The title, *Architecture Chronicle*, was first used in a design brief that I wrote with Dan Brady for our students in 2005, when we taught together at the Bartlett (Brady and Kattein 2005). While writing our brief, we had come across a quotation from Austro-Hungarian architect Adolf Loos who states that architecture can be written and that he had no need to draw his designs (1924). This was an intriguing thought, which we wanted to discuss with the design unit.

'How does Architecture that is written, differ from one that is designed? Can architecture exist in the space of text? What words would construct a cathedral? And would the town square be a poem or a tag line of graffiti?' we asked the students (Brady and Kattein 2005). The outcome of the project was unexpected; several students had chosen a diary format to write about architecture. Two types of diary were presented. The first type explored a sequence of spaces as the diary's author experienced them. The second type reported on the design process itself. The latter format served as a blueprint for this book, because it reflects on architecture as a process that takes place over a period of time.

PRACTICE

Following a period of few significant publications, about 30 years ago there was a resurgence of literature on architectural practice in England and the USA out of which emerged classic books like Dana Cuff's *Architecture: The Story of Practice* (1991) and Andrew Saint's *The Image of the Architect* (1983). More recently Leon Van Schaik's *Mastering Architecture: Becoming a Creative Innovator in Practice* (2005) and Jeremy Till's *Architecture Depends* (2009) are recognised works. Van Schaik's book finds that there is a great diversity of practice models and that excellence in design can be achieved in a number of ways. Till defines the contemporary architect as a 'Transformative Agent' who has lost control in a working environment defined by outside factors. A more useful model to define contemporary practice is John Evelyn's 17th-century essay *An Account of Architects and Architecture* (Evelyn and de Chambrey 1707) which

defines architecture as a multi-disciplinary practice.

The architect, Evelyn finds, can be defined as four distinct characters. *Architectus manuarius, architectus ingenio*, *architectus sumptuarius* and *architectus verborum*: all contribute to the success of the project. Evelyn's definition of the characters is out of date, but his understanding of the architect as a number of characters is a useful tool to comprehend contemporary practice. Chapter 2 explains how the architect in *The Architecture Chronicle* takes on three distinct characters to maintain control over the design process. The architect-inventor challenges conventions and questions the social status quo. The architect-activist transgresses the boundary of the profession and enters the construction process. The architect-arbitrator engages the audience to realise the ambitious project.

THEATRE

Parallels between architecture and theatre have repeatedly been drawn. I am aware of Walter Benjamin's (1997) and Jane Jacobs' (1996) writing about the city as a stage for social activities and Helen Furjan's (2002) essay about the performative qualities of Sir John Soane's House in London amongst others. My interest lies in the parallels that can be drawn between producing theatre and practising as an architect. In *Delirious New York: A Retroactive Manifesto for Manhattan*, Rem Koolhaas observes that 'movie stars who have led adventure-packed lives are often too egocentric to discover patterns, too inarticulate to express intentions, too restless to record or remember events' (1978). Interestingly, Koolhaas' book is not about film, but about architecture. The term 'movie

star' in Koolhaas' quote needs to be changed to 'architect' to reveal the true meaning of his phrase. Working as an architect amongst actors, directors, theatre technicians, composers, costume designers and musicians has encouraged me to reflect on architectural practice in the same way that theater invites its audience to reflect on political or social events that occur outside the theater, in the real world. *The Architecture Chronicle* concludes that the contemporary architect still draws and writes, but that it is often the architect's ability to engage and direct that asserts his or her status.

DESIGN

Architects like to see themselves as designers. This is due to the elevated status ascribed to the designer. A designer, by definition, is the author of a work. In the Western world, his or her ideas are protected by copyright law, preventing anyone else from taking credit for them and simultaneously stressing the originality of the designer's idea. In his book *Words and Buildings: A Vocabulary of Modern Architecture*, Adrian Forty observes that the pre-Renaissance architect worked on the building site amongst other tradesmen in an environment of dispersed authorship. It was his ability to draw and to write, acquired during the Italian Renaissance, that allowed the architect to remove himself from the site of construction and to upgrade his status from anonymous craftsman amongst others to artistic creator (Forty 2000). New procurement methods have changed the role of the architect in construction projects. To minimise liability, and as a result of the increased specialisation of building professionals, contemporary buildings are designed by a design

team. This threatens the status of the architect as artistic creator. Today, the architect operates once again in an environment of dispersed authorship as a member of the design team working alongside other design professionals. Drawings are more often produced by visualisers, engineers and sub-contractors than by architects, while text is more often written by surveyors or specifiers.

The word 'design', Adrian Forty observes, comes from the Italian word *disegno* (drawing). The contemporary architect still designs, but drawing in contemporary architectural practice has lost its former significance. The key question that *The Architecture Chronicle* addresses is, what exact activities do architects pursue when they design? Through the diary format, the book can reveal how design decisions are made, who is involved in making these decisions and how they are communicated. Design in contemporary architectural practice has attained a new meaning that can no longer be exceptionally related to drawing. Instead, *The Architecture Chronicle* puts forward an alternative term to circumscribe the architect's activities, 'bricolage'.

BRICOLAGE

Bricolage describes an activity in which a number of initially disjointed pieces of material are combined into a larger assembly with a new sense of beauty, purpose or/and utility. Contemporary architectural practice and bricolage are inseparably intertwined. The contemporary architect is a master in synthesising precedent examples, approved details, proprietary systems, existing site conditions, client aspirations and functional requirements. The architect-inventor adapts existing technological systems and intellectual framework to suit their new context. The architect-arbitrator exploits coincidental social situations for the benefit of the project. The architect-activist synthesises found materials and technologies into new structures and spaces. Successful architects combine the individual expertise of all architect-characters for the benefit of the project. Even though each architect-character has a distinct area of expertise, all characters can combine in one and the same person.

Notes
1 Forty observes that architects established themselves as professionals distinct from the building trades during the Italian Renaissance (2000).

DIARY OF AN
ARCHITECT

1.1 Collection of tools of the architect-activist. The tools that I took to Munich were chosen for their versatility. Most of these can be used for more than one purpose: (a) electrical screwdrivers; (b) disc with essential computer programmes comprising photo-editing, desktop publishing and CAD software; (c) self-made, large-radius compass – particularly useful for 1:1 drawings; (d) well-used scraper – a scraper's edge sharpens with age and the initially sharp corners are worn round; (e) universal hammer; (f) pipe wrench; (g) junior hacksaw for small engineering jobs – in spite of technological innovation the best quality engineering is still done by hand; (h) combination pliers for cutting, holding, tightening and loosening; (i) long-nose pliers; (j) technical drafting pens with 0.18mm, 0.25mm and 0.5mm thick nibs; (k) precision pencil sharpener; (l) rubber with narrow end for detailed erasing; (m) precision drafting pencils with medium and hard leads; (n) precision compass with attachment for pens or pencils; (o) handy-sized Leatherman multi-tool with saw, screwdrivers, knives, drills and file – particularly useful on scavenging trips; (p) Stanley knife for rough cuts and cutting thick materials; (q) medical scalpel for precision cutting; (r) multi-purpose scissors for heavy duty cutting with screwdriver attachment and bottle opener; (s) precise paper scissors; (t) 5m measuring tape; (u) metal ruler for use as cutting edge; (v) scale ruler; (w) combination set square and protractor; (x) transluscent adhesive tape; (y) drafting ink; (z) universal glue for a variety of materials

FRIDAY 12 DECEMBER 2003

Today I fly to Munich. I have packed my tools and drawing equipment, a model is travelling with me, safely stowed in a wooden box. There are also samples of wood panelling and carpet and some acetate templates for printing wallpaper. I have been commissioned to design a stage-set for a production in the Prinzregententheatre in Munich for a total fee of €300. My sister is the director. I will be staying on the floor of her flat and spending every day for the next two months working on the construction of the set.

KABALE UND LIEBE

Kabale und Liebe (Intrigue and Love) by Johann Christoph Friedrich Schiller is a German theatre classic, first premiered in Frankfurt on 13 April 1784 – exactly 219 years and 10 months prior to our premiere. The title of the play well defines its contents. The narrative tells the love story of Ferdinand and Luise whose families do not allow them to be together because of their class differences. Ferdinand is the son of the president and Luise the daughter of a musician. Instead, their fathers have other plans for their children whom they want to see married to suitors of their choice for their own political benefit. This results in a network of intrigues that are spun to force the lovers apart.

Kabale und Liebe was a great success in Berlin but banned in Stuttgart, because it was considered an affront to the aristocracy. To this day, the German south has remained more conservative than the liberal north and audiences, particularly those in conservative Munich, have very particular expectations of *Kabale und Liebe*.

Around 120 years after the premiere of *Kabale und Liebe*, the aristocracy lost its power to the parliament of the Weimar Republic. Divisions in contemporary German society are the result of different standards of education, immigration

status or whether an individual originates from the formerly communist eastern part of the country or the capitalist west. The danger of using the traditional class system to define disadvantaged groups in today's society is the historicisation of social inequalities. Using the antiquated class system in this context can eclipse the real and much more complex and fragile relationships in society. Our interest in *Kabale und Liebe* lies in the subliminal social relationships between the characters: no reference is made to the class system. As a result, the characters in our production are made responsible for their own actions rather than becoming victims of a system that they do not control. Our production is set in a house-share instead of a palace and an artisan's cottage (the original context).

Two types of text constitute Schiller's drama: dialogues and stage directions. The dialogues are to be performed on stage, the stage directions are designed to be mute, to give instructions to the stage designer and director in relation to the spatial setting of the play. Scene 1 starts with the following direction: 'Zimmer beim Musikus. Miller steht eben vom Sessel auf, und stellt sein Violonzell auf die Seite. An einem Tisch sitzt Frau Millerin noch im Nachtgewandt, und trinkt ihren Kaffee' (Room at the music master's. Miller is just getting up from his seat and places his violoncello aside. On the table Mrs Miller is sitting in her night gown and is drinking her coffee) (Schiller 1784). The stage direction for scene 1 does not use a single adjective. The frankness of the spatial description of the setting stands in stark contrast to the opulent dialogue. Schiller was aware of his audience for each type of text. Stage directions

provide a brief to inspire the stage designer's imagination. Dialogue is directly communicated to the audience.

Altering the dialogue, even in its smallest detail, is considered an intervention in a work of art. However, to keep a performance within an acceptable time frame, it is sometimes necessary, and this is done with uttermost care by the director in consultation with the dramatic advisor. Alteration normally takes on the form of omission. Adding dialogue, changing the wording or amending the context of dialogue has implications for the integrity of the piece. Taking a creative reading of a stage direction is considered artistic freedom. In fact, taking stage directions too literally may be considered a failure by the directing team to make an interpretative reading of the play.

Schiller would have been intimately aware of this distinction of purpose between the two types of text in his work. His poetic efforts would have been focused on the dialogue. This manifests itself in the language used. The dialogue allows the audience access to the character's innermost feelings, to assess their believability and to judge their truthfulness. The extended meaning given to the dialogue through metaphors and associations makes them a spatial manifestation of the interrelations between the characters and the intrigues that are spun between them. In contrast, the stage directions in the original *Kabale und Liebe* are flat and factual. Whereas the characters are brought to life by the dialogues that Schiller has given them, the spaces or situations that Schiller describes in his stage directions are lifeless until animated by the design team that has been charged with staging the production.

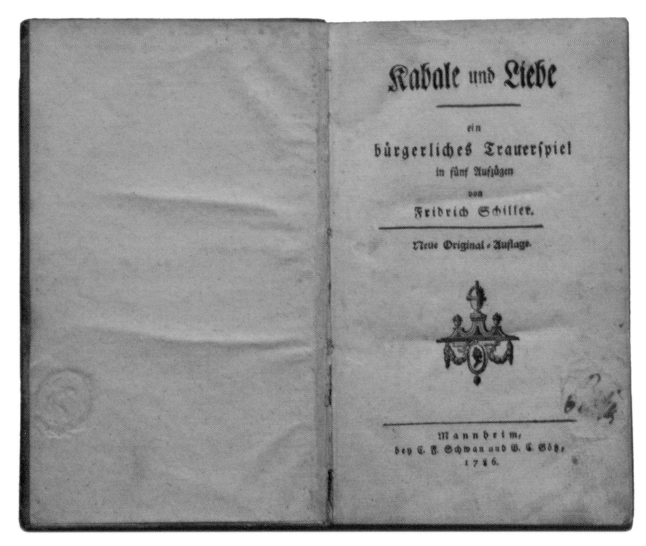

1.2 Cover page of the first edition of *Kabale & Liebe* by Friedrich Schiller. The play is classified as a *Bürgerliches Trauerspiel* (popular drama). It was banned in some parts of Germany because it was considered to be too critical of the aristocracy. The play became extremely popular in other parts of the country. Audience reaction is a useful gauge for the success of a work. Success is not solely a matter of universal praise, controversy amongst the audience is an indicator of critical engagement. A good work will be hated by some and loved by others. It is a poor work that is often treated with indifference

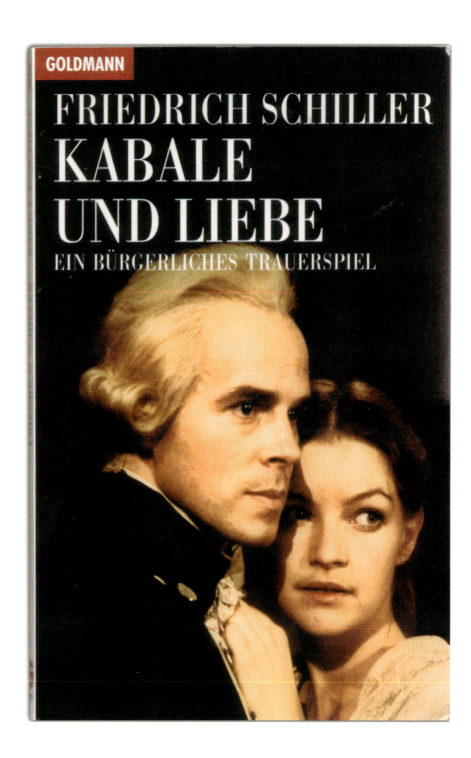

1.3 Front Cover of Goldman paperback edition of *Kabale und Liebe* with photograph by Felicitas Timpe showing actors Jan Niklas und Dietlinde Turban in a TV adaptation of the drama. The historicizing 1996 Goldman cover gives an indication of the Munich audience's past exposure to *Kabale und Liebe* and hence their presumptions about the nature of our production

1.4 Photograph of *Kabale und Liebe* model stage-set with illuminated refrigerator. The theatricality of the refrigerator light in the model that switched on when the tiny door was opened enticed the actors to adopt the stage-set proposal. Their trust in the architect was founded upon his ability to deliver a stage-set that communicated a sense of magic even at its reduced scale

1.5 Colour sample of carpet tiles from the *Kabale und Liebe* model. The sample is dyed using hand-mixed acrylic paint to achieve the exact colour required

MONDAY 15 DECEMBER 2003

The concept rehearsal starts at 10 am in the music library of the Prinzregententheatre. Sitting around a meeting table are Anna Malunat, director; Jan Kattein, stage designer; Katja Kranich, costume designer; Katrin Dollinger, dramatic advisor; Anna Bell, stage design assistant; and the actors playing Ferdinand, Luise, Miller, Wurm, Lady Milford, the President and Victoria. In the centre of the table is my stage-set model that I brought from London. Anna Malunat introduces the group, she is the only one who has met everyone before. Then the rehearsal starts with Anna Malunat explaining the synopsis of the play and our staging concept. Afterwards, she hands over to me to explain the design.

In the centre of the stage is the common room with a refrigerator, a sofa and a lamp, a clock and

a coffee maker; on the left is a carpeted ramp from where doors lead to the characters' own rooms. The entirety is surrounded by walls that extend deep into the auditorium. The wall on the right is designed with an incline overhanging the stage and the front rows of seats in the auditorium. When built, the top of this wall will taper down to 5.3m where it meets the rear wall, this continues around to the left of the stage extending to the rear wall of the auditorium. Skirting board will be affixed to the walls at a height of 1.6m. In the model, the walls below the skirting board are stained brown with the wood grain showing through. A satin lacquer is applied on top to give a sheen to the stained surface. Above the skirting board the walls are wallpapered. The refrigerator in the model is made from copper plate. The door opens on a pivot hinge made from a piece of brass wire soldered to the back of the door. The fridge door handle is made from a bent piece of brass wire.

The concept rehearsal marks the beginning of a very intense working process which involves a large amount of personal engagement by all involved. The atmosphere in the room during my presentation is reserved. When I come to talk about the fact that one of the characters will live in the fridge and open the model fridge door, the battery-operated lamp inside comes on and casts a streak of light onto the stage floor. Suddenly everybody's face brightens, and I know that I have the actors on my side. From now on, all my stage design models will have an electric light of some description.

In the evening, between 6 pm and 10 pm, the first rehearsal takes place with a makeshift stage-set consisting of a ramp on the left (left and right are always as seen from the auditorium in the theatre), an uninhabitable refrigerator with ice box, an electric coffee maker and some canvas screens standing in for the walls of the room. Anna Malunat announces the rehearsal times for our production: 10 am to 1 pm and 6 pm to 10 pm, excluding Saturdays where there are no evening rehearsals and Sundays where there are no rehearsals at all. From now on my days will start at 8 am, with the first shift of theatre technicians, and will finish at midnight, when the last metro will take me home.

WEDNESDAY 17 DECEMBER 2003
The general design for the stage-set was completed before I came to Munich. The following materials are being ordered today for the first phase of construction: 16 sheets of 13mm thick plywood, 6 sheets of 6mm thick plywood, 8 sheets of 22mm pine blockwood measuring 5.5×2.2m, 80 linear metres of 7×2.5cm theatre batten, 40 linear metres of 5×5cm softwood.

The technical director has assigned a full-time member of staff to help build the stage-set for a two-week period in January. How to use this time is primarily up to me. My role in our production is not only to design the stage-set, but also to manage the construction process and to organise any additional materials and props that are needed. It is remarkable how difficult it has become to get hold of old refrigerators. They are treated as hazardous waste due to the CFC gas that is inside the cooling system and that contributes towards ozone depletion when released into the atmosphere. I telephone around several departments at Munich Municipal Council until I am finally put through to Herr Lange, the council's special representative for the safe disposal of old domestic refrigerators.

Prinzregententheater

Bayerische Theaterakademie
August Everding

Hochschule für Musik und Theater

Bayer. Theaterakademie * Prinzregentenplatz 12 * 81675 München

Stadtverwaltung München
Geschäftsbereich Wertstoff

Fax. 233 31369
233 31166

München, den 17. Dezember 2003

Sehr geehrter Herr Lange,

Wie bereits am Telefon besprochen benötigen wir als Requisite für eine unserer Produktionen einen Kühlschrank.

Das Gerät muß nicht funktionsfähig sein. Es sollte zwischen 1,4 bis 1,6 m hoch sein und 20 Jahre oder älter.
(desto älter, desto besser)

Der Zustand spielt keine Rolle, das Gerät sollte aber weiß oder elfenbeinfarben sein.

Wie bereits erwähnt steht uns am Freitag den 19.12 ein Lieferwagen zur Verfügung und es wäre praktisch, das Gerät dann schon abzuholen.

Ich werde Sie morgen anrufen, um Näheres zu besprechen.
Vielen Dank für Ihre Hilfe.

Freundliche Grüße

JAN KATTEIN

1.6 Fax sent to Herr Lange (Munich City Council Recycling Department) describing, in detail, the refrigerator required for the *Kabale und Liebe* stage-set. The material acquisition process has two approaches, material-led and design-led. Either a material is identified, found and integrated into the design or an idea develops while designing that directs the architect-activists' search for a particular material. Most designs are the result of the combination of both methods; the use of the refrigerator followed the latter

(Munich City Council, Recycling Department, Munich, 17 December 2003

Much Honoured Mr. Lange,

As already discussed on the telephone, we require a refrigerator as a stage prop for our production. The appliance does not have to function. It should be between 1.4 and 1.6 metres tall and 20 years old, or older. (the older the better) The condition does not matter, the appliance should be white or ivory coloured though. As I mentioned, we will have a van at our disposal on Friday 19.12. and it would be convenient to collect the appliance then. I will call you tomorrow to discuss details. Thank you for your help.

Kind regards,

Jan Kattein)

My phone call interrupts the recycling department's Christmas party. Herr Lange only feels obliged to answer my call because he considers me a colleague, since I am calling on an internal line (the Prinzregententheatre is a public theatre owned by the City of Munich and is, like Herr Lange's department, connected to the same telephone system). Herr Lange asks me to send a fax listing the details of the fridge that I need. The fax describes the fridge required as follows: 1.4 to 1.6m tall, 20 years or older (the older the better), white or ivory coloured. Obviously, functional specifications of power consumption and storage capacity do not concern me since the fridge is not to be used for refrigeration. The size of the fridge that I specified is selected for two reasons: the fridge must have proportions appropriate to the room and the wall against which it is to be positioned, secondly, the fridge is to be occupied by one of the characters. The decision for a character to occupy the fridge was made by myself and Anna Malunat early in the design process. Besides the fridge, the stage-set is rational. The wallpapered walls, carpeted ramp, panelled doors with door handles, chairs and seats are all reminiscent of a domestic interior. The insertion of the irrational occupied fridge makes links with the world of the fantastical, undermining the rationality of the surrounding domestic interior.

The colour, white or ivory, is important so that the fridge looks comfortable among the other colours in the room. Age is a key design parameter. It is important, in this context, to distinguish between age and history. Sometimes stage designs make literal reference to the time period when a play was written, this is often done by reproducing the architecture that was common at that time. The problem with this method is that the contemporary relevance of a play can be undermined by a historic setting. Other stage designs firmly reside in the present by reproducing particular contemporary architecture on stage. The problem with this method is that it fails to engage a large portion of the audience who do not relate to contemporary architecture. Our production avoids any literal reference to a particular time period, it exists at the intersection of past and present. This way, each audience member connects to the space individually, allowing the stage-set to float in space–time without being pegged down by any specific reference points. This, I thought, would be achieved in three ways: wherever possible used materials, furniture and finishes will be re-used, repaired and adapted; craftsmanship is important; finishes will be true to their substrate. Needless to say, Herr Lange did not got back to me about my refrigerator. The theatre will close for Christmas in three days.

MONDAY 5 JANUARY 2004

Today I arrive back in Munich. The timber for the walls has been delivered and everything is ready to start construction. Even though the wallpaper is the last piece of decoration that is needed, it is the first piece of the stage-set that needs to be started, so that the printing process can run in parallel with the building of the wall.

The pattern is modelled on the end papers from a book on Englishness that was found on the top shelf in the basement of an antiquarian bookshop on Charing Cross Road in London.

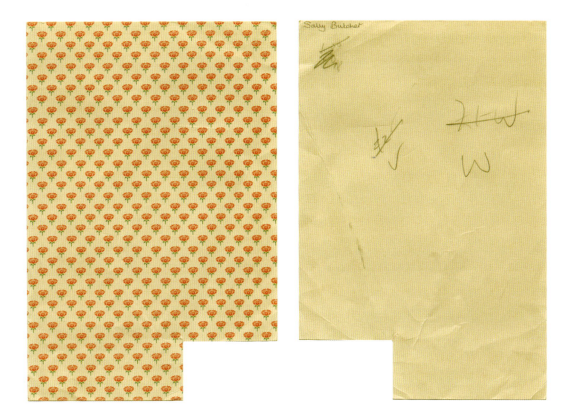

1.7 Front and reverse side of the original pattern used as a template for the *Kabale und Liebe* wallpaper. Regular patterns like this are usually designed as tiles that are then multiplied across a large surface. Through careful investigation, a tile can be identified and isolated. An isolated tile is the key for scaling and then re-creating a large patterned surface

Unfortunately, the book went missing in our last move, but I still have the original inside cover that we used for the wallpaper. I remember that the book was bought partly for the sound of its title (that I do not remember) and partly for the pattern, which was the only colour print inside the book otherwise illustrated in black and white.

The pattern is first used in the 1:50 model of the stage-set that I had made during October. For this purpose, a rectangular section from the inside of the book cover was cut along the centre of the blossoms horizontally and along the base of the stems vertically. This sample of the pattern was then scanned and tiled digitally to produce the wallpaper at the appropriate scale. The original is printed on light yellow paper, this was found to be the appropriate background colour and was reproduced with a high resolution ink-jet printer to match as closely as possible. When the model photographs and pattern samples were sent to Munich during November they found immediate approval. The appropriateness of the pattern to the contents of the play was applauded in particular. The fact that I was proposing to wallpaper a stage-set for an 18th-century classic German play with a pattern derived from an English national symbol – the Tudor Rose – remained entirely undiscovered.

Different options are evaluated to manufacture the wallpaper for the stage-set. Digital reproduction is considered, but dismissed, as most digital printers are not able to print to the edge of the paper. This method would cause the pattern to be discontinuous. We also fear that the wallpaper glue that we intend to use to hang the wallpaper would dissolve the ink. Screen-printing is considered, but dismissed due to the lack of professional equipment. We finally settle on a self-invented technique that will use templates and airbrush equipment. The Prinzregententheatre does not possess airbrush equipment, and we borrow this from the Munich Opera workshops that are located in a group of industrial warehouses in a village outside Munich. I prepared the templates digitally in London so that the pattern will match up at the edges and I had brought the line plots of the pattern, on acetate. There is one template for the red sections of the rose and one template for the green sections. I cut the templates manually during the Christmas break using a medical scalpel. Mounted behind a wooden frame, they can be aligned with the edges of a wallpapering table that we have fitted with roll holders at either end. The paper used has to have the yellow tint of the original book cover. Lining paper was chosen. We were unsure if the English lining paper, to whose dimensions the templates had been drawn, would be the same width as the German lining paper that would be used on site. The width is the same and I calculate that we have to make 200m of wallpaper with the 1m wide templates. At first the blossoms are sprayed with red acrylic household paint thinned with water. Afterwards the stems are sprayed with green acrylic paint. 12.5 litres of red paint and 7.5 litres of green paint are needed, and I estimate that it will take two weeks to complete the wallpaper.

The first tests show that the results are better than we had hoped. The technique that we have established makes the pattern even more intense than expected. The roses appear to be in constant circular motion, their edges blur as they dance across the wallpaper. The copy improves the original.

WEDNESDAY 21 JANUARY 2004

Today the president leaves. Anna Bell and I are decorating the refrigerator and the doors when we hear loud voices from outside followed by quick steps along the corridor. When his shoes are later found in the ornamental planters by the main entrance we know that he will not come back. It will be very difficult to find a new president three weeks before the premiere.

Rehearsals are cancelled for the remainder of the day, and instead I invite everyone for tea in our workshop. Wallpaper scraps, paint tins and brushes are cleared away to accommodate a white ornamental bench with red velvet upholstery and golden detailing that is brought up from the foyer.

1.8 *Kabale und Liebe* wallpaper sample. The self-invented printing technique gave us an unexpected result. The blurry edges accentuate the impact of the pattern and every rose is slightly different from its neighbour. Inaccuracy in this instance is desirable and contributes towards the liveliness of the pattern. An even and sharp print applied across the large expanse of the walls of the set would have looked monotonous and lifeless. With the *Kabale und Liebe* wallpaper, a happy accident that occurs during the printing process became a key design parameter. The wallpaper was designed by both drawing and making

A small kitchen table with a yellow patterned Formica top is taken from the furniture store and some cups and a tea pot are borrowed from the props department (accompanied by the warning from the props administrator that these items are to be used for ongoing productions only). Tea is brewed in the costume department and cake bought from the reduced stock offered in the local bakery. There are 13 people permanently involved in the production – all with different working hours spread out between 8 am and midnight.

THURSDAY 22 JANUARY 2004

I telephone most of the carpet-fitting contractors listed in the Munich telephone directory to obtain used carpet. However, the type and colour of carpet (an olive green wool carpet to match that of my childhood bathroom) is not available, because it has long gone out of fashion. What makes the design for the carpet interesting is not that it originates from my personal history, but that it has gone out of fashion. Its origin is only important as it allows me to describe the carpet in detail.

Today, we finally find a suitable carpet. It is being used in the Reaktorhalle – a disused nuclear-research reactor turned into a theatre – to cover the stage for acoustic reasons. The carpet has not been stuck down and is easy to remove and transport to the Prinzregententheatre where it will be dyed and cut into tiles. Any holes and tears are carefully patched with self-adhesive tape before dyeing.

MONDAY 26 JANUARY 2004

Teatime has become a daily highlight with attendees from all departments of the theatre,

including those not involved in our production. More chairs and tables are brought from the furniture store and more tea cups from the props department. A milk pitcher, a chipped sugar pot and a kettle are acquired from the charity warehouse and paid for with the props budget. Every day at 5 pm the workshop turns into a tea salon where the eclectic collection of furniture, antiques and contemporary pieces, tells the story of 200 years of German seating furniture. The architect-arbitrator has selected the furnishings personally to ensure the consistently high quality of design and craftsmanship of each piece. If I was spending such an extended amount of my time hosting tea-parties, I want my guests to take their tea in an inspiring and well-composed environment – the furniture is part of that.

1.9 Sugar pot and milk pitcher from teatime. Furniture and crockery for teatime were carefully selected with the stage-set in mind so that the other team members could familiarise themselves with their material qualities

1.10 View of workshop with scattered stage elements. Carpet tiles and stage-set elements are spread out in the workshop to improve drying of paint and dye, but also so that they are prominently visible to guests at teatime. Familiarity with the material will make it easier for the end-users to adapt to the stage-set once it is assembled on stage only four days before the premiere

Stage time is very precious in most theatres and rehearsals take place in rehearsal rooms with dummy stage-sets until just before the premiere. The mock stage-set does not have any of the material qualities of the finished stage-set. Teatime is an opportunity to invite the actors into the workshop so that they can familiarise themselves with the set they will perform in. This makes it easier for them to adapt to the final stage-set.

TUESDAY 27 JANUARY 2004

Today we find a refrigerator. One of the technicians who joins us for teatime tells us about an old refrigerator that matches our specification. The said appliance is being used to cool beer in the staff mess room on the fourth floor. The technical director says that we can use it if we find a substitute. In the afternoon we go to the charity warehouse where we buy a replacement refrigerator for €35. We transfer the beer into the new refrigerator, and the old machine is brought into the workshop for careful disassembly, repair and adaptation. The technicians are happy to have a new refrigerator that is not leaking and we are delighted to have the exact refrigerator that we wanted.

As a result of the extended hospitality, we are falling behind with the manufacture of the stage-set. A decision is made during teatime that the actors will help to lay carpet tiles and to stain the wood panelling on the walls during their midday break.

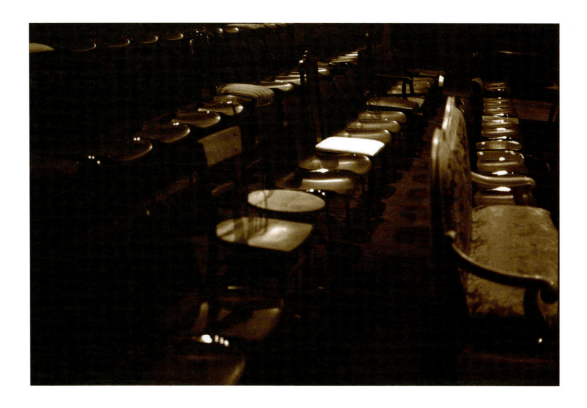

1.11 Audience seating for *Kabale und Liebe*. The seating furniture from teatime is moved into the auditorium. Teatime provided a useful opportunity to compose the chair collection and to rehearse the assemblage that would become the audience seating. In most theatres the audience seating is a permanent fixture of the building that is bolted to the ground for safety reasons. The design of the auditorium and its seating is the responsibility of a specialist sub-contractor or, in older theatres, the architect of the theatre building. In *Kabale und Liebe* the auditorium and the stage-set are designed at the same time and by the same architect

Anna Malunat says to me in private that she has never heard of a theatre production where the actors volunteered to do DIY.

MONDAY 2 FEBRUARY 2004
The *Technische Einrichtung* (technical set-up) is a milestone in any theatre production. All the segments of the set are transported onto stage and assembled. It becomes very difficult to do any more work once everything is on stage because rehearsals take place for most of the day and any construction work has to be carried out during the lunch break and after 10 pm when rehearsals have finished.

Our teatime furniture is moved into the auditorium to replace the regular audience seating.

For this purpose brackets have to be made and screwed onto every furniture leg to fasten them to the floor. This is a requirement from the fire brigade. There is no teatime today because of a lack of furniture and because the workshop space is now required for the next production. Rituals in the theatre appear to be as temporary as stage-sets, but teatime is not really required any more, there are only ten days left until the premiere and the group has formed a tight team under the pressure that this deadline imposes.

The technical director announced the completion of the technical set-up at 4 pm. The following works are still outstanding: all the wallpapering, carpeting, decorating and, worst of all, only half of wall number 2 is built, due to a shortage of materials and workshop time.

3. Feb. 2004

Lieber Jan,
genialität lässt sich auf drei Buchstaben
reduzieren, hab Dank für Deinen unerschöpflichen
Erfindungsreichtum und Deinen Verdienst
um den interkulturellen Austausch in AKA Ost.
Ich werde unsere Tea-Time vermissen.
Es hat großen Spaß gemacht an diesem Streich,-
Bastel- und Baulehrgang teilzunehmen:)

Toi, toi, toi
und viel Glück für Deine künftigen
Projekte wünscht Katrin

1.12 Note from dramatic advisor dated
3 February 2004 praising the architect-
inventor, thanking the architect-arbitrator
for organising teatime and applauding the
architect-activist for constructing the set

(Dear Jan,

*geniality can be reduced to three letters, thank
you for your never ending inventivism and
for the inter-cultural exchange in AKA-Ost
[Akademietheatre East]. I will miss our teatime.
It was very enjoyable to participate in your
painting, DIY and building workshop. Toi, toi,
toi and much luck for your future projects,*

wishes Katrin)

All of these works have to be finished for the lighting rehearsal on Friday 6 February.

TUESDAY 3 FEBRUARY 2004

The theatre technicians have knowingly forgotten to lock their toolbox. This arrangement allows us to continue work overnight without compromising their responsibilities under health and safety legislation. We were also made aware of a stack of short lengths of timber that are left over from the previous production. Anna Bell and I finish building the missing part of the rear wall today screwing a collection of small lengths of timber together. This is then wrenched in position with some ropes. This completes the superstructure. Wallpapering can start tomorrow and the other finishes have to be applied in parallel.

WEDNESDAY 4 FEBRUARY 2004

There is a quarrel today during the rehearsals because Lady Milford does not want to take her knickers off. The situation is resolved technically before it

1.13 *Kabale und Liebe* stage. The photograph was taken from the top of the lighting gantry above the audience seating. This overall view cannot be perceived by the audience. To achieve maximum spatial engagement, the audience is seated amongst and below the massive inclined walls of the room. Without theatre lighting and void of occupation, the architectural theatre set lacks theatricality

escalates by allowing her to wear tights underneath her knickers. These sorts of quarrels are common in the run-up to the premiere because everybody is under so much pressure.

THURSDAY 5 FEBRUARY 2004

The wallpapering is almost complete. The carpet tiles have all been stuck down. The carpet looks exactly as I had imagined and as it is shown in the model. The tiles have taken the dye unevenly; this gives the effect of an abstract green image composed of very large individual pixels that all have slightly different shades of green. Anna Bell is repairing the refrigerator door with skin-coloured plaster strips. All the cracks and holes in

the insert are being obscured and the beige plaster corresponds well with the colours of the fridge casing and the brown stained wall next to the fridge. I notice today that there is no blue in the stage-set. There is green, yellow, brown, red and ivory. This works well. I decide that I will consciously omit one primary colour from all of my designs from now on.

FRIDAY 6 FEBRUARY 2004

Lighting is the responsibility of the stage designer. Because of my lack of experience, I work closely on this with Anna Malunat. We developed a lighting concept in January and have already met with the head of the lighting department from the

Munich Opera who is supplying the equipment and will operate the lighting controls. Four rows of fluorescent fittings with four tubes each are hung in a grid, as shown on my general assembly drawing. It is important that the lights become an integrated feature of the room, so they are hung with an incline downwards toward the back of the stage. This design creates a ceiling to our room. In addition to the lights drawn, some fluorescents are also hung into the auditorium because it is important that this too be part of the room. The fluorescent tubes are put into coloured sleeves. In each lamp holder there is a pair of tubes in bright yellow and a pair of tubes in bright green. It is uncommon to use fluorescent light for the theatre, but it ideally suites our intentions, because it evenly, and non-hierarchically, illuminates the entire space. The fluorescents can be dimmed and it is our intention for the production to start with a warm and comfortable yellow and to finish with a harsh and aggressive green, slowly and unnoticeably blending between these two conditions. It is our plan that the lighting will follow the steady decline of the drama on stage. In addition, there are some feature lights: a living room lamp with a shade and a flexible neck is positioned at the end of the ramp, there is the light in the refrigerator, and each character has a light behind their door. One single red spot is set up as a humorous comment and will illuminate the red coat that is hung on stage next to Miller's door whenever his dialogue refers to the red coat. I do not think that anybody in the audience will notice this, but it makes me happy to see the red lamp come on. Some 5kW halogen back-lights that have been installed by the lighting designers directed towards the audience are removed, because they confuse the clarity of the lighting strategy.

WEDNESDAY 11 FEBRUARY 2004

Tickets for the premiere and all the other shows have long been sold out, so our dress rehearsal is being opened to theatre staff. Apart from this being the first public exposure that we have, it is also an opportunity to test the technical features of the stage-set and to take photographs. The theatre photographer is also there. Theatre photographers retain the copyright of their photographs and charge for each print made. To avoid charges, I take my own camera. The dress rehearsal is also the sign-off point for the municipal fire department who come to inspect every stage-set before allowing a production to open to the public. Our escape strategy is complicated because the perspective of the stage-set requires that the wall and the ramp continue through a double door into the hallway behind. The hallway is also the main escape route for the audience and the staff from the costume department. To avoid blocking this route, the entire back section of the stage-set is built onto a trolley. At the pull of a rope the trolley can be folded up and than wheeled backwards to clear the escape route. The door to the stage closes automatically.

The sign-off goes well. The only additional requirement is that the steps that the actors will use behind the decoration have to be marked clearly with luminescent tape to avoid the danger of tripping. The technical complexity, even though unconventional, must have convinced the fire officers.

1.14　Luise standing and Miller coming out of his door during dress rehearsal. The leather coat next to Miller's door is borrowed from the previous production and is illuminated bright red every time Miller's dialogue refers to the coat. The red lamp has not yet been directed accurately. One can see the illumination of the rear wall above Miller's door. The stage designer's job in the theatre is mute; it must not interfere with the dialogue. Any critical interaction with dialogue or action on stage occurs spatially. On this occasion, the illumination of the red coat accentuates Miller's all-words-no-action attitude towards his daughter's pleas for help

1.15 The stage-set extending into the main fire-escape corridor behind the stage. The rear section of the set had to be built onto a trolley that could be folded up and rolled away to clear the fire-escape route

Technical problems that we record during the dress rehearsal include a tape player unplugged because an actor stumbles over the power supply, a wheel broken off Miller's table when the table is wheeled down the ramp, the clock stops during Ferdinand's solo. A superstition amongst people working in theatres says that a poor dress rehearsal is pre-requisite for a successful premiere.

THURSDAY 12 FEBRUARY 2004

The suspense in the run-up to the premiere is almost unbearable. We decide to visit the Nymphenburg, located at the edge of Munich amidst the former royal hunting grounds. There are a number of small, themed, hunting lodges distributed about the grounds. One has a huge marble bath in the basement, one is decorated like a primitive hut and one features Delftware wall tiles that were famously removed from the royal residency in town. These tiles must have, at one time, formed part of an elaborate mosaic, but the tilers at the new site seem to have mixed up their sequence because the painted scenery is oddly disjointed.

On 25 August 1845, Prince Ludwig (later King Ludwig II of Bavaria) was born in Nymphenburg. His castles are the subject of a book, entitled *Gebaute Träume: Die Schlösser Ludwigs II von Bayern* (Built Dreams: The Mansions of Ludwig II of Bavaria) (Petzet and Bunz 1995), that I was given for my birthday. On page 284 is a photograph of the ground floor of the king's castle. It shows a room with white walls and ceiling. In the background an open door allows a glimpse of the room beyond. In the centre of the room are four trussed iron columns arranged in a rectangle, they are fixed to base plates at floor level and extend into an opening in the ceiling. Within the depth of the ceiling the underside of a platform supported on four trussed beams is held in place by rollers that run along tracks fixed to the inside corner of each column. Inside the column that is closest to the door a counterweight is suspended on wire. An axle connects the two columns closest to the picture plane. At either end of the axle is a winch that is operated by a hand crank. The floor of the room is made up from a variety of different stone slabs that are randomly cobbled together to form a polychrome mosaic.

The room on the floor above is the king's dining room. The walls are painted in cream and the ceiling is watery green. There are golden ornaments and flying angels. The floor is a fish-bone patterned parquet. In the centre of the room, underneath a chandelier, stands a small table, about the size of a regular kitchen table. The table's golden feet rest on a rectangular floor panel hardly larger than the table top. A black line in the floor reveals the panels function, it is the top of the platform that can be lowered through an opening in the floor into the room below where the table can be set.

On page 36 a water colour by Heinrich Breling shows the mechanism in operation: the king, with his left hand in his pocket and his right hand holding on to his ornamented dining chair, is waiting at the edge of the hole. Below his feet one can see the table being set on the floor below.

1.16 King Ludwig's dining room in Herrenchimsee from *Gebaute Träume: Die Schlösser Ludwig II van Bayern* by Achim Bunz and Michael Petzet

The lavish architecture of the dining room makes decadent royal feasts come to mind: multiple courses of delicacies being served by a whole army of servants and waiters, the magnificent glass chandelier turning the room into a celebration, the candlelight reflected in the golden frescoes on the ceiling and the twitching flames animate the stucco angels to create a joyous dancing rotunda encircling the group of guests seated around the royal table. The fire in the fireplace provides a comforting warmth from the back and the fine red wines help to warm heart and mind.

The table in Heinrich Breling's picture is too small to accommodate any guests and the lift platform is too small for a larger table. Nobody has bothered to light the candles on the chandelier and instead a dull ghostly light illuminates the king from behind.

1.17 The sub-stage mechanism to raise and lower the table into King Ludwig II's service quarters from *Gebaute Träume*

The food that is being put on the table in the room below is anything but a feast: a lonely plate and goblet have been arranged for the king's meal. A servant hurriedly delivers one single platter with some indefinable grey slices that look like the leftovers from the previous day while another servant is already turning the crank to raise the table back up to the dining room. The magic table in Herrenchimsee was the fastest such apparatus in the world, it could be lowered, set and raised in 10 minutes flat. At Herrenchimsee, the king ran out of funds before he was ever able to build the royal kitchen and in the meantime food had to be prepared off site and brought in from a nearby monastery using horse carriages and heated stone slabs as hotplates.

In Breling's watercolour the king is already in the dining room before his meal is ready.

1.18 Watercolour detail by Heinrich Breling showing the king awaiting the ceremonial raising of his dining table from the service area below from *Gebaute Träume*. The king's early arrival in the dining room while meal preparations are still ongoing can hardly be attributed to his anticipation of the unappetising meal that is being assembled by his staff in the service quarters below. Instead, the king has come to witness the theatrical raising of his dining table with a mechanism that was designed especially by the technical crew of the Munich Residence Theatre. King Ludwig II used modern stage machinery to animate the everyday domestic activities in his castles and mansions, creating spaces with a curious theatrical domesticity. *Kabale und Liebe* is sited in the theatre, but it uses everyday objects, spaces and materials to link the theatre to the domestic. The reason behind Ludwig's actions was to escape from his despised domestic life as king into a fairy-tale world like Richard Wagner's operas. *Kabale und Liebe* seeks to escape wonder and detachment of the theatre by association with the domestic context, a context familiar to the audience. This way, we thought we could make the play as relevant to our audiences lives as it was to the contemporary audience when first published

The *Tischlein-deck-dich* that King Ludwig had installed in his dining room is only one example of a whole collection of spaces and mechanisms that were taken from the Munich theatres and introduced into the design of his castles. Ludwig's decorating practice involved stage mechanisms, lighting systems, technical and design staff and even entire stage-sets that were relocated from the Munich theatres to his castles. To perfect the illusion, the king is known to have hired the costumes from the theatres' costume departments to dress up for the occasional re-enactment of a scene from one of Wagner's operas. Ludwig surrounded himself with theatre and theatricality. Michael Petzet explains how, from dining and bathing to sleeping and travelling, every moment of the king's domestic life had performative qualities.

This total theatre presented this lonely visitor with the perfect illusion of a stage which is at the same time auditorium. It is a final escalation of the proscenium arch doing away with the dark abyss of the empty auditorium from the king's private performances.

What is interesting in Ludwig's dining experience is the idea that a meal can begin before eating starts and that it can end well after eating is over. Breling's watercolour suggests that the king's dining experience is within the prologue and the epilogue with little satisfaction offered by the main course.

A visit to a theatre is defined by a series of rituals that are triggered by distinct signals. An audio signal communicates the request to proceed into the auditorium. The dimming of the auditorium lights focuses the attention of the audience towards the stage. The opening of the curtain marks the start of the play and demands absolute silence.

It seems unlikely that the king has come in anticipation of the food that he is about to be served. There is an incongruity between the apparent blandness of the food and the advanced mechanical extravaganza used to serve it. Surely, it would have been easier to carry the king's meagre plate up the stairs than to crank the table down to prepare the meal, crank it back up to serve the meal, crank it back down to clear the table and back up to close the hole.

King Ludwig stands in his dining room consuming the technical finesse of his *Tischlein-deck-dich* (magic table, lit.: 'table-set-itself') and the exquisite delicacy of the ornamental decoration. The raising and lowering of the magic table is part of the meal.

1.19 King Ludwig's Venusgrotto at Linderhof complete with swan-shaped royal barge, animated light effects and artificial waterfall, was conceived and constructed by stage technicians especially brought in from the Munich Residenztheatre

This sequence of rituals repeats itself after every interval. At the end of the performance the falling of the curtain and the bows of the actors trigger the applause, and the illumination of the auditorium lights politely remind the audience that it is time to go home. The audience is eager to please. Anticipation of the first signal sets in when entering the theatre building. This starts the relentless anticipation–signal ritual cycle. The audience's eagerness to please makes it easy for the stage manager to direct their movement through the theatre building. However, the consistent anticipation of the next signal deprives them from engaging with the performance. Our performance undermines the anticipation–signal ritual sequence by engaging with the theatre experience as a whole. Just like King Ludwig's dining experience, the prologue and the epilogue are a key constituent of the theatre/dining experience. The prologue and the epilogue subvert the expectations of the audience, making our *Kabale und Liebe* production critically engage with the theatre rituals. In practice, this works as follows.

1.20 Hunding's Hut and Gurnemanz Hermitage are the architectural expressions of an increasingly solitary life-style adopted by a king who gradually lost the ability to distinguish between drama and reality

1.21 Gurnemanz Hermitage

FRIDAY 13 FEBRUARY 2004

The audience arrives at 6.30 pm in anticipation of a relaxed pre-performance conversation in the foyer while sipping a cool drink from the bar. Instead of the expected bar, drinks are sold from an obscure wheeled contraption that advertises itself with a pennant and a bell. The operative is a man, dressed as a female housekeeper, who has been instructed to be polite but not to speak. Whereas the audience is amused by the wheeled bar, the mute barman is perceived as an intruder. A fragment of the performance has been re-located from stage to foyer. This intrusion on a traditionally audience-only space creates uncertainty that manifests itself in hushed conversations and a heightened awareness of the surroundings. When admission starts, the doorman merely waves his hand for the audience to start rushing to the auditorium entrance. They are full of anticipation of a lazy recline in a velvet-soft theatre seat only to realise that the auditorium has been fitted with garden chairs, kitchen chairs, stools and benches. Commonly, the audience is granted a moment to find their seats and finish their foyer conversation before the curtain is raised and the performance starts. Not so in our production. The man who was previously selling lemonade has somehow already made his way into the auditorium and is drawing the outline of a body onto the back-stage floor.

The air in our auditorium is heavy with the smell of the rosewater that I had sprinkled onto the carpet tiles. It is as if the roses from the wallpaper

1.23 Park Herrenchimsee. King Ludwig's final work, Herrenchimsee, a lonely palace was sited on an island in the Chimsee, with only a group of neighbouring monks sharing his solitary existence. The palace, a miniature Versailles decorated with paintings of the French kings did not have a kitchen, the king's swimming-pool sized bath tub was too large ever to be filled with bath water, the innovative air heating system too complex ever to be put into use and the south wing was left unfinished due to lack of funds. During the one occasion in 1885 when the king stayed at Herrenchimsee, the palace served as a mere stage-set representing the king's imperial ambitions. An enormous firework display designed to eclipse the shortcomings of the architecture entertained the king during his brief visit and food was delivered on carriages from the nearby monastery

are suddenly blooming and emitting their scent into the dusty ambience. The smell emphasises the lack of separation between stage and auditorium. Fluorescent tubes that bathe the room in a soupy yellow light reinforce the unity between stage and auditorium and actor and audience as do the carpet tiles and wallpapered walls that continue from the ramp on stage into the auditorium.

A man opens a door and walks out in his underwear. He appears completely oblivious to the audience as he fetches himself a cup of coffee from the coffee maker that gurgles away in the front right corner of the room. The play has started. Or has it? The murmuring of the audience quietens down for a moment. A few minutes later the man, who has been drawing, finishes, opens the refrigerator door and disappears inside. Then nothing happens until another door opens on stage and a man steps out

to start reciting the first section of the dialogue. The signal curtain-up has been removed. The operatives of the theatre's heating department, who have their workshop and underground plant rooms below the main building, have been instructed to steadily lower the temperature in the auditorium from comfortably warm to chilly as the play progresses. The layout of the room leaves the audience in no doubt that they are sharing the space with the characters on stage. The walls are precariously overhanging the seats, the seats are part of the stage-set, the carpet runs into the auditorium, admission is through a door in the decoration, the lighting evenly illuminates the entire room and there is neither a proscenium arch nor a level change separating the audience from the stage. There is no theatre curtain nor any other visual key that reveals the start of the performance.

Akademietheater Ost

Akademietheater West

Akademietheater Mitte

Flur

Kabale & Liebe Zeichnung **Grundriss** Masstab **1 150** Datum **02 12 03**

1.24 Plan of the *Kabale und Liebe* stage-set. The plan shows the blurring of the boundary between auditorium and stage: the raking walls of the decoration and carpet tiles continue into the auditorium and the auditorium seating is integrated with the stage-set

1.25 Occupied refrigerator. The refrigerator is actually powered by the plug socket attached to the stage decoration. There is a light inside the refrigerator that turns on when the door is opened. This effect was very difficult to achieve, due to stage safety regulations, but it helped to identify the stage space with a familiar domestic setting

1.26 Plug socket. The features, including the surface mounted power cable, were copied from a plug socket in my grandmother's kitchen

The starting moment has been blurred. During the performance the audience is directly addressed through the public address system. It is indiscernible whether the clearly noticeable chill is emitted from the modified air-conditioning system or the lack of emotion from the characters on stage, who murder each other with poisoned lemonade of the same brand sold in the foyer. There is some polite coughing from the audience. In the second half this turns into impolite shuffling of feet. Then a woman tramples down the aisle trying to find the exit and tramples back when she realises that the entrance through the decoration is now blocked.

By the end of the performance some seats are empty. The public address system normally used to announce the beginning of admission is used in our production by Ferdinand to communicate his increasing desperation about the failure of his relationship. The crackling sound emitted by the public address system being normally reserved to communicate with the audience makes the audience feel naturally addressed. The brightly illuminated auditorium and dark stage focus all attention upon the audience themselves.

Traditionally the foyer is an audience-only space and the back-stage is a performers-only space.

1.27 Set photograph of the penultimate scene from *Kabale und Liebe*. The plan (Figure 1.24) is dated 2 December 2003, but it was in fact, drawn months after the premiere, in March 2004. This representational drawing is a make-believe construction drawing that appears in a report on the production used by the technical department of the Prinzregententheatre to present to other stage designers as an exemplary stage design submission. The *Kabale und Liebe* set was designed by making. The conviction drawings that were submitted were not used for construction, and drawings for construction were never issued. Instead, the architect-activist directed the design in the workshop and acquired materials as the design progressed

Both have a dedicated function that is essential to maintain the functioning of a traditional theatre. The back-stage houses the processes that create the theatrical illusion on stage. With its almost endless maze of corridors, it connects together spaces for stage machinery, the dressing rooms and props storage, carefully concealing from the audience the structure behind the illusion that could spoil the theatrical experience. The foyer houses the social component of a visit to the theatre. This is the place to be informal, to mix and mingle and to assert one's status as a culture enthusiast and theatre connoisseur while safe in the hands of the stage manager whose responsibility it is to announce the start of admission over the public address system. In *Kabale und Liebe* the performance intrudes into this audience-only space. The absence of a curtain extends the performance into both the pre-performance time and the post-performance time. The presence of the actors on stage and in the foyer prior to the performance intrudes upon the audience's pre-performance time. Their continued occupation of the stage after the performance intrudes upon the audience's post-performance time. *Kabale und Liebe* is intimately aware of theatre conventions and seeks to erode them by extending the performance into spaces that are traditionally no-go areas for the actors. The undermining of the site's inherent conventions makes *Kabale und Liebe* put into question the very institution it was written for.

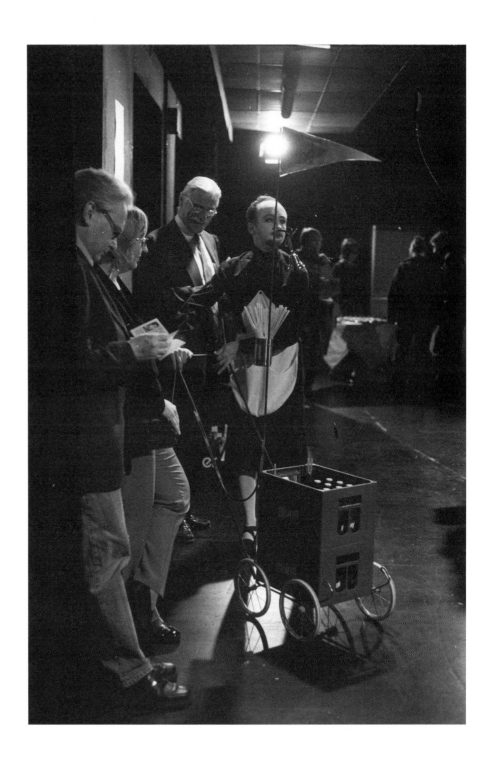

1.28 The lemonade salesperson in the foyer intruding into the audience-only space. Three audience members look towards the floor or hide behind their copies of the programme booklet in embarrassment. Even though lemonade can be bought in most theatre foyers, the fact that it is done in a performative manner in *Kabale und Liebe* is unsettling to the audience because it undermines the traditional theatre experience

1.29 Detailed drawing of the ramp trolley

1.30 Detailed drawing of the doors, drawn
after the completion of the set. The lines in
this drawing only reveal some aspects of
the architecture, most of its qualities remain
hidden. To enliven the drawing and to add
theatricality, I drew the hinged door flap even
though it was never built. The medium used
for representation is an important design
parameter. A design represented with the use
of a computer will be very different from a
design represented with watercolours

At first sight, the setting of *Kabale und Liebe* appears domestic: patterned wallpaper, routed skirting boards, carefully detailed architraves, elaborate auditorium furniture and carpet tiles have material qualities normally associated with someone's house. Looking again, one notices the institutional emergency-exit sign carefully integrated into the wallpaper pattern. The structure behind the decoration is plainly visible: on the left the back sides of the door linings are exposed, on the right is an unobstructed view of the timber framing, structural steel cabling and lighting switch gear. The stage-set does not deny that it is a theatre stage-set. Instead, it exists at the boundary between the domestic setting that it portrays and its real site, the theatre. It relies on the audience's creative reading to complete the illusion. Where Ludwig brought the theatre into his home to escape the reality of domestic life, *Kabale und Liebe* brings the home into the theatre to critically examine its social condition.

The rosewater that is sprinkled through the auditorium prior to admission and the tampering with the theatre air-conditioning to change the ambience of the auditorium make the production undermine the non-material conventions of the theatre. *Kabale und Liebe* engages the audience by questioning the rituals that have become associated with a visit to the theatre.

LE NOZZE DI FIGARO

Le nozze di Figaro (*The Marriage of Figaro*) is a comic opera composed by Wolfgang Amadeus Mozart (1756–91) with libretto in Italian by Lorenzo da Ponte (1749–1838) (Mozart and da Ponte 1786). It is today one of the most frequently performed operas on stages worldwide. The opera tells the story of the turmoil surrounding the wedding preparations of Count Almaviva's valet, Figaro, and Countess Almaviva's head chambermaid, Suzanna. The opera is based on a stage comedy by Pierre Beaumarchais (1732–99) entitled *La Folle Journee ou le mariage de Figaro* (*The Crazy Day* or *The Marriage of Figaro*, 1784).

Le nozze di Figaro is the subject of the 2005 Ring Award, the bi-annual stage design and directing competition run by the Wagner Forum Graz, Austria. The competition is open for teams (one director and one stage designer) who are less than 35 years of age and have not previously had a main stage production. *Kabale und Liebe* had not been a main stage production and Anna Malunat decided that the Ring Award was a good opportunity for public exposure of our work. It is a well known competition in its field, attracting professional visitors from all over Germany, Austria and Switzerland who are on the look out for new talent for their theatres. Past winners have been able to use the competition as a springboard to launch their careers.

The 2005 Ring Award was a three-stage competition. Stage one required the submission of a written design and directing concept at the beginning of August 2004. Twelve teams were chosen from all stage one entries to present their ideas in front of a jury in Graz, in January 2005. Four finalists were chosen by the jury to go to Graz during June 2005 to rehearse and then stage the second act of *Le nozze di Figaro* with a cast of professional and amateur singers and piano accompaniment. Set and costumes would be made by a local theatre workshop.

Work on the first stage submission starts in the spring of 2004. Due to the length of the three-stage competition process, my involvement with the competition overlapped with another production, *Herr Gevatter* that I will write about later.

TUESDAY 2 MARCH 2004

Anna Malunat sends an email with the competition brief. The brief outlines the competition procedures, deadlines, registration fee and prizes. She has spoken to a past Ring Award participant and warns me that the well-ordered appearance of website and competition brief is deceptive. In reality, successful competitors had, in the past, decided to drop out half way through the competition because of unacceptable working conditions. In 2003 no winner was chosen because the jury found that neither of the finalist's productions deserved a prize. The first thing I look for on the competition documentation is the small print. Even after reading this, I decide to take part. Anna Malunat writes:

> I have found an approach for Figaro, but it is the very first attempt. Situations change sooo quickly. The figures always think they have everything under control but one second later everything is different.

The assessment of the opera is remarkably succinct. This is true for music and libretto. Around philanderer Count Almaviva and his deprived spouse intrigues are spun and entrapments concocted, admiration turns to feud and an enemy can become an accomplice in the ubiquitous search for love and sexual pleasure. No wonder that Beaumarchais' play, the basis for Mozart's

opera, was banned in Vienna for causing offence to the aristocracy.

What defines *Le nozze di Figaro* is the music–text relationship. Lamenting lyrics are almost exclusively accompanied by jolly orchestration. Rapid action on stage is accompanied by slow orchestration and fast orchestration by slow dramatic action. Orchestration and lyrics appear to be in conflict. The visual is in contradiction with the acoustic, the eyes appear to be questioning the ears. *Le nozze di Figaro* is the product of an artistic disagreement between two musical geniuses: Mozart in argument with da Ponte.

However the disagreement is not limited to the composer–librettist relationship. There appears to be disagreement within the libretto as well. As soon as the audience has understood the relationship between two characters, that understanding is undermined by one of the intrigues that are spun in the Palacio de Almaviva. When the audience has made the emotional decision to support a character, that character embarks on an action that undermines the trust that the audience has just placed in him or her. The libretto of *Le nozze di Figaro* is full of this tension between the emotional and the logical.

FRIDAY 30 APRIL 2004

Anna Malunat sends a more detailed analysis and concept with initial stage-set suggestions. The document is more of a stream of consciousness than an in-depth understanding, but it backs up her earlier assessment of the opera with background information and quotations. Two key ideas develop that appear to be central to her thinking about the opera:

Redaktionsschluss: 23. Feburar 2004

Der Rechtsweg wird ausgeschlossen. Die Veranstalter behalten sich das Recht vor, den Wettbewerb in jeder Phase abzuändern oder abzubrechen bzw. zu widerrufen; dies insbesondere, wenn die hiefür von der öffentlichen Hand in Aussicht gestellten Mittel nicht oder in nicht ausreichender Höhe zur Verfügung gestellt werden. Der Widerruf ist jedoch auch aus anderen Gründen möglich. Die Teilnehmer des Wettbewerbes verzichten für den Fall der Abänderung und des gänzlichen Abbruches des Wettbewerbes darauf, Ansprüche auf Aufwandsersatz oder sonstige Ersatzansprüche welcher Art auch immer geltend zu machen. Dieser Verzicht erstreckt sich jedoch nicht auf allenfalls bereits entrichtete Teilnahmegebühren, welche im Widerrufsfall an die Teilnehmer rückerstattet werden.

ibung.cfm 01/03/04

1.31 Small print from the Wagner Forum competition brief. The ten lines of small print put into question the tightly typed three-page document of the competition conditions, by allowing the organisers to intervene at any stage and in any manner of their choosing.

(Recourse to legal action excluded. The organiser reserves the right to change or cancel the competition at any stage. This applies in particular if the public funds that have been promised do not become available or are insufficient. Cancellation is however also possible for other reasons. The participants of the competition will not pursue any claim for expenses or replacement of any kind if the competition is changed or cancelled. This relinquishment does not however cover the participation fees which will be refunded to the participants in the case of cancellation)

1. In the introduction to the book *Das Schwindelerregende Kapitalismus und Regression* (The Dizziness of Capitalism and Regression, 2004) Carl Hegemann talks about Denis Diderot's (1713-84) statement that the central aim of theatre should be to create dizziness in the audience. Diderot defines dizziness as the sort of sensation experienced during an earthquake. *Le nozze di Figaro* already goes a far way towards creating dizziness in the audience through the eye–ear conflict and the logic–emotion tension.

2. The historical context of *Le nozze di Figaro* is the Rococo: a time of great creative and cultural achievements in Europe and also a time of political and social change. *Le nozze di Figaro* was written three years before the start of the French Revolution, the destruction of existing political and social structures by a section of the population who felt disadvantaged by the status quo. In his book *Geist und Sitten des Rococo* (Spirit and Customs of the Rococo, 1923), Franz Blei does not lament the corrosive side of the rioting. Instead, destruction, was a creative act, because it was initiated to make room for new structures and social systems. There is substantial evidence that the aristocracy were aware of their

pending persecution years before the first outbreak of revolutionary activity, but, rather than preparing their defences, they decided to live in excess until the end. This situation is the social context of *Le nozze di Figaro*. Anna Malunat writes about the characters: 'What do they all do all day? Nobody appears to ever do any work.' The creative act of destruction, we decide, will be subject of our staging of *Le nozze di Figaro*. Destruction is difficult to stage because stage-sets tend to be re-used again and again for subsequent performances and are sometimes even archived for a revival decades later. What makes destruction dramatic is its inherent lack of control. The problem with staged destructions is their lack of drama, caused by the fact that they are controlled in every detail and have been rehearsed from every angle. Our performance will only ever be staged once and we are able to build real destruction into it.

I start the stage model. Budget and time scale do not allow a site visit. This is the first time that I have started a design project without having previously visited the site. The information that I have is a line drawing of stage and auditorium in plan and section and a postcard with images of the interior. Because of the height and complexity of a theatre building, it is very difficult to imagine the space from the line drawings. The postcard provides more accurate information about the site.

THURSDAY 29 JULY 2004

Anna Malunat makes an international bank transfer of €30 for the registration fee to the Wagner Forum.

Even though this is a trivial amount of money compared to the time and effort already spent on the project, it has the psychological effect of formalising our involvement.

MONDAY 9 AUGUST 2004

Today is the deadline for submitting the competition documents. Anna Malunat and Magdolna Parditka were in London until yesterday to finish everything. Our submission consists of:

1. application form;

2. cover letter;

3. illustrated general concept;

4. illustrated summary concept;

5. copy of the instruction to the bank showing that the participation fee has been paid.

The application form only has space for the name of a director and a stage designer. Even though Magdolna Parditka has provided all the costume drawings, there is no room for her name on the form. In spite of the risk of being disqualified, our cover letter explicitly states that credit for the submission should go to all three team members.

The illustrated general concept is written in German and has the following three sections, 'General thoughts about the opera', 'Translation of these thoughts' and 'Planning of the scenes'. The first section summarises our understanding of *Le nozze di Figaro*, the second is sub-divided into stage, costumes and direction and explains how the concept would

1.32 Pages 304–5 of Franz Blei, *Geist und Sitten des Rokoko*. *Geist und Sitten des Rokoko* served as an important reference to understand the historical context of *Le nozze Di Figaro*. Perhaps even more interesting than the historical information the book provides, is its format. *Geist und Sitten des Rokoko* is a collection of letters, personal accounts and reports that the editor has carefully woven together to create a captivating narrative with little need for further explanation. The book gains its historical authority by reproducing original sources which simultaneously makes it an informative and entertaining read. The editor relies on his reader to make connections, discover patterns, find reasons and identify key events. The format of *Geist und Sitten des Rokoko* aids understanding of *Le nozze di Figaro* as a collection of contradictory and opposing situations and musical compositions producing an entertaining and delightful comedy where the outcome is what the audience makes it to be

(... last week there was a serious turmoil in the Palais Royal, in Camp des Tartares. With certain accuracy one can say that Paris is like a kingdom where the Palais Royal is the capital. In reality everything unites there. One can even find certain relief that one would look for in vain somewhere else. There are furnished apartments to let for ½ Louis per hour where everything that defines refined luxury comes together. One hardly questions to what end. One even hears rumours that the followers of the opposition find the same amenities in a neighbouring gallery where the price however has been fixed at 1 Louis per hour. However, a thousand similar motives that contribute towards the degeneration of our good morals are the reason for the crowd that gathers every evening under the gallery of the Tartares. At the end of the theatre performances all the nymphs of the locality who are elegant gather there to be stained by the dirt of the streets ...)

manifest itself on stage, the final section is a scene-by-scene storybook. To produce the storybook, paper figurines were made and placed inside the stage-set model which was then photographed. The figurines were drawn at large scale, they were then scanned, reduced to 1:20 scale, printed, cut out, folded and glued to a penny coin at the base, so that the weight of the coin helped them stand up.

A substantial effort has gone into making the model. It is arranged like a doll's house. There are two rooms on the top floor and three rooms on the lower floor. A large staircase in the centre connects the two floors. Two doors are attached to the model with piano hinges, when opened to 110°, they form the right and left auditorium walls. Cut-outs in the doors make up the audience boxes, extending the stage-set into the auditorium. The model was made with the following design parameters in mind:

1. spaces should look like they have a history while being timeless (this was done for the same reason as in *Kabale und Liebe*);

2. create dizziness and be destructible;

3. photograph well.

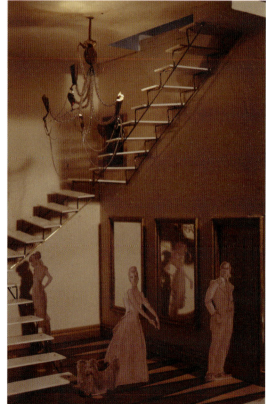

Parameter 1 is realised through the choice of materials, parameter 2 is realised using lighting and varying the depth of rooms and parameter 3 is realised through general layout and scale.

Materials for the model were acquired from a variety of sources including car-boot sales and charity shops, but also from the materials stored in my studio. This is where I found some of the carpet tiles used in the *Kabale und Liebe* stage-set. They were re-dyed and used in the *Le nozze di Figaro* model. Anna Malunat said to me once that she enjoys quoting her previous productions. In the *Le nozze di Figaro* model I am quoting from the *Kabale und Liebe* model.

1.33 The Countess' room. Detail photograph of *Le nozze di Figaro* model

1.34 The Countess' room. Detail photograph of *Le nozze di Figaro* model

1.35 The entrance. Detail photograph of *Le nozze di Figaro* model

The photographs were staged individually for every scene in the opera to produce a storyboard that, aside from the physical position of objects and characters on stage, also communicated the material qualities and lighting conditions

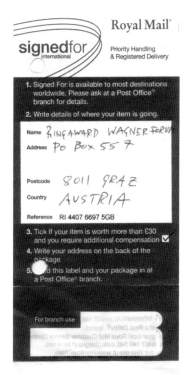

Royal Mail

signedfor international

Priority Handling
& Registered Delivery

1. Signed For is available to most destinations worldwide. Please ask at a Post Office® branch for details.

2. Write details of where your item is going.

Name ℞INGAWARD WAGNER FORUM

Address PO Box 557

Postcode 8011 GRAZ

Country AUSTRIA

Reference RI 4407 6697 5GB

3. Tick if your item is worth more than £30 and you require additional compensation ☑

4. Write your address on the back of the package.

5. ...d this label and your package in at a Post Office® branch.

For branch use

1.36 Post Office receipt for the competition documents

It is not uncommon in architectural practice to quote from previous designs. Quoting from one's own work starts to associate particular architectural qualities with a particular spatial and dramatic intention.

The model has a complex lighting system which we think can be used to direct the eyes of the audience at ever new dramatic situations in the various rooms by switching room lights on and off. By increasing the speed of the light changes with the progression of the second act we think we can transfer dizziness to the audience. In reality, the model looks beautiful with the individually illuminated rooms, but cannot be used to test the effect on an audience.

Destructibility is built into the model by two miniature chandeliers that can be automatically released on the upper floor of the model so they will crash down on the lower floor, causing a short circuit and cutting out the light. In the theatre this would be a dramatic effect because the windowless auditorium would leave the audience in complete and sudden darkness.

To photograph well, the model is made at 1:20 scale. This scale provided enough detail to show finishes while being small enough to conceal errors and inaccuracies.

Six copies of the summary concept have to be sent to the jury members by the Wagner Forum. Our summary concept works in two ways: the front side of each page features an illustrated summary of the general concept, the back side of each page featured a drawing of the figurines in their underwear and a drawing of their costumes in the form of a cut-out doll. To assemble the cut-out doll, one would have to cut through the written concept on the other side of the paper. Thus, the summary concept contained an element of destruction and an in-built challenge to

the jury members. The format of the document is a direct response to the contents and structure of the opera. In the opera, the music questions the libretto, in the summary concept, the cut-out dolls question the written conception that would have to be cut apart to assemble them.

HERR GEVATTER

Herr Gevatter: Ein Hausmärchen (Mr Death: A Domestic Fairy Tale), written and premiered in 2004 is an opera in seven scenes by Hauke Berheide, Ulrich A. Kreppein, Björn Raithel, Anno Schreier and Raphael D. Thöne. *Herr Gevatter* was commissioned by the Staatstheater Saarbrücken as part of their series Music Theatre Workshop and co-produced with the Kammerspiele Düsseldorf and the Akademietheater Munich. Anna Malunat was commissioned to direct the world premiere of the opera, and I was commissioned by the Akademietheater Munich to design a stage-set that could be installed at all three venues. The stage-set was made in the theatre workshop in Saarbrücken.

I was designer and maker in *Kabale und Liebe*. My role in *Herr Gevatter* was strictly limited to designing as opposed to designing and making. To attain the same high quality product in this changed role, many of the working methods had to be re-established and new ways of communicating introduced, particularly because I was working from London and only went to Saarbrücken intermittently.

Site-specificity, that had played such an important role in the design for *Kabale und Liebe*, had to be re-defined because I was designing for three different sites at the same time. How can one design a site-specific space that is none the less adaptable to three different sites?

1.37 Reverse sides of the pages of the
summary concept with cut-out dolls

1.38 Reverse sides of the pages of the
summary concept with cut-out dolls

The libretto is inspired by a fairy tale by the brothers Grimm entitled *Herr Gevatter*. In the fairy tale a sombre figure gives a poor man supernatural powers to heal children. When, after he has become famous as a miracle healer, he returns to his benefactor's house, he witnesses obscure events in the stairwell that reveal the sombre figure as the devil. The fairy tale ends with the man fleeing the devil's house in panic.

The message of the fairy tale is unusually enigmatic, and the libretto does nothing to resolve the enigma. Instead, it dissolves the narrative, reducing words to sounds and characters to instruments. The reason for this is evident: the composers of the music are simultaneously the authors of the libretto. Being composers by training and profession, they naturally have a greater interest in the musical qualities rather than the logical or narrative qualities of the words. Sound takes precedent over meaning. As a consequence, the singers on stage become the instruments that produce the sounds. The questions that we asked at the beginning of our work on *Herr Gevatter* were: 'What is the role of a director for an opera where characters are used as musical instruments?' and 'What is the role of a designer for an opera where the narrative has been reduced to musical sounds?' The role of a director in an opera is to direct the narrative given by the libretto.

W. A. Mozart

Le nozze di Figaro

Komische Oper in vier Akten

Langfassung des Regiekonzeptes, des Bühnenbildkonzeptes & der
Kostümgestaltung fuer den Ring Award
Graz • Austria • 2005

Grundsätzliche Überlegungen zum Stück

Spiel

... Und Ernst

Warum Spielen

Wirklichkeiten

Schönheit

Die Umsetzung dieser Überlegungen

Der Zweite Akt

Der Dritte Akt

Kostüm Antonio Der Curato

Die Kostüme

(Text nicht lesbar)

Die Spielweise

(Text nicht lesbar)

Die Bühne

(Text nicht lesbar)

Bilderplanung & Texte zu den Bildern

Prolog

Sintonia

(Text nicht lesbar)

Das Erste Akt

Figaro und Susanna

(Text nicht lesbar)

Scena I-II

(Text nicht lesbar)

Bartolo und Marcellina

(Text nicht lesbar)

Scena III

(Text nicht lesbar)

Marcellina und Susanna

Scena IV

(Text nicht lesbar)

Chérubino und Susanna

Scena V Bild 146

(Text nicht lesbar)

Scena VI-VII Bild 146

Bartolo, Susanna, Chérubino und Basilio

(Text nicht lesbar)

Scena VIII

Die Vorigen und der Bauernchor

(Text nicht lesbar)

Scena X

Susanna und die Gräfin

(Text nicht lesbar)

Scena VI-VIII

Susanna und die Gräfin, Barbarina und Chérubino, Antonio und der Graf, Figaro, der Chor

(Text nicht lesbar)

Der Vierte Akt

Scena I-IV Bild 146

Barbarina allein, dann Figaro und Marcellina

(Text nicht lesbar)

Garten

(Text nicht lesbar)

Scena IX-XII

(Text nicht lesbar)

Das Ende

Scena ultima

Die Vorigen

(Text nicht lesbar)

The role of the stage designer is to design a setting for that narrative. An opera that does not have a narrative nor a setting is called a concert. A concert is staged by a conductor and not by a director and stage designer. To fulfil our contractual duties in relation to *Herr Gevatter*, a narrative had to be brought in from somewhere else. This found narrative would provide us with characters to direct and a setting to design. Work on *Herr Gevatter* started on Sunday 8 August 2004, when a suitable narrative was found at the Holloway Road car-boot sale.

SUNDAY 8 AUGUST 2004

The market is located in a school playground. It takes place on Saturdays and Sundays between 10 am and 2 pm. We usually go on a Sunday because the ratio of non-professional pitches to professional pitches is in favour of the non-professional pitches. There are two types of professional pitches: those selling new goods and those selling used goods. The pitches selling new goods are not interesting because the goods sold are often of inferior quality. The most interesting pitches are the non-professional pitches that are taken by people who only ever come once to clear out their house, shed or attic. The goods sold on these pitches often include curiosities sold cheaply because the pitch holders do not appreciate their real value. We have, over the years, accumulated a substantial number of treasures from here. Some items are immediately incorporated into ongoing projects, some are stored for later projects, some inspire new projects, some become part of everyday household use and some become part of everyday household use and are later incorporated

into a project. Because the expenditure for items bought in the Holloway Road car-boot sale is small, items are sometimes bought and test-used for a short period of time before they are put back into circulation through the local charity shop network. This avoids waste, supports the charity shop and, most importantly, allows for deliberation about the usefulness and beauty of an item.

I did not find anything today, but Chrysanthe bought a most curious little book entitled *The Doubtful Guest* (1998) by Edward Gorey. Every second page is taken up by a monochrome ink drawing that is hatched to show shadows and textures. The other pages feature a short paragraph or sentence of text. The precision and sharpness of the black lines on the white background remind me of etchings. The book tells the story of a family that receives an unannounced visit by a furry creature wearing red shoes and a stripy scarf. The creature has most extraordinary habits. It enjoys standing with its nose to the wall, hiding in a terrine, eating the dinner plates and dropping golden watches into the garden pond. Most of the illustrations feature the interior of an 18th-century country house. The architecture is drawn with precision and technical understanding. There is a hallway with a wide staircase and a balustrade with wooden spindles. Dark wooden panelling lines the walls. The grain of the wood suggests oak. The panels are held in place by horizontal and vertical framework. The moulding that covers the gap between the panels and the framework is mitred. There are construction joints where vertical and horizontal elements of the framework meet. The grain on the framework follows the direction of

1.39 (page 45) Competition submission for the 2005 Ring Award

1.40 (page 46) Competition submission for the 2005 Ring Award

The summary concept contains a condensed version of the full concept. On the reverse side of its pages Magdolna Parditka has drawn the individual costume parts and Count Almaviva, Suzanna and Marcellina in their underwear. The costume parts have tabs that if cut out can be attached to the characters. The jury members are thus invited to participate in a game resulting in the destruction of the competition documents. Even if it is unlikely jury members will get out their nail-care set to cut out and assemble the dolls physically, this possibility will engage them mentally

the wood. The grain on the panels is vertical. The proportions of the panels are pleasing and the ratio between panels and framework is natural. The top of the panelling is terminated with a piece of moulding. The wall above the panelling is wallpapered. The pattern of the wallpaper is floral, but regimented. A painting is hanging on the wall. It has a dark frame. On the right is a heavy curtain that is slightly too long, trailing along the floor. A lampshade in the shape of an onion is hanging on the far right. The carpet seems thick and it is patterned. In spite of the light tones of interior finishes, they appear heavy. Surfaces are evenly illuminated by an overcast Sunday afternoon. The characters that appear in the drawings are angular and slightly gawky. Their dress appears old fashioned.

Text and image share a symbiotic relationship. The text describes the drawing and the drawing illustrates the text. The text–drawing relationship is a closed system where the text appears to justify the existence of the drawing and the image the existence of the text, but there is no reference to known settings, known characters or a particular era. The book concludes: 'It came seventeen years ago – and to this day it has shown no intention of going away.' The drawing shows the perplexed family gathered around the furry creature that is sitting on an upholstered stool looking in the opposite direction. The German word for stool is *Hocker*, *Hocker* also translates as 'sticker' (a guest who outstays his/her welcome), but it is unlikely that Edward Gorey, an American who hardly ever crossed the boarders of New England and certainly never came to Europe, would have been aware of this coincidence. What is implied

is more important than what is said. What is shown in the drawing is less important then what is concealed and what is implied by the text is more important than what is explicit. Gorey's work requires imagination beyond the literal. A Gorey reader reads between the lines and beyond the picture plane. The drawing–text relationship in *The Doubtful Guest* is comparable to the music-words relationship in *Herr Gevatter*.

WEDNESDAY 8 SEPTEMBER 2004

It is time to start drawing for *Herr Gevatter*. The first drawing for the stage-set is entitled *Herr Gevatter: Bühnenbild zum Selbermachen (Herr Gevatter: DIY Stage-Set)*. It is 660×750mm. The following elements are shown on the drawing at 1:50 scale: baseplan of Staatstheater Saarbrücken with auditorium and stage, left wall element, right wall element, toy box, umbrella stand, rocking horse, bunk bed and ladder, staircase and wall-mounted washbasin. All elements are drawn with the appropriate folds to allow for their assembly as three-dimensional cardboard models. Dashed lines indicate where they are to be folded. Symbols of scissors indicate where cuts are to be made. The folds are labelled with letters 'A' to 'Z' and 'a' to 'o' corresponding to the letters marked on the base plan. Textures on the panelled wall elements and an area of flooring are shown with black ink hatching. Textures on the rocking horse, sink and umbrella stand are shown using montaged photographs. Written instructions in German on how to assemble the model appear on the left. The model is photocopied on to thick cartridge paper, rolled up and sent in a postal tube to Anna Malunat in Munich. The architect-arbitrator has invented

another tool to engage his team members. The drawing-model is a DIY-stage-set model that engages the recipient by requiring her to become physically involved in its assembly.

When assembled, the drawing produces a room with a raking wall on the left that is divided into eighteen framed panels in two horizontal rows. The back wall consists of three panels and one window fitted into one of the upper panels. An extractor fan is drawn at 3m from floor level in the centre of the right top panel. The right wall is a two-sided wall. The wall facing the main room is divided into eleven panels and one door that leads through the wall into an adjacent room where the staircase is located. The main room represents a basement studio flat and the adjacent room, a stairwell with a staircase leading up to street level. The surface texture of the drawing is copied from Edward Gorey's *The Doubtful Guest*.

Inigo Jones is well known for his activities as an architect and is credited with the building of London's first square, Covent Garden, in the 1630s. Jones spent many years of his life studying Italian Renaissance architecture and is widely respected as the person to have brought about an artistic renaissance in Britain during the 16th century. In addition to some of the finest neo-classical buildings in Britain, Inigo Jones is also the author of around 470 theatre and costume design drawings that survive in a collection held at Chatsworth House.

John Peacock's book *The Stage Designs of Inigo Jones: The European Context* (1995) reveals the extent of Jones' involvement in theatre design, his working methods and the connection between his work as a theatre designer and as an architect. His most successful designs for theatre, like *Temple of Love* (1635), were carried out when Jones had already completed designs for two of his most famous buildings: the Queen's House in Greenwich (1616) and the Covent Garden Piazza. Stage design, architecture and painting all had their purpose in Jones' goal to introduce Italian renaissance art and architecture to England. According to Peacock, the role of theatre design was twofold: during the earlier stages of his career Jones used his designs to educate his audience about Italian Renaissance architecture, and during the later stages of his career he used his theatre designs to critically review and appraise political and social events affecting his position as surveyor to the king. Peacock writes about Jones' set for *Britannia Triumphans* (1638):

> The houses in the foreground recall the King's efforts to regulate building in London (in which Jones was involved as an administrator) and the architect's efforts to promote a more regular, classical style of urban housing. The centrepiece of the background, St Paul's Cathedral in the course of restoration, symbolises both Charles I reforms of the Anglican Church and Jones' austere revision of Italian classical architecture. (Peacock 1995)

Jones' practice established a dialogue between the three disciplines of painting, stage design and architecture. Jones-painter records Italian Renaissance architecture on site during one of his excursions, Jones-stage-designer educates his audience about the Italian Renaissance and Jones-architect builds Italian Renaissance architecture in England that Jones-stage-designer then again disseminates in his stage designs.

1.41 *Herr Gevatter: Bühnenbild zum Selbermachen*, The *Herr Gevatter: Bühnenbild zum Selbermachen* was designed to engage the reader. The drawing cannot be clearly understood until its individual elements are cut out and assembled. The reader of the drawing engenders a closer understanding of the intention of the design when he or she becomes the maker of the model

(Instructions

1. Cut all segments along the fat lines.

2. If a thick line appears in the centre of a model section, then a slot should be made in its position.

3. Score carefully along the dashed lines.

4. Pre-fold along the dashed lines using a wooden ruler

5. Slide the tabs on the steps through the slots in part

6. The tabs marked with letters belong into the slots with the corresponding letters.

7. Fold the tabs from the back and apply glue.

8. Now glue all other segments together. Two segments with corresponding letters are to be glued together.

Enjoy!)

Herr Gevatter

Buehnenbild zum Selbermachen

Jan Kattein · Architect

All at once it leapt down and ran into the hall.
Where it chose to remain with its nose to the wall.

In their book, *Inigo Jones: The Theatre of the Stuart Court (1973)*, Stephen Orgel and Roy Strong extend the influence and the list of disciplines covered by Jones' work even further:

> Inigo Jones is the most important single figure in the arts in seventeenth century England. Architect, painter, engineer, designer, connoisseur, collector, author, theoretician, he occupied a key position for nearly half a century at the courts of James I and Charles I. His lifetime saw a major aesthetic and cultural revolution, resulting for a brief period, in the English court becoming the most civilised and sophisticated in Europe. (Orgel and Strong 1973)

Jones' achievements are uncontested in both books. His working methods, however, seem to have raised controversy amongst scholars. In a sub section titled 'Copying' in the chapter titled 'The Theory and Practice of Imitation' Peacock introduces the two sides of the argument. One faction is represented by Roy Strong who writes: 'Jones was a relentless plagiarist, a magpie artist who lifted from a multiplicity of sources ideas for scenery and costumes' (Orgel and Strong 1973).

1.42 Pages 8–9 of *The Doubtful Guest* by Edward Gorey

1.43 Textures used in the Herr Gevatter Design. Clockwise from top left: wall texture from *The Doubtful Guest*, wall texture from the drawing-model, wall texture in the actual stage-set, wall texture in the stage-set model.

The other faction is represented by John Newman, who acknowledges that Jones copied other author's work, but justifies his practice. Peacock quotes Newman's argument:

> Jones's artistic career was ... a sustained campaign to educate his compatriots in the appreciation and understanding of the visual arts. Had he been less a copyist he would have been less a sure teacher. (Peacock 1995)

Peacock defends Jones' practice, but stops short of concurring with Newman. Each critic approaches Jones from a different angle. Strong's withering comments are directed at Jones the artist. He implies that an artist's work needs to be original for him or her to claim authorship. The layout of Orgel and Strong's book substantiates and emphasises the claim of plagiarism. Adjacent to each main image featuring Jones' work appears a smaller image reproducing a work by another designer. On page 678 the main image is an elevation drawing of the Palace of Fame from Jones' scenery design for *Britannia Triumphans*. Adjacent, on page 679 the authors reproduce an etching by Remigio Cantagallina depicting the Palace of Fame in *Il giudizio di Paride*. The resemblance between the original and Jones' version is staggering. The accusation of plagiarism against Jones-artist clearly stands. Newman's defence of Jones is directed at Jones the teacher, copying other authors' work to educate the English public. Newman's argument is in line with current copyright legislation in the UK, which allows the copying of limited amounts of other authors' work for private study and educational purposes but not for public dissemination.

In Peacock's eyes, Jones is predominantly a stage designer. Theatre in ancient Greece was an art with an educational remit, financed by the state to instruct the population. Given this context and the fact that the architectural style that Jones copied had been brought to Italy from Greece by the Romans, it seems logical that Peacock is unable to side with either faction. From Peacock's point of view a stage designer is allowed to copy, as long as it is for educational purposes.

Whether our appropriation of the characters and narrative from *The Doubtful Guest* would be considered plagiarism depends on one's point of view. If working in the theatre makes me an artist, Strong may be inclined to accuse me of plagiarism. If it makes me a teacher, Newman would defend my practice for its educational benefit to society.

As an architect, the situation is slightly more confusing. We have to distinguish between a moral and a legal right to copy. The Copyright, Designs and Patents Act of 1988 protects architects' drawings from being copied. The drawings remain the property of the architect throughout the construction process and are used under licence to complete a building. It is illegal to make copies of the drawings without the architect's consent. However, there is no known case where an architect has been prosecuted for copying another architect's building. Copyright legislation protects an architect's drawing from being copied, but it does not protect a building from being copied. In this context, I will be in breach of copyright if I copy Gorey's drawings, but not if I copy the story that the drawings tell.

All architects rely, to a certain extent, on copying. Most architects' practices have extensive libraries featuring other architects' work, and most architects enjoy looking at another architect's buildings.

340 The Palace of Fame
Pen and brown ink, over incised lines
12⅞ × 9½ inches 32.5 × 24.1 cms

Detailed drawing of the Palace of Fame with a scale beneath.
The Palace was drawn up from under the stage as the
mountain had been in *Coelum Britannicum* (see no 277). This
building, a favourite one with Jones, occurs elsewhere in the
designs (eg no 123), and as Simpson and Bell pointed out,
is copied from Giulio Parigi's first *intermezzo* of *Il Giudizio di
Paride* (1608) (fig 111). It would fall into Jones's category of
a scene of relieve.

LITERATURE Simpson & Bell (299)

Fig 111 Remigio Cantagallina after Giulio Parigi, *The
Palace of Fame in 'Il Giudizio di Paride'*, Florence, 1608, detail

1.44 Pages 678–9 of *The Theatre of the Stuart
Court* by Stephen Orgel and Roy Strong

279 Scene 1: Side Wings of a City in Ruins

279 Scene 1: Side Wings of a City in Ruins
Pen and brown ink; squared with a point and black lead for
enlargement and splashed with scene-painters' distemper
$16\frac{1}{2} \times 18$ inches 40.8 × 45.8 cms

INSCRIPTION Across the top: 5, 10; 10, 5; across the bottom
5, 10; 10, 5; to the right: 5, 10, 15, 20, 25, 30.

The size of the proscenium opening: 15 × 17 inches
38.1 × 43.1 cms

The design is scaled in $\frac{3}{4}$ inch squares. A strip of the drawing
has apparently been removed near the bottom and the
remainder replaced, resulting in the squaring up no longer
tallying. The design is for four pairs of side wings, the first
three pairs of which are copied from the *Palazzo della Fama*,
the scene of the first *intermezzo* of *Il Giudizio di Paride* (1608)
(fig 94).

LITERATURE Simpson & Bell (151); Nicoll, *Stuart Masques*,
Fig 55

Fig 94 Remigio Cantagallina after Giulio Parigi,
The Palace of Fame in 'Il Giudizio di Paride'
Florence, 1608

584

585

1.45 Pages 584–5 of *The Theatre of the Stuart*
Court

The book presents the original piece of
artwork adjacent to Inigo Jones' stage design
drawing to substantiate a claim of plagiarism.
Whether copying is plagiarism depends upon
the intention of the person copying. Copying
for educational purposes is exempt from most
copyright restrictions, even if the person
copying earns their money in education

1.46 Notre Dame du Haut Zhengzhou, China. Notre Dame du Haut is arguably one of the most iconic buildings ever built. The original was completed by Le Corbusier in Ronchamp in 1954. An identical copy appeared in Zhengzhou, China in 1994. The photograph shows that construction methods have 'improved' since 1954 giving the new Ronchamp an immaculately smooth facade and patent glazing. The replica artwork at the pavement edge appears to have been placed there to justify the incongruous appearance of the building on its new site, excusing its presence by association with the world of sculpture. To copy the shape of a building without understanding its philosophy is likely to make it inferior to the original. Notre Dame du Haut Zhengzhou was recently demolished, apparently following intervention by the Fondation Le Corbusier

An important part of architectural education is the study of existing buildings. To asses what type of copying is morally acceptable, we have to distinguish between replication and referencing. A replica is, by definition, a facsimile of the original, excluding any design work by the person producing the replica. To reference is to become intellectually and creatively engaged with another architect's work. As a result, a reference quite often looks very different from the original. The better the reference, the closer the intellectual resemblance and the greater the visual dissemblance between original and reference. *Herr Gevatter* references *The Doubtful Guest*, it does not replicate it.

MONDAY 13 SEPTEMBER 2004

Anna Malunat phones. She has received and assembled the drawing-model. She has also made her own scale figures that she is using to test the scenes of the opera while developing the detailed stage concept. During the realisation of the *Kabale und Liebe* stage-set, I worked alongside the technicians in the theatre workshop and was able to oversee the making of every detail of the set, but in Saarbrücken I am excluded from the workshop. To retain the same degree of control over the realisation of the set, I decide that the set should be made out of cardboard. This way I can draw templates at full scale and send them to Germany for assembly.

SATURDAY 18 SEPTEMBER 2004

I have made a prototype cardboard umbrella stand. The original umbrella stand was found on the upper section of Finchley Road in front of a housing block amongst other discarded furniture. The main structure is made from four pieces of 5mm thick steel rod bent into the shape of an elongated number '2'. The four kinks of the rod are connected by a steel ring with each rod rotated in plan by 90°. The heads of the rods are welded together and connected to a vertical rod with a bamboo handle at the top. A second ring with a larger diameter connects the four rods at the neck, again at 90° rotation to each other. A black steel bowl sits inside the lower steel ring. Small red rubber sleeves cover the ends of the rods where they touch the floor. The finish of the stand is brass, which has worn off in several places, revealing the oxidised steel underneath.

To reproduce the umbrella stand the structure has to be simplified and since cardboard is a sheet material, certain adaptations must be made. The final design consists of two distinct elements.

1. Two heart-shaped pieces of superstructure with a vertical lengthwise cut which can be slid into each other to form a cross-shape in plan.

2. A row of eight unequal rectangles connected along their long sides with end pieces that have two closing tabs on one end and corresponding slots at the other end. Once cut out and scored, this sheet can be rolled around the cross-shaped superstructure and clipped shut with the tabs and slots.

After completing a workable prototype I apply hatching with a ruler and a calligraphy quill that has to be dipped into drafting ink. Drafting ink is thicker than fountain-pen ink and is commonly used for architectural drawings, albeit rarely with a quill. This is time consuming, but produces the clearest black lines and the occasional ink splotch – a desirable effect that gives the overall pattern a slight irregularity.

SUNDAY 19 SEPTEMBER 2004

Today I complete a 1:50 scale model of the stage-set. It was a challenge to find a material that could represent corrugated card at 1:50 scale. I discovered that light bulbs are sold in small trays of very fine corrugated card. Only about one-third of each tray is useful for modelling because the remaining two-thirds has writing describing the contents and giving details of the manufacturer. I had to unpack and re-stack about 100 light bulbs at a supermarket in Stroud Green Road to gather enough of these miniature crates to make the model. The shop assistants who witnessed my activity pretended that they did not see me. The hatching on the cardboard was applied with a 0.18mm thick technical drawing pen. Two pen nibs became defective during the process. A small light bulb illuminates the table lamp. The bulb is battery powered and can be controlled by a toggle switch hidden behind the decorations.

MONDAY 25 OCTOBER 2004

At 12:59 pm I receive an email from the Wagner Forum in Graz: 'Dear Jan Kattein, you have progressed to the semi-finals! – Congratulations.' Below the message is a list of the teams that we are competing against.

1.47 Original umbrella stand. The development of the drawing-model established a working method that was used for the entire *Herr Gevatter* design. The disadvantage of this working method is that the design is only ever as good as the architect's drawing and that the maker's skill and craftsmanship in the workshop remain unexploited

1.48 Template drawing of cardboard umbrella stand

1.49 Template drawing of cardboard
chandelier

1.50 Template drawing of cardboard rocking
horse

The Ring Award website provides more detail: 89 teams made submissions for the first stage, 12 teams were selected for the second stage, one of these is the team Malunat, Kattein, Parditka in this non-alphabetical and hence implied hierarchical order.

TUESDAY 18 JANUARY 2005

Anna Malunat sends an email with the text of the second-stage submission for the Ring Award. Our brief is to produce a detailed storyboard for the second act of *Le nozze di Figaro*. I decide to make a long concertina-ribbon that shows the model photographs, figurines and text in sequence. We have already provided all the information that is requested for the second-stage submission during stage one, so the concertina-ribbon is simply a re-formatting exercise of existing information. Much more important during stage two will be our presentation in Graz on 30 January 2005. The presentation will consist of two parts, our oral presentation and an exhibition featuring our model, drawings, photographs and a costume prototype. We decide to focus our preparations on two things: clarity of intention and the humorous and inspiring team spirit within our group. We believe that the

1.51 Model of performance space

jury will judge us on the merits of the concept, and also on how the team members relate to each other.

WEDNESDAY 19 JANUARY 2005

Anna Malunat sends a fax with the light on-and-off times for the rooms of the *Le nozze di Figaro* model. The times are based upon a recording of the second act of *Le nozze di Figaro*. This information is put into a computer script by Chris Leung, an interactive systems specialist at the Bartlett School of Architecture. The script is then loaded onto a microchip that is connected to the lights in the model. A CD player is also attached and programmed to start simultaneously with the lighting script. Our model theatre can now play on its own with the exhibition audience watching as the rooms and characters reveal and conceal themselves in an interplay of light and darkness.

SATURDAY 29 JANUARY 2005

We are travelling by overnight train from Saarbrücken to Graz. The model is safely packed in a custom-made box with wheels. It is lucky that the box fits through the inter-carriage doors in the German train from Saarbrücken to Munich. The doors of the Austrian train that we take from Munich are slightly narrower and so the model box has to be stored in front of the carriage entrance door. It is funny that everybody feels the urge to use the blocked door even though there is another door only 2m further along the train. One man even attempts to climb over the top of the box.

Finally, in the afternoon, we arrive in Graz. The station is outside the centre, so we have to take the tram to the opera house. The model is then to be set up in the assembly shop. We arrive on time at

1.52 Model photographs from our submission
for the first stage of the Ring Award 2005

3 pm, as requested by the organisers. Once inside the assembly shop, we join a group of thirty or so confused Ring Award participants with boxes and luggage huddled in a corner, while large elements of stage-sets from ongoing opera productions are being shifted around on several cranes suspended from the ceiling. The operatives of the cranes are grumpy because they have to do extra work to make room for our event. There is no one around who is able to advise us on the schedule of events for the day. We decide to leave the opera house and come back when order is restored.

When we return, all the other teams have set up their models and there is only one dark corner left for our model. This suits us well, because the animated lights in the model require low, ambient lighting.

SUNDAY 30 JANUARY 2005
The programme for the day lists the following sequence of events:

10 am Viewing of the models

11 am Presentations of the concepts of the semi-finalists in front of public audience and Ring Award jury

7 pm Announcement of the four finalists and of the winner of the audience award.

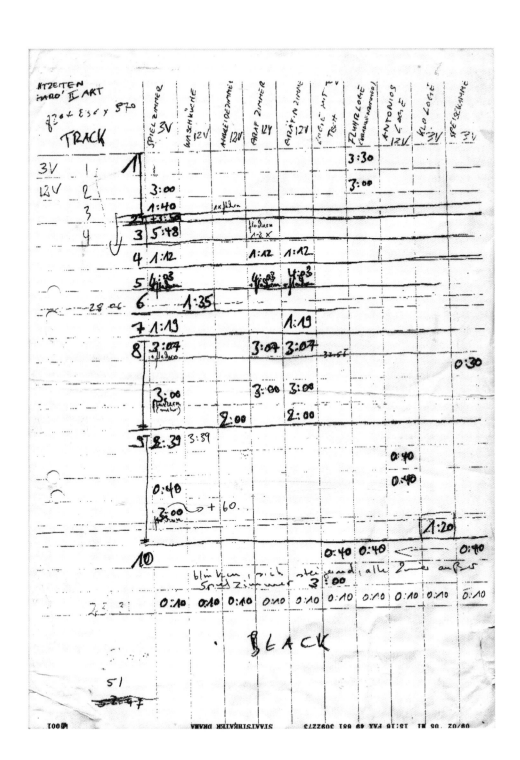

1.53 Lighting script for the micro-processor controlled lighting circuits. The model could be animated with lights and scenes were set using scale paper figurines. The model was not site specific, nor did it respond to the budgetary or operational realities of a contemporary theatre production. The model was our theatre; it was complete in itself and, in that sense, was more like a puppet theatre than a stage-set model

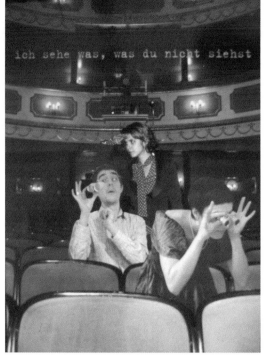

1.54 Maquette with Magdolna Parditka's
costume design on exhibit in Graz

1.55 Model theatre exhibit in Graz

1.56 Slide made for our presentation
advertising the good team spirit in our group.
In reality it had been impossible to organise a
team meeting for a group photograph so this
slide is a collage that was made from individual
photographs of team members digitally
processed and pasted onto a background
photograph of an opera auditorium

Anna Malunat has written out a presentation, but we decide that spontaneity is an important team characteristic to get across to the jury. Magdolna Parditka has brought a slide projector and we will show slides alongside our presentation. We choose an analogue presentation method to maintain independence from the theatre's audio-visual department, but also because we feel that the clicking of the slide projector and the mechanical changing of the slides is more theatrical than the seamless image transition of a digital projector. Apart from the slides of the model, we have also prepared a humorous slide of the team in an operatic setting.

We arrive at the venue at 9.30 am to install the slide projector and to switch on the model lights. At the entrance to the assembly shop someone gives us promotional pencils from a local newspaper. A stage has been set up alongside the back wall. There are some chairs for the audience and a long table for the jury. The models from all the teams line the outside walls of the room. After installing the slide projector, I walk around to inspect the models of the other teams. I have never seen a model made by a stage designer before. It is interesting that the theatre does not feature in any of the models on display. The theatre is shown as a black box made of non-descript material, often foam-core board. The role of the theatre in the model is merely to provide structural support for the stage-set inside. The representation of the site in these models reminds me of the survey drawings that we were given of the Schauspielhaus. While my model with its humble, wide open doll's-house style doors appears to embrace the viewer, the other models appear to keep the viewer at bay. They can only be experienced from one fixed viewpoint, they convey an image rather than a space.

Our presentation is in the early afternoon. Stage fright deprives us of our ability to watch and listen to the other presentations. Suddenly our turn comes. The model is moved onto the stage along with Magdolna Parditka's costume design mock-up, then we are given microphones and Anna Malunat introduces us and the concept. Later, I introduce the stage-set and Magdolna Parditka explains the costumes. There is applause, and we leave the venue to go for a walk. In the evening the winners are announced. Apart from us, a Russian team with a poetic stage design concept using paper, a British/Irish team with a stage design using religious symbols

and a German team are winners of the second stage of the Ring Award 2005. The British/Irish team also win the audience award, but this is probably due to their fright-less performance on stage. After the ceremony, involving the presentation of bouquets and certificates, Herr Bayermann, technical director from Schauspielhaus Graz GmbH, takes all winners on a tour of the Schauspielhaus stage. It suddenly becomes clear that the design proposal that has just won the second competition stage is unrealisable at full scale.

TUESDAY 8 FEBRUARY 2005

The technical set-up of *Herr Gevatter* was last week. The stage-set is still incomplete. A large amount of hatching is outstanding, in particular the cross-hatching in the stairwell and the light-well. The table is unfinished and the stools are missing. The completed elements are well made and look convincing. The only thing that is totally unacceptable is the wall-mounted electric extractor fan that the workshop has made. My drawings clearly specify an electric fan. Instead, a two-dimensional cardboard cut-out in the shape of fan rotors has been stuck onto the rear wall of the stage-set. I re-make the fan today. Modelled on the Vent Axia extract fan in the ground floor gents' toilet at the Bartlett, I make a cardboard fan powered by a hair-dryer motor linked to an old mobile-phone adaptor. The fan rotor is connected to the motor axle with a circular piece of wood that is glued to the rotor and the motor axle is inserted into a small hole in its centre at the back. A pull-cord switch with string and bead allow the fan to be controlled by the singers. This will have to be inserted into a hole in the cardboard wall so that light can shine

1.57 Promotional pencil advertising *Der Standard* newspaper

1.58 Ring Award semi-finalists on the makeshift stage holding their bouquets. From left to right: Orpha Phelan (Ireland), Leslie Travers (UK), Anna Malunat (Germany), Magdolna Parditka (Hungary), Jan Kattein (Germany), Elena Artioukhina (Russia), Etel Ioshpa (Russia), Christoph Rodatz (Germany), Marcus Droß (Germany) and Michael Wolters (Germany)

1.59 *Herr Gevatter* cardboard set assembled on stage for the first rehearsal after the technical set-up

through the fan from the back to cast a shadow on the stage floor. The fan is supposed to make a scratching sound when in operation. Anna Malunat had requested this as a commentary on the modern music of the opera that employed similar scratching sounds. It is difficult to build a fan that scratches only slightly without impeding its movement too much. In the end a paper flap is glued onto the inside of the circular fan housing to rub against the fan blades.

WEDNESDAY 9 FEBRUARY 2005

Today an email from the organisers in Graz details the competition arrangements for the final stage.

The email is in German even though two out of the four teams do not understand the language. The deadline for detailed workshop drawings is 7 March. The rehearsals period is 17 June to 24 June with one single stage rehearsal only. We have been allocated a team of singers from Helsinki, Finland and Magdeburg, Germany. The budget for the stage-set including materials, workshop time and VAT is €11,000 and for costumes €4,000. The rehearsals space we have been given is the set painting shop in the former workshop building.

The email comes during the final phase of rehearsals for *Herr Gevatter*, so we are not immediately aware of the implications of the arrangements for the implementation phase of the competition. In reality we do not have a stage-set design that could be realised for the allocated budget. The material costs alone would exceed the €11,000 allocated. We do not have any drawings, because the design has progressed in model form up to this date. Our concept is too complex to be realised during seven days of rehearsals.

FRIDAY 11 FEBRUARY 2005

Today is the snow rehearsal. The lowering of the ambient temperature is a reoccurring theme in the libretto of *Herr Gevatter* and becomes a key element in Anna Malunat's staging concept. It manifests itself in the vocals, in the characters' use of their costumes and in the stage design. To make the increasing cold visible, I decide to introduce snow. Weather is the stage designer's responsibility. I design two different occasions of snowing:

1.60 Vent Axia fan in Bartlett lavatory that informed the design of the cardboard fan

1. Permanent snowing visible behind the basement window. The snow will collect behind the glass and be blown into the room when the window is opened by the characters on stage.

2. In the final scene, snow will fall on stage and in the auditorium, dissolving the enclosure of the room and turning it into a winter landscape.

Water cannot be used because the cardboard stage-set needs to be re-used for other performances and for shows in Düsseldorf and Munich. To comply with fire regulations, the snow has to be non-combustible. A foam-based snow-machine commonly used in stage shows is tested

and rejected due to the excessive sound levels that it emits during operation. The only snow that can be used is Hollywood Snow. Hollywood Snow is made from shredded white plastic bags. It falls very gracefully and is hardly discernible from crystallised water-based snowflakes. It relies, however, on even dispersal from above the stage. I have constructed a snow dispersal machine using a windscreen-wiper motor that rotates a broomstick with projecting nails at the base of a timber funnel. The system is tested and performs well. The only problem is that the snow occasionally gets stuck in the funnel. Several adjustments have been made in the past weeks including laminating a smooth PVC surface to the inside of the funnel to decrease friction. A de-blocking slider is also added to clear any snow blockages manually. The dispersal machine is installed on the lighting gallery high above the stage in the position of the basement window.

To release snow throughout the auditorium and stage is more difficult. Traditionally a snow swing is used. This is a fabric sheet sewn to nylon mesh with openings of approximately 1-inch square. When the snow swing is untied, the snowflakes in the sheet fall onto the mesh. Gentle shaking ensures continuous dispersal for up to half an hour. The time is adequate for continuous snowfall throughout the final scene, but the problem with the snow swing is that snowing can only occur locally. Some tests are made with a system of my invention that uses computer cooling-fans and acrylic channels. This fails because the snow is too sticky to be expelled by the gentle blowing of the computer fans. In the end we settle for a system involving long sticks fixed to buckets covered with medium grade chicken wire. This system works like giant salt-shakers and can be operated manually from the lighting gallery by three technicians. For health and safety reasons snowing is restricted to the stage and the first row of seats.

THURSDAY 17 FEBRUARY 2005

The dress rehearsal is at 6 pm. Against all expectations, the stage-set is complete. Altogether 4,000 black felt tip pens were used by the theatre workshop to apply the hatching to the walls. In spite of my clear instructions that everything be made from cardboard, the workshop has used three different material strategies to complete the individual elements of the stage-set:

1. My drawings were taken literally and the element was made from cardboard as instructed.

2. My drawings were taken literally for the surface, but timber was inserted for stability.

3. The stage-set element is entirely built from timber, painted brown-grey and then hatched to represent cardboard.

Strategy 3 was used for elements where the structural or mechanical requirements were particularly challenging. The window has to be operable, and it is glazed. The workshop did not rise to the challenge of building mechanical cardboard hinges. The stools have to be stable enough for the singers to sit on, this was difficult to achieve in cardboard, and instead wooden stools were made. The result was a set of stools and a window that were copies of a copy.

1.61 Snow in Saarbrücken. Hollywood Snow is sifted through purpose-made snow dispensers from the lighting gantry and gently settles on the first rows of audience seats during the final scene of the opera. When the audience leaves the opera house the streets of Saarbrücken are covered in a thin layer of white because it has started to snow for the first time this year. The transition from fake snow inside to real snow outside has caused the theatre space to seamlessly melt into the city space, blurring the boundary between inside and outside

The window and stools that I had designed were cardboard versions of timber stools and a timber window. This meant that the painted and hatched timber of the final version was a timber place holder for a cardboard stool that was a copy of a wooden stool.

Even though the architect-inventor in me was shocked by this inconsistency in realising the vision, the architect-arbitrator knew that the amount of effort that the workshop had put into the making of the set forbade any complaints at the eleventh hour. The architect-activist had his hands tied by health and safety regulations and was unable to rectify the inconsistency.

SATURDAY 19 FEBRUARY 2005
The premiere starts at 7 pm. The auditorium is almost full. This is surprising because contemporary music productions in a small town like Saarbrücken do not necessarily attract public interest. There is moderate applause at the end. The theatre director has to ask his assistant to remind him of Anna Malunat's and my name during his premiere speech. When we leave the theatre building it is snowing for the first time this year. The Hollywood Snow from stage and auditorium turns into real snow as the audience leaves the building, dissolving the theatre and extending the stage-set into the city.

The Staatstheater Saarbrücken was short-changed by the composers who delivered a concert and not an opera. We were unaware of the absence of a narrative in *Herr Gevatter* when we signed our contract, because when we accepted the commission the final version of the composition had not been completed. Once the contracts were signed, we were expected to fulfil our task to direct and design. To honour our contract, a narrative, characters and a setting had to be found quickly. Neither Anna Malunat nor myself had the expertise of writing a narrative and inventing characters and settings. Instead, this was done by appropriating a found narrative, *The Doubtful Guest*.

1.62 Hollywood Snow under the cardboard chandelier

1.63 Hans on cardboard rocking horse

In an opera, all sound is controlled by the musical director. Any sounds, including words, noises or sound effects introduced by the directing team, have to be agreed with the musical director, who decides whether the proposed sound is detrimental to the music, the volume and during which section of the music it may be played. During the premiere of a new piece, the introduction of sounds not specified by the score is considered inappropriate. We did not have the freedom to introduce spoken words into the opera. Our narrative had to be mute. The illustrations in Gorey's *The Doubtful Guest* are silent narrative. The text is not required to communicate the story.

SUNDAY 20 FEBRUARY 2005
Today we are driving to Berlin with the *Le nozze di Figaro* model for a special presentation. Herr Andreas Homoki, director of the Komische Oper (Comic Opera) saw the second stage Ring Award presentation in Graz and has invited all participants to present their concept in Berlin and exhibit their models in the Foyer of the Komische Oper. A separate jury has also been invited to award an additional prize. The Komische Oper has agreed to pay all travel expenses and has invited all participants for dinner to an exclusive restaurant.

MONDAY 21 FEBRUARY 2005
The Komische Oper is housed in an eclectic building that combines a neo-classical theatre with a modernist 1950s extension (the foyer and public areas of the original theatre that had suffered bomb damage in the Second World War). The brass details of the model look very contextual in front of the golden anodised aluminium framing of the foyer windows. The classical auditorium appears like a found object that is carefully integrated into the spacious and yet delicate extension. 1950s architecture is not really appreciated enough. The building is too recent to be given historic value and too old to be recognised for its innovation. To engage the audience, this sort of timelessness is what the architect-arbitrator strives to achieve with his designs. As a means to self-sustain, fashion has to perpetually renew itself. Because of cultural and social changes, a design is in fashion only for a brief period of time and out of fashion for most of its lifetime. As a result of this limited life expectancy, fashion has to have an immediate impact on its audience. Being out-of-fashion fosters a much slower and more subtle engagement that can last beyond the duration of the performance. The presentations carry on all day. Members of the jury are Andreas Homoki; Werner Hintze, dramaturg at the Komische Oper; Professor Hartmut Meyer, professor for stage design at the Universität der Künste; Hans Neuenfels, director; and Sebastian Baumgarten, Director-in-Chief for Musiktheater und Schauspiel in Meiningen. Professor Meyer has asked all his students to attend the event. I have always considered my work to be architecture, because I have never had any training in stage design. In the Komische Oper, my work is exposed to the stage designing profession for the first time. Our presentation is at 3 pm, and we are presenting the Ring Award concept and model that we know is not realisable for budgetary and programme reasons. We do not win.

1.64 Mother switching on the cardboard fan. The operational cardboard fan was modelled on the Bartlett lavatory fan. It not only played an important role as a detail of the stage-set, its function was first and foremost to manifest to the team the architect-arbitrator's conviction of the design and to encourage interaction with the set. The architect-activist had to manufacture the fan himself. Limiting the design input of the workshop staff to cutting out and assembling ready made templates, meant that no-one at Staatstheater Saarbrücken had acquired the expertise to fabricate an operational cardboard fan

The evening meal is a success with the well-respected Werner Hintze in a tipsy state tearing our concept apart and calling for simplification – maybe he is right. To have allowed the concept and design to develop so far without site and practical limitations has made it very complex.

FRIDAY 1 APRIL 2005

Christian Gschier from Wagner Forum Graz writes requesting that we urgently contact the workshop to arrange a meeting in Graz. This email is probably the result of our failure to submit the workshop drawings by the deadline. The architect-arbitrator knows that a late submission is unprofessional and is furious because the architect-inventor has not re-designed the stage-set yet. Anna Malunat

suggests that we build part of the stage-set only, the lower, central room and that the floor becomes a major feature, a sort of game board that realises in a horizontal direction what our dolls house stage-set had done in a vertical direction. The architect-inventor really has to start drawing. Even though I understand that the previous design cannot be realised, the architect-inventor did not anticipate having to do two designs when we first signed up for the competition.

WEDNESDAY 6 APRIL 2005

In response to Christian Gschier's email, the architect-arbitrator phones Herr Beyermann in Graz. Herr Beyermann says that he had expected the final drawings on 5 March. I know that but pretend

to be surprised and explain that everything needed re-designing. I have finished the new drawing and posted this to Anna Malunat and Magdolna Parditka. It is a large pencil drawing consisting of two sections: one plan and two elevations, at 1:50 scale, reducing the original design to a minimum. The two elevations are both front elevations showing the design at the beginning and end of Act 2 when the chandelier has fallen from the ceiling. The second section shows details, at 1:2 scale, of a series of chairs salvaged from a previous design. Each chair is associated with a character and all have been changed to encourage physical interaction: the chair for Figaro is fitted with two wheels, Marcellina's chair has 1cm cut off one of the legs, the Countess' chair is fitted with wheels and a pedal system, Suzanna's chair is fitted with a ball bearing so that it can rotate, Cherubino's chair is fitted with springs on each leg and Bartolo's chair is split into two halves that can be folded apart. I have done two things to engage the workshop staff:

1. The revised and simplified concept is reproduced on the drawing to engage through the narrative.

2. The character chairs are drawn with intimate technical detail to engage through the technical aspects of the project.

The drawing is a line drawing. Material qualities and operation of the chairs are described in words.

SATURDAY 9 APRIL 2005

Anna Malunat phones and asks that the dressing room and the window be removed from the

Marcellina

**Vorderansicht
1:5**

Marcellinas Stuhl wackelt. Eines der Vorderbeine ist um 1 cm gekürzt. Der Sitz ist mit etwas abgenutztem schwarzen, glänzendem Leder bezogen, das Holz ist gelblich lasiert, abgegriffen.

drawings. I do not mind, because I have worked on the design for too long to have any attachment to it.

MONDAY 11 APRIL 2005

Today I send our stage design submission to Herr Beyermann in Graz. The submission is 37 days late and comprises a cover letter, the big drawing and photographs of two of our kitchen chairs that I have made several months ago referred to as 'prototypes made especially'.

1.65 Marcellina's chair. Front Elevation, 1:5. The chair wobbles. One of the front legs is short by 1cm. The seat is covered with worn black, shiny leather, the wood is stained yellow

Figaro

Figaro

26cm

4x Rad mit Vollgummireifen

Seil

Vorderansicht
1:5

Seitenansicht
1:5

F i g a r o s S t u h l kann gezogen
werden. Vier weisse hölzerne oder blecherne
Räder mit schwarzen Vollgummireifen sind
am Ende von zwei Achsen befestigt, die durch
die Stuhlbeine gehen. Dadurch kann der Stuhl
vorwärts und rückwärts rollen. Er quitscht.
Die Beine des Stuhles sind auf 26cm von
sitzflächenoberseite gekürzt. Das Holz ist hell-
blau (RAL 5024), hochglänzend angestrichen.
Der Sitz ist nicht bezogen sondern auch hell-
blau angestrichen. Ein weiss-rot restreiftes Seil
dient zum ziehen des Stuhles.

1.66 Figaro's chair. Figaro's chair can be dragged.
Four white, wooden or pressed metal wheels with
solid, black rubber tires are fixed to the end of two
axles that run through the chair legs. Thus the
chair can roll backwards and forwards. It squeaks.
The legs of the chair are cut down to 26cm from
the top of the seat surface. The wood is painted
gloss, light blue (RAL 5024). The seat is not
covered but also painted blue. A rope with white
and red stripes serves to drag the chair

Cherubino

Messinghalterung

Bettfeder

C h e r u b i n o s S t u h l kann hüpfen. Die Beine des Stuhles sind gekürzt und je mit einem Messingteller, an dem eine Bettfeder (oder zwei ineinander wenn zu wenig Federwiederstand) befestigt ist, bestückt. Das Holz ist Rosa, hochglänzend angestrichen (RAL 3015). Der Sitz ist mit altrosafarbenem Samt bezogen.

1.67 Cherubino's chair. Cherubino's chair can bounce. The legs of the chair are shortened and fitted with a brass plate on which a mattress spring is fastened (or two twirled into each other if the spring resistance is too low). The wood is painted pink, high gloss (RAL 3015). The seat is covered in salmon coloured velvet

Schanier

Bartolo

Draufsicht
1: 2

Bartolo

Vorderansicht
1:1

B a r t o l o s S t u h l lässt sich in der
Mitte auseinanderklappen. An der Rückseite
der Rückenlehne und an der Rückseite des
Sitzbrettrahmens ist ein Messingscharnier
angebracht. Zur Verstärkung ist an jeder Seite
der Schnittstelle unter der Sitzfläche ein Stück
Leiste eingesetzt. Eine Kurvenförmige
Metallschiene mit Schlitz hält die beiden
Stuhlhälften vorne zusammen. An die beiden
vorderen Beine sind Räder geschraubt, so dass
die beiden Stuhlhälften auseinanderrollen kön-
nen. Der Sitz ist mit abgegriffenem Kunstleder
bezogen, hellblau, ganz verwaschen (nicht
knallig), das Holz ist gelblich lasiert, abgegriff-
en.

1.68 Bartolo's chair. Bartolo's chair can be
folded apart in the centre. On the back side of
the back rest and on the back side of the seat is
a brass hinge. To strengthen the seat, a section
of moulding is fitted to the underside on either
side of the cut. A curved metal track with a slot
keeps the two halves of the chair together in the
front. Wheels are fitted to the front legs so that the
two chair halves can be rolled apart. The seat is
covered in worn faux leather in light blue, washed-
out (not vibrant), the wood is stained yellowish
and worn. Each character has their own chair. The
chairs each have an added function related to the
personality that we associate with the character.
This added function is designed to encourage the
creative use of the piece of furniture

1.69 Construction and conviction drawing.
The entire stage-set is represented in one
drawing that provides construction details
and engages through its massive size, a
variety of scales, sequential drawings and the
textual descriptions

TUESDAY 19 APRIL 2005

Christian Gschier sends an email reading as follows:

> Good Evening!
>
> Just now I come back from a meeting with Josef Loibner and Michael Beyermann. The plans submitted were checked for their realisability. The following date to discuss details was suggested by Mr. Beyermann: 3. May 2005; 09.00–12.00 o'clock; Theatreservice GmbH [set workshops]; Sternäckerweg 120, 8042 Graz. Please confirm this appointment also with Michael Beyermann and Josef Loibner. With kind regards Christian Gschier.

WEDNESDAY 20 APRIL 2005

An email from Michaela Peterseil from the Wagner Forum shows an edited version of my CV for approval before publication. Most references to my architectural education and career have been edited out in favour of my stage-design experience. I respond with my own version of the CV for publication that firmly insists on my background in architecture. By defining one's discipline, one also defines a professional audience. Architects are much more likely to look at other architects' work for inspiration and critical engagement then at the work of a stage designer and stage designers are much more likely to look at another stage designer's work. The architect-arbitrator chooses to engage with the architect's profession, using stage design as a means to investigate, question and critically illuminate architectural practice.

WEDNESDAY 27 APRIL 2005

The model for the new stage-set is complete. It is at 1:50 scale. I send four model photographs to Herr Beyermann in Graz.

THURSDAY 5 MAY 2005

Anna Malunat sends the lighting concept that she has worked out in collaboration with Michael Bauer, the head of the lighting department of the Munich opera. I now translate the concept into a plan drawing showing the position of individual lamps.

SUNDAY 8 MAY 2005

Magdolna Parditka sends the estimate for costumes that she has received from Theatreservice GmbH, Graz. The total price quoted is €9,205.26. This includes €2,176.50 material costs, €469.48 rental charges and €5,026.07 in workshop time. Most of the items included in the estimate are either made or bought by Magdolna Parditka and savings are already included accordingly. The estimate does not allow for fitting. The time scale allocated to the production of all costumes is half a day. At €4,000, our budget does not even cover half of the cost. Whereas the stage-set has gone through a radical re-design, the costume design has remained the same through all stages of the competition. No design adjustments have been made to respond to site, programme and budget. The high cost also suggests that the costume design was not able to engage the workshop staff.

MONDAY 9 MAY 2005

Magdolna Parditka sends an enquiry to Herr Beyermann, copied to myself and Anna Malunat, asking whether the budget can be used to outsource the costumes as she would otherwise 'at the estimated cost of €9,205 not be able to realise her costume concept'.

Jan Kattein

From:	"Michaela Peterseil" <████████████>
To:	"Anna Malunat" <████████████>; "Jan Kattein" <j.kattein@ucl.ac.uk>; "Magdolna Parditka" <████████████>
Sent:	20 April 2005 15:07
Subject:	Biografien!!

liebe Anna, liebe Magdolna, lieber Jan

danke für den Text zu eurer Inszenierung. - ein Freund hat mir das Open Office-Dokument in der Zwischenzeit umgewandelt.

zu dem Biografien:

wenn ich den Besetzungsblock auf die rechte Seite rüber schiebe (was ich persönlich nicht schön finde, da es dem inhaltlichen Text sehr ein Gewicht nimmt), können eure Biogrfien max. 600 Wörter inkl. Leerschläge lang sein. Jetzt hat Annas Bio 1400 Zeichen und die von Jan 840.

meine Vorschläge, die es ermöglichen würden, dass auch die Besetzung auf der "Besetzungslisten-Seite" links bleibt, wären so:

Inszenierung: Anna Malunat
aus München
* 11.01.1980, Bonn
2000-2005 Regiestudium an der Bayr. Theaterakademie. Seit 2003 Stipendiatin der Akademie "Musiktheater heute". Sie war Hospitantin von Sven-Eric Bechtholf, Peter Konwitschny u.a. Februar 2005 Diplominszenierung mit der Uraufführung von "Der Herr Gevatter: Ein Haus Märchen" am Staatstheater Saarbrücken.

Bühnenbild: Jan Kattein
aus London
* 26.08.1975, Bonn
1997-2003 Studium an der Bartlett School of Architecture in London. Er entwarf für Anna Malunat die Bühne zu Schillers "Kabale und Liebe" (2004) und zu "Der Herr Gevatter: Ein Haus Märchen" (2005). Er lebt in London, ist Dozent an der Kingston University und der Bartlett School of Architecture und leitet ein eigenes Architekturbüro.

Kostüme: Magdolna Parditka
aus München
* 13.09.1975, Budapest
1995-1999 Musikstudium an der Eötvös-Lorand-Universität. 2000-2002 Kunst- und Musikstudium an der Universität von Pecs, seit 2002 Bühnenbild- und Kostümstudium an der Akademie der Bildenden Künste, München. 2004 war sie Kostümassistentin von Karl-Ernst Herrmann bei "Cosi fan tutte" in Salzburg.

das hier sind die Biografien, die ich von euch bekommen habe:

04/07/2008

ANNA MALUNAT

1980 in Bonn geboren, und aufgewachsen. 1999 Abitur. Mit 9 Jahren Klavierunterricht. Von 1996 bis 1999 Schauspielausbildung am Odoroka Mime Theatre.
Studium der Germanistik und Komparatistik an der Rheinischen Friedrich Wilhelms Universität in Bonn. 1999 und 2000 verschiedene Hospitanzen am Schauspiel Bonn, am Grillo Theater Essen und am Burgtheater Wien.
Von 2000 bis 2005 Studium der Schauspiel- und Musiktheaterregie an der Bayerischen Theaterakademie August-Everding/ Hochschule für Musik und Theater München.
Im Rahmen des Studiums Tätigkeit als Hospitantin und Assistentin 2001 an der Deutschen Oper Berlin für Intolleranza von Luigi Nono in der Inszenierung von Peter Konwitschny, 2001 am Hamburger Thalia Theater für Die Schwärmer von Robert Musil, Regie Kristian Lupa, und Anfang 2003 an der Komischen Oper Berlin für Mozarts Don Giovanni, wiederum unter der Regie von Peter Konwitschny.
Eigene Inszenierungen im Rahmen des Studiums waren: 2001 Ödön von Horváth: Stunde der Liebe; 2002 W.A. Mozart: Bastien und Bastienne; 2003 Claudio Monteverdi, Darius Milhaud, Bohuslav Martinu: Ariadne; 2004 Friedrich Schiller: Kabale und Liebe. Im Februar 2005 Diplom mit der Uraufführung der Kammeroper Der Herr Gevatter der Kompositionsklasse Manfred Trojahn am Staatstheater Saarbrücken.
Stipendium der Akademie »Musiktheater Heute« der Kulturstiftung der Deutschen Bank, Finalistin im Grazer Ring-Award 2005, Wettbewerb für Regie und Bühnenbild, Finale im Juni.

Jan

Jan Kattein ist 1975 in Bonn geboren. Er studierte Architektur an der Bartlett School of Architecture in London. Seit er 2002 sein Diplom mit Auszeichnung erhielt sind seine kritischen Stadtprojekte in Galerien in London und Österreich ausgestellt worden. 2002 erhielt er einen Royal Academy Preis in Architektur.

Dies ist seine dritte Kollaboration mit der Regisseurin Anna Malunat fuer deren Produktion von Kabale und Liebe in Muenchen er 2004 das Bühnenbild entwarf und fuer deren Produktion von Ein Hausmärchen in Saarbrücken er 2005 das Bühnenbild entwarf.

Jan Kattein wohnt in London, wo er als Dozent an der Kingston University und der Bartlett School of Architecture tätig ist und sein eigenes innovatives Architekturbüro leitet. Als Doctorant an der Bartlett School of Architecture entwirft er zur Zeit eine Stadt fuer die Zukunft.

bitte ergänzt meine kurz-variante minimst oder streicht eure langen CVs stark zusammen. Die Biografien sollen für die Zuschauer nur kurze Anhaltspunkte sein, woher ihr kommt und wo ihr studiert habt. Die weitere

04/07/2008

1.70 Email with CV as edited by Wagner Forum Graz (left)

(Stage design: Jan Kattein from London, *26.08.1975, Bonn. 1997–2003 studies at the Bartlett School of Architecture in London. He designed the stage-set for Anna Malunat for Schiller's "Kabale und Liebe" (2004) and for "Der Herr Gevatter: Ein Hausmärchen" (2005). He lives in London, is a teacher at Kingston University and the Bartlettt School of Architecture, and runs his own architect's office)

and original (right)

(Jan Kattein was born in Bonn in 1975. He studied architecture at the Bartlett School of Architecture in London. Since his diploma, received with distinction in 2002, his critical urban projects have been displayed in galleries in London and Austria. In 2002 he received a Royal Academy Award in architecture. This is his third collaboration with the director Anna Malunat, for whose production of Kabale und Liebe he designed the stage-set, in Munich in 2004 and, for whose production of Ein Hausmärchen he designed the stage-set, in Saarbrücken in 2005. Jan Kattein lives in London, where he teaches at Kingston University and the Bartlett School of Architecture and where he runs his own innovative architecture practice. As PhD student at the Bartlett School of Architecture, he is currently designing the city of the future)

CV as finally printed. The CV edited by the Wagner Forum Graz omits many references to my background in architecture. Instead, three references are inserted to emphasize the fact that I live in London. My background in architecture has a critical significance to my practice in stage design. Innovative design solutions can occur at the boundary of two disciples, and, hence, I insist that my qualification and practice as an architect features prominently in the CV. The Wagner Forum puts undue emphasis on the fact that I live in London because they want to advertise the international status of the competition

(CV *1975 in Bonn. He studied at the Bartlett School of Architecture. His critical urban projects have been exhibited repeatedly in London and Austria. In 2002 he received a Royal Academy Award in architecture. In 2004 he designed the stage-set for Anna Malunat's production of Kabale und Liebe, in Munich, and in 2005 for Ein Hausmärchen in Saarbrücken. He teaches in London at Kingston University and the Bartlett School of Architecture. As PhD student at the Bartlett School of Architecture, he is currently designing the city of the future)

Lebenslauf

* 1975 in Bonn. Er studierte an der Bartlett School of Architecture. Seine kritischen Stadtprojekte sind mehrfach in London und Österreich ausgestellt worden. 2002 erhielt er einen Royal Academy Preis in Architektur.
2004 entwarf er das Bühnenbild für Anna Malunats Inszenierung von Kabale und Liebe in München und 2005 fuer Ein Haus Märchen in Saarbrücken.
Er ist in London als Dozent an der Kingston University und der Bartlett School tätig und leitet sein eigenes innovatives Architekturbüro. Als Doctorant an der Bartlett School of Architecture entwirft er zur Zeit eine Stadt fuer die Zukunft.

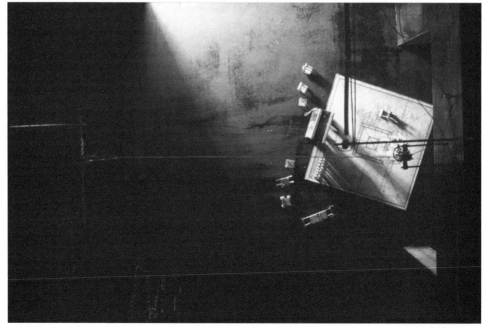

1.72 Model of the revised stage-set for
 Le nozze di Figaro

1.73 Model in plan before disassembly

1.74 Model in plan after disassembly

The design has been simplified to its most
crucial components. The costumes have
remained the same and so the figurines from
the earlier competition stages are reused in
the photographs. Designing is not only an
accumulative process, taking away is equally
important as it helps to clarify intentions and
objectives. The design for *Le nozze di Figaro*
went through a process of multiplication
before it ultimately resolved in simplicity

The designer is proposing to become contractor of
her own design, in costume terms the equivalent of
the architect-activist.

TUESDAY 10 MAY 2005

Theater Holding GmbH is owned in equal parts
by the city of Graz and the county of Styria. It
has four daughter companies, Opernhaus Graz
GmbH, Schauspielhaus Graz GmbH, Next Liberty
Jugendtheater GmbH and Theaterservices
GmbH. The stage-set manufacturing arm of
Theaterservices GmbH is called Art & Event
Graz GmbH. Opernhaus Graz is responsible for
staging productions in the opera house, but in
our case had contracted Schauspielhaus Graz and

their technical department to use the premises
for the Ring Award finals. In order to manage
co-ordination between the daughters, some of the
individual companies have employed dedicated
members of co-ordination staff. Each company
pays for the services that it receives from one
of the other companies. Most other theatres
simply have different departments each of which
contributes its specialist skill and knowledge
to realise a production. Co-ordination between
the departments occurs by colleagues talking
to each other. The theatre canteen is the most
important forum for inter-departmental exchange.
Open at all times, from 8 in the morning, when the
first technical shift starts to late in the evening for

a post-performance snack, the canteen is the place where members of all departments and at every level of the hierarchy co-ordinate design issues, financial issues, dramatic issues, maintenance and technical issues, informally, over a cup of coffee. The canteen is also the home of the architect-arbitrator. Here he can transgress official channels of communication and engage everyone involved in the production: makers to adopt the design and users to adopt the stage-set. The canteen at Opernhaus Graz is located in a dingy basement vault with inadequate lighting. It is hardly used. The architect-arbitrator has a difficult standing in Graz.

Today, the meeting to discuss the realisation of the stage design at Art & Event's offices is attended by the following people: Ilse Raiter, workshop manager; Josef Loibner, production manager; Michael Beyermann, technical director of Schauspielhaus Graz; Christian Gschier, stage designer and member of the Wagner Forum Graz.

1.75 Detail of swivelling chair

1.76 Rolling chair

1.77 Rolling chair

Unfortunately, none of the people who will make the design are present, only their managers. It will be very difficult to engage them if all communication occurs through others. The only means by which to engage the makers is my drawings. The information presented in the meeting includes the stage-set model at 1:50 scale, photographs of the stage-set model, photographs of the chair prototypes, the overall drawing of the layout and the details of the chairs.

WEDNESDAY 11 MAY 2005

My email to Herr Beyermann and Josef Loibner confirms the key points discussed in the meeting. The window shown in the drawing is to be omitted. A detailed drawing of the leaning door is attached to the email. The cast-iron radiator that we identified in the furniture store in Graz on Monday can be used, but its surface should be 'polished-up – not to look new, but to look a little cared for'. A Bakelite radiator knob, that we had borrowed for this purpose from the men's toilet at the Komische Oper in Berlin, will be sent by post and should be attached to the radiator together with radiator pipes fixed to the floor. The chandelier should have a diameter of 1.6m. It is to consist of two parts, one ring with light-bulbs and two smaller rings that

will be connected by threaded artificial crystals. These are to be suspended inside one another so that the crystals can be made to fall at the end of the performance leaving the light bulbs suspended on their own (we are not allowed to smash light bulbs on stage for health and safety reasons). The oak floor needs to slope. It is to be made of DIY-quality parquet flooring with oak veneer placed on top of a tilted podium 300mm high at the rear sloping down to 20mm at the front. The floor is to be cut along the fish-bone pattern so that it can be disassembled. I will provide a detailed drawing of this once the size of the individual flooring elements has been confirmed. In the position of the fire shutter, a strip of the floor can be removed and is attached to a cable with counterweights that will be hung onto the shutter pulley, so that the floor removes itself if the shutter falls.

FRIDAY 13 MAY 2005

Christian Gschier confirms the details of the rehearsal arrangements. One of the singers is from the Opernhaus Graz ensemble and is only available at the times given in his contract. These are three hours in the morning between 10 am and 1 pm and three hours in the afternoon between 6 pm and

1.78 Multiple exposure photograph of the rolling chair's feet. Due to the management structures in Graz, there was no personal contact between the architect and the maker. The only way to engage the maker was through construction drawings and photographs. Multiple exposure photographs showed how the chairs moved. The makers operate at 1:1 scale in the workshop, therefore detailed photographs were submitted to address them at a scale they were intimately familiar with

9 pm or 7 pm and 10 pm on Thursdays and Fridays. Additionally, he will be available on Saturdays from 10 am to 2 pm. The other singers are not limited by these rehearsal times because they are performing on a voluntary basis and are not under contract to Opernhaus Graz.

SATURDAY 14 MAY 2005

A detailed drawing of the floor is sent to Josef Loibner at Art & Event. The drawing is entitled 'parquet detail' and shows the arrangement, cut lines and construction detail of the floor at 1:20 scale.

An email from Christian Gschier from the Wagner Forum confirms that Magdolna Parditka can use the costume budget of €4,000 plus any budget remaining from the stage-set to have the costumes manufactured herself.

WEDNESDAY 8 MAY 2005

My email to Herr Beyermann clarifies his query about the position of the chandelier as follows:

> I have checked the exact position of the chandelier in relation to the pulley systems. You are correct, pulley bar no. H1 is much further back. To avoid having to move everything backwards (it is important to us to be able to perform on the front stage), I have thought up the following, is it possible to suspend a point-load pulley from the audience side of the proscenium bridge to suspend the chandelier there? It does not matter that the chandelier is in the way of the curtain. We do not require a curtain. When the audience enters, the curtain is already open, when the performance ends the lights go off, but the curtain remains open. The fire shutter is not affected. There would be in excess of 200mm between the shutter and the audience side of the chandelier (according to the drawing).

> I hope this helps. If you have any further questions, then I am available by phone or email this afternoon.
> With kind regards,
> Jan Kattein

Much of the technical effort around my stage design is always invested in overcoming the limitations of the theatre building. Its obstructions are the challenge that helps the architect-inventor to come up with apt design solutions. However, it is strange to think that in the 200 years that the Schauspielhaus in Graz has existed, no one has ever had the desire to suspend a chandelier below the proscenium and that no provisions were ever made for this.

WEDNESDAY 15 JUNE 2005

At 2.15 pm I arrive at Graz Airport. The key for our flat is waiting at the Schauspielhaus against payment of the rent charges in advance. We have arranged accommodation away from the other teams and from our ensemble to keep a distance between private and professional life. The flat is located at 2 Richard Wagner Gasse in one of the only high-rise apartment blocks in Graz. The address of the flat is pure coincidence. The Wagner Forum does not approve of our non-conformist accommodation arrangement with the Schauspielhaus.

THURSDAY 16 JUNE 2005

The rehearsals are starting in the old painting shop. Our ensemble is enthusiastic, even though communication occurs in a mixture of Russian, Finnish, German and English. In the afternoon I visit Art & Event. Work on the set is progressing throughout the different departments.

Jan Kattein • Architect
105 Cornwallis Road • London N19 4LQ • UK
020 7272 3241

Project Name	**Figaro**
Drawing Name	**Parkett Details**
Drawing Number	**004**
Revision	
Scale	**1:20**
Date	**14 May 2005**
Drawing Status	**Preliminary**

Do not scale from this drawing.

1.79 Drawing of demountable floor for
Le nozze di Figaro. Most stage designers
deliver their drawings in perspective. These
drawings have a representational quality that
underlines the designer's intention but leaves
the construction details to be decided by the
workshop team. The construction drawings for
Le nozze di Figaro are drawn in the manner
of the architect, with a set of detailed plans,
sections and isometrics, that leave no room for
anyone to doubt their authority and give clear
instructions on assembly and detail

The chandelier is being hung with crystals in the decoration workshop, the floor and podium are in progress in the joinery shop and the radiator is being finished in the painting shop. The floor looks too new and requires staining. One of the set painters has prepared some samples for my approval. I explain that the floor should be slightly darker around the edges at the floor wall joint. This is the area where dirt would collect naturally in a room. This dirt is created with a slightly higher concentration of varnish. The chairs have been finished, but they are not made according to my drawing. The details are more crude. Instead of the ball bearing that I had drawn for the rotating chair, a mandrel has been attached to one leg. The springs under Cherubino's chair are small and thin and they do not look very bouncy. Unfortunately, time does not allow any modification, and I am pressured into accepting things as they are. The workshops argument is that these small details cannot be seen by the audience anyway. The architect-arbitrator knows, however, that a stage-set is not only for the audience visual pleasure, but also to engage and inspire the singers on stage.

SATURDAY 18 JUNE 2005

Rehearsals are progressing without the stage-set. It is difficult for the singers to imagine how the stage-set operates without seeing it because the elements rely on so much detail.

Interaction with the stage-set is vital. The disassembly of the floor needs to be rehearsed, but the floor is still in the workshop. I am being put under increasing pressure to provide the real stage-set for the rehearsals. Art & Event is closed during the week end. Knowing that some of the elements were not made according to my plans motivates me to set up a secret repair-workshop in a spare room behind the rehearsals stage.

SUNDAY 19 JUNE 2005

Basic tools are purchased from a car-boot sale including an electric drill, a hammer, a hacksaw, a box of rusty screws and various other sundries. Some paint, brushes, cake decorations, hinges, drill bits, sandpaper, pliers, rope and springs are purchased from a builder's merchant. All equipment is set up in the workshop in the rehearsals building. There are a large number of chairs and some other disused materials that are available in the rehearsals building. By the end of the day, the architect-activist has re-made two of the chairs in accordance with the original design intention.

MONDAY 20 JUNE 2005

I telephone Christian Gschier from the Wagner Forum to ask that the stage-set be delivered for rehearsals. Then I travel to Art & Event to inspect the chandelier that has allegedly been completed. The result is disappointing. To save money, the rows of crystals have been hung with such large spacing that the structure of the chandelier is very dominant. No more crystals can be ordered before the premiere. I request delivery of the chandelier to my workshop for completion.

TUESDAY 21 JUNE 2005

The chandelier and the stage-set arrive in the afternoon. I receive a donation of a large box of

1.80 The architect-inventor testing the
Count's chair

1.81 Marcellina's chair with cushion from
Graz Cineplex car-boot sale

1.82 Cherubino's chair with brass bell

When the chairs were delivered, by Art & Event, they appeared lifeless and unrefined. The makers had followed the drawings, but had not completed the design. The bell, cushion and lettering were added in the repair workshop to give character and a sense of humour to the chairs. The architect-inventor had failed to communicate these aspects in the construction drawings and the architect-arbitrator had not been able to engage the makers, so the architect-activist had to take over to rectify the design

golden beer bottle tops from the Puntigam brewery in Graz and a large quantity of light-coloured buttons is purchased from a number of charity shops in Graz. I had bought thread at the car-boot sale on Sunday. All team members are put on chandelier-threading duty during the time between rehearsals and this way an extra sixty strings are threaded with punched beer bottle tops and buttons. The threading is not simple because the thread tears easily. We cannot use stronger thread because it has to be thin enough to break when the chandelier falls from the ceiling so that buttons and beer bottle tops are released to jump around the

front stage and ultimately fall into the auditorium. Threading the chandelier is a popular activity and team members who have finished their duties for the day stay behind to help threading. This work does not require much intellectual engagement and hence there is room for social interaction. Apart from helping to complete the stage-set, the threading of the chandeliers advances team bonding.

THURSDAY 23 JUNE 2005

I have finished all the chairs. Cherubino's chair has been fitted with a spherical brass bell that rings as the chair jumps on its sprung feet. Golden letters with Marcellina's name have been applied to the

1.83 Overall image of chandelier

1.84 Detail of chandelier strung with beer bottle tops, fake crystals and buttons. Even though originally used as a cheap substitute for crystal, the buttons and beer bottle tops became the materialized epitome of our understanding of *Le nozze di Figaro*. The playfulness of the detail undermines the opulence of the overall structure. This is also true of Figaro's wedding preparations in the libretto and the intrigues and manoeuvres of the characters on stage which undermine them

backrest of her chair. The gardener Antonio's chair has been entirely re-made. An old iron trolley found in the yard was cut with a hack saw and a wheel was attached to the back-rest. The upper parts of two walking sticks have been cut and screwed onto the front legs. When held by the handles of the walking sticks, the chair can now be pushed like a wheelbarrow. Bartolo's chair has had some lace stapled to the underside making the chair look like it has a beard. The other chairs are mainly left the way Art & Event has made them. The chandelier is complete. Today is the technical set-up. At 3 pm all stage-set elements are transported by lorry to Schauspielhaus Graz for assembly on stage. Assembling the floor takes an entire crew of technicians most of the set-up time. The door and radiator are brought directly from Art & Event. The other stage-set elements are collected from the rehearsals stage. At 4.30 pm a fireman comes to inspect the closing of the fire shutter and the associated lifting of the oak flooring strip. The set is approved. At 5 pm, when the lighting set-up is scheduled to start, we realise that the door opens on the wrong side. The entire second act has been rehearsed with a door opening the other way. Many of the looks, gestures and positions of the singers on stage do not work. The technicians have to leave the stage so that the lights can be set up, and the door remains as is. Anna Malunat is furious and the architect-arbitrator really should have checked the door opening in the workshop before it was delivered.

FRIDAY 24 JUNE 2005

I go to the theatre early with my drill and tools. Two things have yet to be finished. The door needs to be turned around and the door frame needs to have

its golden line drawn along the profiled edge of the architrave. Changing the door requires moving the hinges and the lock to the opposite side. The problem is that this leaves a large hole on the side where the lock used to be. This has to be filled, sanded and painted before the stage-set is taken down to make space for other rehearsals. The official Ring Award programme starts at 7 pm this evening at a bar in the centre of Graz. We arrive after the opening speech by the president of the international Wagner Forum and are unable to enjoy the evening. It is difficult to celebrate before a premiere.

SATURDAY 25 JUNE 2005

The programme starts at 10 am with a whole series of opening speeches by the following dignitaries: Dipl. Ing. Heinz Weyringer, chair of the Wagner Forum Graz;[1] Matthias Fontheim, director of Schauspielhaus Graz; Mag. Siegfried Nagl, Mayor of Graz;[2] Mag. Franz Voves, first county captain of Styria; Waltraud Klasnic, captain of Styria; Dr Heinz Fischer, president of Austria.

We arrive after the speeches at 11.30 am in time for the staging of *Le nozze di Figaro* by Elena Artioukhina with stage-set by Etel Iospha.

1 Dipl. Ing. = Diplom Ingenieur, a post-graduate qualification in engineering.
2 Mag. = Magister, someone who holds an MA degree.

1.86 Theatre technicians assembling the oak floor jigsaw. Setting up a stage-set is sometimes more theatrical than what is going to be staged there

1.87 Rotating chair on completed oak floor

Elena Artioukhina and Etel Iospha are our competitors. Rumours abound that Elena Artioukhina has brought her husband from Russia to help with the directing and that a substantial part of the rehearsals were taken up by the two spouses arguing in Russian about what should happen on stage. A theatre production relies on each member of the team respecting each other member's specialist responsibility. This is why in spite of all co-operation, job descriptions are precise. To have two directors direct one opera is a receipt for disaster.

Instead of the curtain a huge sheet of paper hangs behind the proscenium. One by one the characters make their appearance on stage by cutting, tearing and ripping their way through the paper. Paper costumes are manufactured on stage, a horn rolled out of a sheet of paper and a paper gun folded. The architect-inventor in Artioukhina's and Iospha's production must have worked at full blast. The architect-arbitrator was not able to fully engage the audience and the other team members on stage. As a result, the paper play becomes repetitive after five minutes. After the performance there are a number of receptions hosted by the people who made the opening speeches.

Our premiere is at 5 pm. The stage-set has been set up by the technicians. The singers already sit in their chairs when the audience enters. Marcellina is knitting on her wobbly chair. Figaro is sleeping (and snoring quietly). The Count and the Countess are arguing in silence. The programme for the day announces the introduction of the jury members by Heinz Weyringer. A lectern is set up at the far right side of the stage for this purpose. The singers have been instructed to rock on their chairs impatiently during the speeches. This does not go unnoticed, and Heinz Weyringer, who had expected the curtain to be closed behind his lectern, decides to retreat before the end of his speech. Some technicians are called in to clear away the lectern, and we are ready to begin. The pianist starts the Mozart scores when he notices that his piano is not functioning properly. After another two or three attempts, some audience members next to me become visibly agitated. Finally the pianist opens the top of the piano to pull a furry mouse out between the strings. The mouse has two little black bead-eyes, real rabbit fur and a leather tail and was sold as a toy for cats in the local pet shop, but the audience does not know this. The pianist starts his score again and Figaro sings his aria pacing the room taking measurements for his marriage-bed. Everything goes as planned until Bartolo leaves the oak floor and the door on stage re-opens after him. He notices, turns around and tries to close it again, but the latch is jammed. The audience, who have been primed by the mouse-in-piano scene, think that this is another silly joke, but in reality the closing of the door is critical for the understanding of the rest of the second act. The singers exchange looks and are getting visibly agitated. The functioning of the stage-set is the responsibility of the architect-arbitrator, and I try to hide behind a tall man who is sitting in the row in front. When I look back up, Bartolo has taken his key chain out and is fiddling with the latch while the Count and Countess are giving him cover from the front during their duet. The door is repaired *en scène*.

As the opera progresses, the wheel on Suzanna's chair breaks off, but the disassembly of the oak floor is already so advanced that the audience does not notice.

1.88 Act 2 of *Le nozze di Figaro* at Schauspielhaus Graz on 25 June 2005

1.89 Act 2 of *Le nozze di Figaro* at Schauspielhaus Graz on 25 June 2005

1.90 Act 2 of *Le nozze di Figaro* at
Schauspielhaus Graz on 25 June 2005

1.91 Act 2 of *Le nozze di Figaro* at
Schauspielhaus Graz on 25 June 2005

1.92 Act 2 of *Le nozze di Figaro* at
Schauspielhaus Graz on 25 June 2005

1.93 Act 2 of *Le nozze di Figaro* at
Schauspielhaus Graz on 25 June 2005

1.94 Act 2 of *Le nozze di Figaro* at
Schauspielhaus Graz on 25 June 2005

1.95 Act 2 of *Le nozze di Figaro* at
Schauspielhaus Graz on 25 June 2005

The curtain is already open when Heinz
Weyringer welcomes the audience and the
singers are waiting on their chairs to enter the
game. During the second act the characters
become increasingly deprived of their ability
to distinguish between play and reality. Their
confusion finds expression in the breaking-
up of the stage-set and its dispersal around
the room. This situation peaks when the
chandelier crashes down from the ceiling
spilling beer bottle tops, buttons and fake
crystal into the auditorium

Then the chandelier crashes from the ceiling and the lights flicker and go off. The buttons and beer bottle tops jump across the stage and then there is absolute silence. After a few minutes the characters on stage slowly get up, brush the dust off their clothes and arrange the chairs ready to play again. When the speechless audience realises what is happening they quickly start their applause to prevent the entire performance starting again.

Afterwards, Anna Malunat, Magdolna Parditka and myself are taken to the smoking room where we are to have a question-and-answer session with the audience in a public event called 'speakers corner'. It occurs to me later that we have totally failed in achieving our objective. The result of our staging was shock and not dizziness. An audience is shocked when it is faced with an event of major impact that occurs unexpectedly. During the after-shock, the audience tries to recover from the sudden event. If there are grave consequences of the event that caused the shock, the audience is sometimes gripped by horror. All three, shock, after-shock and horror are unpleasant. Dizzyness is a much more complex experience. The discomfort caused by the lack of control over one's own body mixed with the pleasure of weightlessness makes dizzyness more engaging. Whereas shocking someone can cause resentment or repulsion, making someone dizzy can cause delight, engagement and reflection.

SUNDAY 26 JUNE 2005

The premiere of the British/Irish team is at 10.30 am. In spite of all good intentions, we are unable to attend. Instead, we arrive on time for the prize-giving ceremony at 12.30 pm. All participants are asked to appear on stage.

We refuse out of fear that the disappointment of not having won will show on our faces. The moderator of the prize-giving ceremony utters hushed threats, but we insist that we sit in the auditorium until the prizes are announced. The first prize is the prize from the University of Zurich, and it is presented by students of an arts management course. The winner of this prize is the Russian team with the paper stage-set. Then follows the prize of the City of Graz presented by Councillor Mag. Dr Christian Buchmann. This prize is awarded in equal parts to the Russian team and to us. For a minute we hesitate whilst deciding whether to leave our comfortable anonymity amongst the audience to go up on stage for half a prize. However, the silence is more embarrassing than to show ourselves, so we quickly climb up on stage before the moderator can implement her threats. We decide unanimously that the phallic glass trophy that comes with the prize could not easily be split in half and should thus be given to the Russians to take back home.

The next prize is from the county of Styria presented by national assembly member Mag. Dr Andrea Wolfmayr. I wonder whether titles are congenital in Austria when my attention is suddenly diverted by the announcement that we have been awarded the prize from the county of Styria. We are handed another engraved glass monstrosity and several doctors come to shake our hands.

The main prize, obviously, is the Ring Award. This prize is awarded by the jury and, apart from a monetary prize and a glass monstrosity, it also constitutes the 'commission for a stage production at Opera Graz'. This prize is presented to us by Jörg Kossdorf and Heinz Weyringer.

Wagner Forum Graz

SCHAUSPIELHAUS, GRAZ
Hofgasse 11, 8010 G R A Z, INFO 0316 / 8000

Finale ring.award.05
W.A.Mozart. Le Nozze di Figaro, 2.Akt

25 - Jun. - 2005 **ab 10.00 Uhr**

Vollpreis Verkaufspreis
EUR 20,00 EUR 0,00 Freikarten
(Preise inkl. 10% MwSt)

GENERALPASS 25.06. - 26.06.2005
Freie Platzwahl

/
0000391674001001550001
156516/DI Heinrich Weyringer Wagner Forum

OPER
SCHAUSPIEL
NEXT LIBERTY

THEATER, GRAZ
DIE NEUE SPIELZEIT

ORPHEUM THEATER, GRAZ
KASEMATTEN

1.96 Ticket for Ring Award finals

ZERO EMISSION LUMINAIRES

The *Zero Emission Luminaires* were sited on Caroline Street in Blackpool's South End. They are the only project in *The Architecture Chronicle* designed, constructed and installed outside the theatre building. Street theatre contains an element of chance and unpredictability inherent to its site. This brings potential risks but also opportunities of which theatre inside a theatre building is devoid. The *Luminaires* were an experiment to test the risk and potential of such a production. They were also an experiment to see whether the three architect-characters can manage and execute a project outside the protective shell of the theatre. In order to understand the project's relationship with its location, I will use this introduction to talk about Blackpool and then about the particular challenges that work outside the theatre building presents.

Blackpool is a resort town of some 142,000 inhabitants, located in Lancashire on the Irish Sea. Since the 1890s Blackpool's industry has focused on tourism and much of the current population are involved in entertaining and accommodating several million visitors every year. The entertainment industry has brought many famous actors, opera singers and comedians to Blackpool. The town is home to a number of festivals. The most famous of these is the Blackpool Illuminations, which takes place once a year, at the end of the summer season. During the Blackpool Illuminations several miles of sea-front are lit up by millions of light bulbs.

The expansion of budget airlines has brought Mediterranean beaches and their mild climate within reach of the traditional Blackpool visitor. The failure of the resort to meet the expectations of modern travellers, has caused visitor numbers

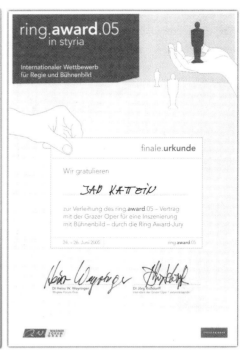

1.97 Certificate for participation in the finals

1.98 Certificate for the Styria County Award

1.99 Certificate for winning the Ring Award

One certificate is missing from my files, but maybe one of the other team members has it. Even though three out of the four teams had three members, the design of the certificate pro forma does not have enough room for three names and Magdolna Parditka's name had to be written half-way into the margin.

Three out of a total of six signatures are missing at the bottom of the certificates. The Ring Award certificate is signed by Dipl. Ing Jörg Kossdorff, director of Opernhaus Graz GmbH, and promises 'a contract with Opera Graz for staging a production with stage-set'. The certificate neither specifies where and when the production is to be staged, nor what the production is. This gives Opera Graz maximum leverage when negotiating a contract with the Ring Award winners

to decline sharply in recent years. The resort has been thrown into a vicious cycle. Dwindling visitor numbers result in lower income, which causes under investment and results in decay and dilapidation which causes visitor numbers to fall. This is the reality for the town that once tried to out-trump Paris by building the famous Blackpool Tower inspired by Gustave Eiffel's French equivalent, hosted shows by Charlie Chaplin and in 1879 was the first municipality in the world to install electric street light.

In search of a new destiny, Blackpool Council has teamed up with a number of developers to demolish large parts of the town and replace them with ever larger facilities for tourists. The scale of the proposed development threatens to destroy the character of the town. Critics are concerned that the proposed developments fail to engage with Blackpool's existing community, history and culture. Even the expected economic benefits may never reach local business owners who will have the remainder of their dwindling clientele taken away by super-hotels and mega casinos.

In the meantime, Blackpool has attained a much more gentle charm. Big wheels, merry-go-rounds and roller coasters slowly rust away on the three entertainment piers, while under-occupied hotels have turned their front rooms into local drinking dens and cafes advertise 'free toilets for patrons' to entice the occasional tourist onto their premises to spend 60 pence on a cup of tea. It appears that the entire population is waiting for the inevitable destruction of their town, either by large-scale commerce or by the rising sea-levels which threaten to flood the town located in a particularly vulnerable coastal area.

Work on *Kabale und Liebe* and more so on *Herr Gevatter*, shows that a theatre has established working methods that provide parameters for the stage design. The different departments in a theatre take a large share of the responsibility to manage, advertise, fund and procure a production. The *Zero Emission Luminaires* project left all these responsibilities to me. As a result, I operated as designer, maker, promoter, actor, director and negotiator, testing the roles of the architect-arbitrator, architect-inventor and architect-activist in the context of these new tasks.

A call for proposals for lighting installations to take part in Blackpool's Festival of Light had been passed on to me from an original email message that festival director, Philip Oakley had sent to students from the Royal College of Art.

In the context of work I was pursuing for an urban infra-structure that acts as a catalyst for community-led urban regeneration, I had previously drawn a series of sustainable street lights that would engage the local community by enticing them to adopt and maintain the architecture and hence take responsibility for their urban surroundings. With the drawings already far advanced, I decided that the Blackpool Festival of Light could provide an opportunity to realise and test the proposals at full scale.

MONDAY 13 JUNE 2005

I send my proposal to Blackpool Council's Illuminations Department. It contains the following information: two 1:2 scale drawings measuring 2.2×0.9m wide, photographs of previous projects, a project description and a covering letter. The project description states:

1.100 Article '2020 Vision' by Tanya Gold from *The Guardian* 'Travel Section', 10 September 2005. The article mentions the *Zero Emission Luminaires*. The piece conveys an atmosphere of decay and melancholy, failing to recognise the beauty and the romance of the town. Many readers will share this desolate view of Blackpool. Building upon prejudice, however, can cloud one's view and often fails to engage with the actual site or subject matter

Between 1990 and 2000 electricity used for lighting and appliances in British Households has gone up from 40 to 48 million tons oil equivalent per year. these figures show that the key to reducing energy consumption in the UK may not be the introduction of evermore efficient appliances. consumer behaviour needs to change.

The project description titles the *Luminaires* as:

'A new type of Zero Emission Streetlight': ... Individual units are dis-placeable, repairable and upgradeable and constructed entirely from recycled and reused materials. Their fuel is entirely derived from zero emission

sources. All *Luminaires* are 4m high and can hence be constructed under the permitted development order.

Permitted development rights allow local authorities to carry out highways works without requiring a planning permission as long as the works do not exceed 4m in height. The *Luminaires* are designed to be retractable, for maintenance reasons but can be extended to a full 4m when illuminated. The initial design of the luminaires is conceived on a purely theoretical basis. The first drawings are large-scale detail drawings which are based on research and experience, but no tests are carried out. The drawings are pencil on lining paper, which is joined horizontally to provide sufficient width. Lining paper is not acid free and has been selected for its tendency to yellow with age, like the *Kabale und Liebe* wallpaper.

The drawings are best described as construction drawings that fully explain the mechanisms involved. The architect-inventor is under no illusion, however, that a lot of the detail will have to be re-designed according to the materials that will become available. To lessen the environmental impact and for financial reasons, the *Luminaires* are to be constructed entirely from recycled and reclaimed materials. Even though the drawings look like construction drawings, they are not really intended for construction and are, as previously, better defined as conviction drawings.

The initial design of the methane-powered *Luminaire* shows one insulated fermentation vessel, the base of which is fitted with four castor wheels. A vertical post is attached to the fermentation vessel that holds a ceramic plate with a gas filament underneath. An automatic lighter and a gas valve can be controlled from below. A long, narrow plastic bag is drawn to hang on the side of the vertical light post to serve as gas storage.

The drawings and the project description refer to two differently powered *Luminaires*, one of them powered by fermenting biomass and one by wind energy. It also states that a number of other prototypes are being developed using solar energy, tidal energy and discarded chewing gum. The architect-inventor did have some ideas on how a prototype using solar energy could be constructed. The section about the tidal energy and the chewing gum is entirely invented.

The cover letter states that General Design are intending to produce twelve '*Zero Emission Luminaires*' to be installed on a terraced street in Blackpool's South End. I have previously used the company name General Design when working collaboratively with other designers. On non-collaborative projects, I use the name Jan Kattein Architects. The difference between General Design and Jan Kattein Architects is the relationship between myself and the people I work with. General Designs is a group of equal partners, Jan Kattein Architects establishes a clear hierarchy.

I know that I will need volunteers to help realise the project; the budget is too low to pay wages. To procure the project under the name General Design will make volunteers feel more integrated into the design process and encourage them to take on responsibilities themselves. General Design is a thoroughly democratic organisation where every member has a say; a brainchild of the architect-arbitrator who knew he would need to rely on others to realise the project. It will be a relief not having to adhere to the management structures required by an architect's office for reasons of liability.

WATER COLLECTOR

AIR LOCK

SPARK

1.101 Overall drawing of the methane-powered *luminaire*. The original drawing was at 1:2 scale and contained substantial technical detail. The detail was made up by the architect-inventor without the architect-activist testing or verifying the efficacy of the ideas. Even though the drawing looks like a detailed construction drawing, it was never intended to inform construction, but used by the architect-arbitrator to convince the client of the technical feasibility of our proposal. Its vast scale (2.2×1m approx.) was to convey the energy and conviction behind the project

1.102 Water collector

1.103 Detail of fermentation vessel inlet

1.104 1:2 Lamp detail

The Architect's Act (1997) requires practising architects in the UK to hold professional indemnity insurance. General Designs does not require such insurance as long as it does not include the term architect in its name.

If successful, the architect-arbitrator can use General Designs as an organisation with a fluctuating membership through which he can pitch for larger jobs. Also, volunteers can claim credit for their input more easily if the project is run under the name of General Designs.

General Design itself should be a model of how the urban concept behind *Zero Emission Luminaires* can be realised in real life. The non-hierarchical structure of the organisation is central to the project's objective. The project brief describes the main aim as follows: to introduce 'a new urban infra-structure which encourages involvement in its upkeep, maintenance, care and construction'. General Design should run in the same manner in which the architect-inventor imagines the city to grow around our project once it is installed on site. The project consists as much of the invention of General Design as it consists of the production and testing of the *Luminaires*.

TUESDAY 14 JUNE 2005

I receive a telephone call from Philip Oakley confirming that he is very excited about the project and that he will try to organise funding. I know that the only way to realise the project will be to receive financing from Blackpool Council, and the cover letter which was sent with the proposal yesterday says:

> We have access to a workshop in London where the lights could be made, we do however need your financial assistance with transport to Blackpool, materials and possibly external help.

The original invitation from Blackpool Council to participate in the Festival of Light stated that:

> Although Blackpool Illuminations is the biggest show of it's kind in the World our budgets are very tight and we will have to consider financial help for production costs etc. on an individual basis. There are not sufficient funds to commission specific pieces of work but we are always interested in looking at proposals for future reference.

THURSDAY 16 JUNE 2005

I receive correspondence from the client saying that he will discuss possible funding with the Blackpool Council energy manager. Without a confirmed budget, detailed project planning cannot progress.

WEDNESDAY 6 JULY 2005

Confirmation of funding totalling £3,000 comes from Blackpool. Philip Oakley also writes that he will try to identify further funding sources.

THURSDAY 14 JULY 2005

There is still no confirmation of further funding and we decide to re-align our brief and working method. We had originally intended to produce twelve *Luminaires*. To produce five *Luminaires* seems a more realistic target.

FRIDAY 15 JULY 2005

Today I hold a project meeting with a group of first-year architecture students from Kingston University. I present the details of the project to the students, explain how the project will be managed and reaffirm that I would want everybody to participate in all aspects of the project including design, management

and assembly. No wages will be paid, but I explain that there will be an all expenses paid trip to Blackpool to install the *Luminaires* and that the students will have the opportunity to acquire workshop skills in the Bartlett School of Architecture Workshop – one of the best equipped architectural workshops in the country. I also explain that Blackpool Council intends to publish the project and that all participants will be able to claim credit for the work.

Two of the students confirm that they are very interested in participating and that they have a friend who is also interested. A programme, a detailed material list, a project description, a contact list and a £200 budget are issued during the meeting.

It is very important to the architect-arbitrator to involve all volunteers fully in all aspects of the project for three reasons:

1. I want to take part in the making process and do not want to spend most of my time managing the project.

2. Fully integrating the volunteers will make them feel responsible and hence increase the quality of the final outcome.

3. I want to test a democratic working method where every member of a team contributes towards a project without hierarchical management structures.

SATURDAY 16 JULY 2005

A list of workshop times for the following week is issued by email. The volunteers are only allowed in the workshop when I am present.

The project programme is also issued to all members of General Designs and the Blackpool Illuminations Department. It identifies the following time periods: collect materials, finalise design, construction, Blackpool Festival of Light, Energy Savings Week, fermentation period, operation.

Collecting materials is intentionally set to start before finalising the design as the materials collected will determine the detailed design of the *Luminaires*. Finalising the design is shown as a three-week period. We estimate that it will take three weeks to build the first *Luminaire*, which will then establish the design parameters for the following *Luminaires*. National Energy Savings Week is shown as the operation period in the programme. A testing period has not been programmed because of time constraints, testing of the first *Luminaire* is to run in parallel with the construction of the remaining four *Luminaires*. The fermentation period of two weeks is a hopeful guess based on research. The programme is an important tool to organise the project and to set deadlines for all parties involved, in reality the construction process will progress as fast as it can. If the *Luminaires* are completed early we can build more, if we are running late we will build fewer.

TUESDAY 19 AUGUST 2005

An invoice of £1,500 is sent to Blackpool Council for 'materials and transport expenses in relation to *Zero Emission Luminaires* installation for Blackpool Festival of Light 2005 in the period between 1st August and 19th August 2005'. The invoice is sent on the Jan Kattein Architects invoice pro forma. Even though the project was officially procured by General Design, the company does not have any stationary, nor a bank account to pay cheques into.

Jan Kattein

From:	"Chrysanthe Staikopoulou" <████████████████>
To:	<j.kattein@ucl.ac.uk>
Sent:	05 May 2005 12:48
Subject:	FW: Blackpool Illuminations commission

-----Original Message-----
From: Sue Bradburn [████████████████]
Sent: Thu 05/05/2005 11:49
To: All Students
Subject: Blackpool Illuminations commission

> Call for Artists
>
> Blackpool Festival of Light
>
> In this, the 125th anniversary of the electric light bulb and the
> 126th year of the it's lights, a Festival of Light is being launched
> to run concurrently with the world famous Blackpool Illuminations.
>
> Traditionally the Illuminations are a Council organised light show
> running along over 5 1/2 miles of promenade in the UK's most popular
> seaside resort. It's the biggest temporary light show in the World
> attracting over 3.5 million visitors to the Town between September 2nd
> and November 6th.
>
> The Festival is a means of introducing greater creativity into the
> show and to extend it into areas beyond the promenade such as the Town
> Centre. It is also an opportunity for artists to showcase their work
> to a larger audience and work with the Illuminations Department. You
> may also find that the Illuminations and Blackpool provide an
> interesting contrast or foil to your work by which to gain media
> coverage.
>
> Venues may be shop windows, clubs, bars, hotels, open spaces, theatre
> foyers, trams etc. Installations may consist of any form of light such
> as daylight, fibre optic, neon, fluorescent, tungsten, halogen, laser
> etc. Installations may be site specific, sculptural, performance
> based, projected, product based. Internal or external. There are no
> hard and fast rules and we will consider your proposal however strange
> or ridiculous it may sound.
>
> Artists are welcome to submit proposals to the Festival Director:
> Philip Oakley via e-mail to crashseventy@aol.com call Philip on 07879
> 810 587 if you require further information. Please send small files by
> e-mail.
>
> Please note the following:
>
> Installations should be installed by September 2nd until 7th November
> 2005
>
> Performances could take place at any times between September 2nd and
> November 6th. Weekends are particularly good for audiences.

> Unless you are familiar with Blackpool we will be responsible for
> finding a suitable venue/site for your work subject to your requests
> and specifications together with available power supplies and other
> infrastructure issues.
>
> Once we have found a venue or site for you we will expect you to work
> directly with the venue or site manager to organise design,
> installation and any other issues. We will of course do what we can to
> help, check any electrical work, health and safety issues etc. but
> most of our resources will be concentrated on the main show. So our
> workshops will generally not be available.
>
> Although Blackpool Illuminations is the biggest show of it's kind in
> the World our budgets are very tight and we will have to consider
> financial help for production costs , etc. on an individual
> basis. There are not sufficient funds to commission specific pieces of
> work but we are always interested in looking at proposals for future
> reference.
>
> Work will be catalogued on the Festival website and elsewhere. Point
> of exhibition graphics will be provided.
>
> If you have not visited Blackpool before, or read about it, please do
> so as it is a unique place which may have some relevance to your work.
>
>
> Sue Bradburn
> Media Relations Officer
> Royal College of Art
> Kensington Gore
> London SW7 2EU
> T: 020 7590 4114
> F: 020 7590 4124
> www.rca.ac.uk

1.105 Email titled 'Call for Artists' from Blackpool Council, forwarded by the Royal College of Art press officer. The email vividly advertises the prospect of working in the context of the Blackpool Illuminations. However, when looking at the detail – little prospect for funding, no workshop facilities and little support from the council for the installation of work – the architect-activist would have to take on much greater responsibility then in all previous projects

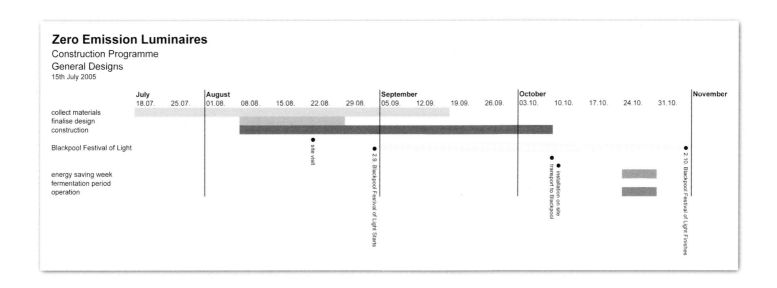

Zero Emission Luminaires

Construction Programme
General Designs
15th July 2005

1.106 Project programme dated 15 July 2005

SATURDAY 27 AUGUST 2005

This is our first trip to Blackpool. Travelling from London Euston Station are Holly Gibbons, Dimitra Holiasmenos, Jan Kattein and Chrysanthe Staikopoulou. A fast Virgin Pendolino Train takes us to Preston in Lancashire where we have to change for a local train to Blackpool. The train to Blackpool is a two-carriage train driven by a diesel engine that envelops the station in a black cloud of smoke as it comes to a halt on the platform. The platform for the trains to Blackpool is at the far end of the station, tucked away from the main concourse.

The main purpose of our trip is to find a site for the *Luminaires*. Philip Oakley has suggested that they could be installed at the Illuminations Department, but it is important that the *Luminaires* relate to a particular urban location.

After checking into the Blackpool Hilton Hotel, which Philip Oakley had booked for us on the reduced Blackpool Council rate, we start to explore the town in search of a site. The following are defining qualities of the site that we are looking for:

1. scale;

2. the existing community;

3. security;

4. darkness.

We look at a number of residential streets and eventually identify Caroline Street, located south of the town centre in an area dominated by family-run hotels and light industry. It runs parallel with the sea promenade about 200m inland from the shore. The western side of Caroline Street is formed by the ends of the terraces of Bairstow Street and Yorkshire Street.

Zero Emission Luminaires

Findings List
General Designs
15th July 2005

item	number required	available from	description	preparation
Fermentation Vessels	**about 12 (depending on size)**	**metal scarp yards, construction site skips, contact plumbers, plumbing merchants**	**copper vessels from domestic immersion water heaters, about 1m high, 50cm dim or so, some big ones would be good**	**remove all insulation foam or rockwool insulation, careful with very old one's for asbestos. If in doubt, do not touch.**
various copper tubes, pipes, brass & copper junction pieces	many	skips, markets, domestic refurbishment	all types and diameters required	clean & polish, ready for soldering
large taps for sludge outlet	about 12	skips, scrap yards, normally used in industrial heating systems, mains water supply	outlet should be min. 1inch if not bigger. Have to seal tight	clean & polish, ready for soldering
pressure gages	about 12	skips, scrap yards, car boot sales, plumbers, normally used in industrial heating systems, gas supply	old ones are nicer, plastic one's are not so nice	clean & polish, ready for soldering
casters & wheels	about 12	car boot sales, markets, scrap yards	cast iron or wood are nice, old pressed metal from prams, tricycles	clean moving bits with white spirit if oily and re-grease
various cranks & handles	about 8	car boot sales, scrap yards	cast iron or wood are nice	clean
various pullies	many	car boot sales, scarp yards	cast iron from treadle sewing machines are good, cast iron from old lift machinery	clean
ball bearings	many	car boot sales, scrap yards	washing machines, trolleys, old machinery has ball bearings	clean
gas lamps	many, we have to experiment	car boot sales, scrap yards	domestic and small industrial, the older the better	clean & test where possible
tubing	many metres	car boot sales	rubber tubing for gas, plastic dissolves I think	clean
various taps & valves	many, many	car boot sales scrap yards, skips, second hand shops	small old taps, brass from old domestic gas fires etc	clean, replace rubber seal if necessary
funnels	about 4	car boot sales, second hand/ charity shops	enemal, brass, baquelite, copper or glass, the bigger the better	clean
various steel rods, tubes, flat, hollow section, sheet	a lot	skips, scrap yards	can be rusty	
office chair bases or machine/catering equipment stands	about 3	skips, scrap yards	should be the old kind, new one's are very nasty, would be great to have wood, cast iron ones	clean, repair if necessary
old flint lighters	about 4	car boot sales		repair if necessary
handles, dials	about 4	car boot sales, scrap yards	baquelite, metal, not plastic	
string		car boot sales	stable string which does not stretch, natural fibres, fine	
various small pullies	many	car boot sales, curtain suppliers	old mecano is fine, brass from old curtain tracks etc.	
brass sheeting, rods etc.	many different ones for moving parts	scrap yards, skips		clean

1.107 Findings list. The programme clearly structures the construction process, but the deadline for completion is immovable. This means that, in reality, the contingency strategy is to simply make fewer *Luminaires* if we are to run late. Even though working to a programme implies strict management and tight organisation, imposed management and organisation were the practices that I was trying to avoid. The findings list was the first attempt to hand responsibility to the volunteers. The descriptions of items were specific and vague at the same time; functionality was clearly defined, whereas appearance was left intentionally imprecise so that a degree of creative input would be required

The eastern side of Caroline Street is formed by a row of two-storey back of pavement terraces constructed in the 19th century.

Caroline Street is selected because the houses are the right scale for the *Luminaires* and because of the intimate relationship between the private space of the house and the public pavement, only separated by a front door. Caroline Street is located close to the municipal donkey stables making it easy to obtain feed stock. The Council's Illuminations Department, where the *Luminaires* are to be assembled and stored during the fermentation period, is also nearby.

After identifying the site, we have an appointment with Philip Oakley at the Illuminations Department. He takes us on a tour of the department, which is in the process of preparing for the Illuminations switch-on on 2 September, before we sit in his office for a more formal meeting. Six large warehouses accommodate the various work shops that fabricate the lighting features. Most features are internally illuminated fibreglass figures or cut-out plywood panels fitted with lamp holders and bayonet light-bulbs protected by cabochons. All the features are well crafted and made to survive the harsh sea-breeze and salty air of the Blackpool promenade. Philip Oakley points out the different figures represented by the illumination features. Most of them are literal copies of characters from children's TV series that I have never heard of. Philip Oakley is critical of the work and feels that the Illuminations Department has failed to re-invent itself since the 1960s. He thinks that it will be beneficial if the *Luminaires* are installed on the premises of the department because his colleagues would then be exposed

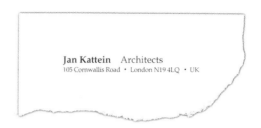

to some innovative precedents. I understand Philip Oakley's criticism in relation to the themes of Blackpool's lighting features. However it is better that he does not know at this stage that we share with the employees of the Illuminations Department an interest in the timeless value of craftsmanship and an old-fashioned attitude towards making. This has evidently been fortified over the many years in which the Illuminations Department has tried to perfect design and construction methods for their work to withstand the harsh wind and hostile weather on the coast of the Irish Sea.

The minutes of the meeting with Philip Oakley cover the following subjects: site/event, insurance, programme, budget and ownership. The key decisions that we make on the subject of site/event area: the *Luminaires* will be kept in the Illuminations Department for fermenting and will then later be wheeled to their site in Caroline Street. Philip Oakley offers to switch off the street lights near the site during the event. On the subject of insurance: Philip Oakley confirms that the *Luminaires* will be covered under the council's insurance and that a risk assessment will have to be submitted. We will have to be careful how this is worded as the insurers may refuse cover if the risk of explosion is mentioned in the documentation.

1.108 Detail of letterhead

Jan Kattein Architect
105 Cornwallis Road • London N19 4LQ • UK

Blackpool Illuminations
attn. Samara Stott
PO Box 117
Westgate House
Squires Gate Lane
Blackpool FY4 2TS

file copy

19th August 2005

Purchase Order Number: ILL 002134

I N V O I C E

For materials and transport expenses in relation to Zero Emission Luminaires installation for Blackpool
Festival of Light 2005 in the period between 1st August and 19th August 2005.

total: £1500

invoice number: 050
Please send payment within 5 working days from receipt of this invoice.
UTR: 82122 65908

+44 (0)20 7272 3241 • j.kattein@ucl.ac.uk

1.109 Invoice sent to Blackpool Council.
The architect, who had been trying to hide
behind the pseudonym General Designs to
avoid the liability and responsibility allied to
his profession, had to act as a double agent in
order to get paid

1.110 Fermentation vessel stirrer

1.111 Lantern height lock

1.112 Lamp detail

1.113 Fermentation vessel clamp

The progress photographs were carefully composed to show details of the unfinished *Luminaires* and to conceal overall progress. They were issued to the client to show that work had commenced, so that payment could be released

Under programme, we confirm that the event dates are to coincide with Energy Savings Week. On the subject of ownership, the minutes state that the ownership of the *Luminaires* will remain with Jan Kattein after the event.

TUESDAY 30 AUGUST 2005

The first *Luminaire* is now complete. A specially made air-inlet valve, constructed from a car tire valve soldered to a screw-on tank cap, is attached to the fermentation vessels. The valve is then connected to a compressor with pressure gauge. The impermeability of the system is tested by pumping 1.5 bars of air into the fermentation vessel and recording the drop in pressure over time. During the first pressure test the pressure escapes within minutes. A mixture of water and detergent is brush-applied to all joints and junctions. Leaks are identified in the positions where the mixture produces bubbles. Leaks are found in the following locations:

1. brazed joints where the fermentation vessels have been re-closed after gutting them;

2. seals on manure infill and outlet openings.

The failed solder joints are re-sealed by improving the solder technique. The seals of the infill and outlet openings are much harder to repair. The glass lids which have been used for the openings have, in their previous lives, served to withstand a vacuum and are designed accordingly. On the *Luminaires* they are exposed to positive pressure from the inside of the fermentation vessels. A re-design is required to counteract the positive pressure.

Veronika Niederhauser, one of the volunteers, is entrusted with the design and manufacture of a bracket. Made from three flat sections of steel, the bracket is fitted with an adjustable cast-steel machine foot with a wing nut welded to the top of its shaft. The base of the machine foot is lined with a self-adhesive felt pad, normally used on the underside of furniture legs, to spread the pressure evenly over the surface of the glass lid. The bracket itself is attached to the side of the inlet and outlet with brass rings that are soldered straight onto the copper. When tightened, the machine foot exerts pressure on the glass lid which pushes the rubber seal against the rim of the copper opening.

A new pressure test finds that the ability of the vessels to retain pressure has markedly improved, but some pressurised air is still escaping. As a further remedial measure, a 10×2.5mm copper strip, normally used as a lightening conductor, is cut up, rolled and soldered to the inside of the copper opening. The edge of the opening is then filed, sanded and polished carefully to form a bull-nosed edge. A third pressure test is carried out and the result accepted as satisfactory. Veronika Niederhauser also asks her parents to send new rubber seals from preserving jars from Switzerland. Swiss rubber seals are of better quality than their English equivalents.

WEDNESDAY 7 SEPTEMBER 2005

Luminaire no. 2 is set to ferment outside the Bartlett Workshop. I am able to obtain several crates of rotten fruit including pears, mangoes and peaches from the Seven Sisters Road street market. I wear old clothes because I anticipate that rotten produce might cause staining. The market-stall

owners think that I want to use the fruit for my own consumption and give it to me free of charge.

One of the fermentation vessels is packed to the top with organic matter and filled up with water. Fermentation is a bacterial digestion process which occurs in organic matter when no oxygen is present. When oxygen is present, composting occurs. Rates of fermentation are mainly dependent on the following three factors:

1. composition of feed stock;

2. pH-value;

3. temperature.

When fermentation occurs, carbon dioxide and methane gas form. Methane is an odourless gas that is used as fuel for cookers and gas lights in some rural areas in China, Africa and India.

To avoid composting the mixture, as much air as possible has to be excluded. The process of composting produces no methane and the carbon dioxide that is generated can lower the pH-value of the mixture inhibiting the growth of the bacteria which causes fermentation.

Blackpool is known for its donkeys, who give tourists rides along the beaches during the summer season and who, in 2005, were granted employment rights by the local council. In a telephone conversation with Mr Oakley, it is decided that donkey dung be used as feed stock when the *Luminaires* are installed in Blackpool. Donkey dung is easily available from the local authority stables, located adjacent to the Illuminations Department, and Mr Oakley thinks

1.114 Sludge outlet before re-design

1.115 Inlet as finally built

AIR LOCK

that the use of donkey dung as feed stock will create greater media interest.

THURSDAY 8 SEPTEMBER 2005

Luminaire no. 2 is fermenting and is stirred daily with an integrated stirring system, that keeps the mixture inside from settling and hardening at the base of the fermentation vessel. The ideal consistency of feed stock to provide a good habitat for the bacteria is thick sludgy liquid. While *Luminaire* no. 2 is fermenting, we work on the gas storage system and the gas lamps of the other *Luminaires*.

We are unable to obtain five gas lanterns. Instead we use candle and electric lanterns and convert them into gas lanterns. The mechanism for the lanterns is copied from a camping-gas lamp. We also use gas filaments from camping-gas lamps. We know that the pressure in the gas pockets of the *Luminaires* will never be as high as the pressure in commercial

gas cylinders, so we amend the design to omit the pressure reduction nozzle inside commercial lamps. Stopcocks are used for gas valves. Rubber tubing connects the gas lamps with the copper distribution system of the *Luminaire*.

FRIDAY 9 SEPTEMBER 2005

The outside temperature has fallen since Wednesday and it is now raining. This will not help the fermentation process. Optimum results are obtained at about 35°C, but good results can also be obtained at much lower temperatures. Heat is emitted as a waste product during fermentation.

1.116 Inlet as drawn

The outlet and inlet valves were the only part of the *Luminaire* that were built as drawn, but the design had to be revised when it was found that they do not pass the pressure tests. The architect-activist has to step in to rectify the design fault by the architect-inventor. In architectural practice drawing and construction are usually strictly separate and the architect-inventor is financially liable for any faults that can be traced back to his or her drawings. As a result, innovation bears a risk and many contemporary architects prefer to limit their creativity to the efficient arrangement of approved and guaranteed systems

1.117 Loading the fermentation vessels

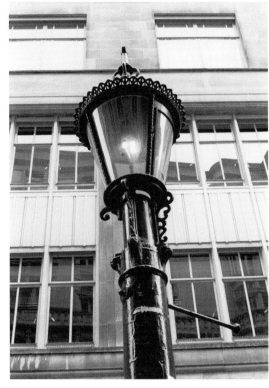

1.118 The London Sewer Lamp, located adjacent to the Savoy Hotel

1.119 The London Sewer Lamp

The London Sewer Lamp illuminates the street 24 hours per day. It is connected to the underground sewerage system where a funnel at the top of the sewer collects methane and conducts it up into the lamp. Sewer laps used to be a common sight in Victorian London. They do not use up any precious natural reserves and burn off the methane gas that contributes towards the greenhouse effect

The London Sewer Lamp, a methane-powered street-light that draws its fuel from the underground sewerage canal shows that effective methane production can take place in the London climate all year around. The lamppost of the sewer lamp is hollow and connects to the underground sewerage system where it joins a funnel shaped opening in the roof of the sewer. Methane collects in the funnel, rises through the lamp post and is burned off at the top. The lamp in Carting Lane, SW2 can easily be identified because it is London's only gas lamp that is lit 24 hours per day.

MONDAY 12 SEPTEMBER 2005

The proposed transport date to bring the *Luminaires* to Blackpool is set for 19 September. I write to Blackpool Council trying to delay the transport for another week to extend the test-fermentation period.

WEDNESDAY 14 SEPTEMBER 2005

Luminaire no. 2 has now been fermenting for a week. It has been placed in the sunniest spot in the Bartlett courtyard, and, for once, the afternoon sun is shining straight onto the fermentation vessel at around 4 pm. The copper glows beautifully in the light and some bubbles can be seen behind the transparent sludge outlet cover.

Gas production potential of various types of dung	
Type of dung	**Gas production per kg dung in m³**
Cattle (cows and buffaloes)	0.023–0.040
Pig	0.040–0.059
Poultry	0.065–0.116
Human	0.020–0.028
Source: *Updated Guidebook on Biogas Development*, 1984.	

Gas production has started. Once the fermentation has properly begun, the sludge can be used to start the feed stock in all the other *Luminaires* and will make fermentation much quicker. Also, heat is generated in the fermentation process, which, in turn, will accelerate further fermentation once started.

THURSDAY 15 SEPTEMBER 2005

Temperatures have dropped again and a drizzly autumn rain has set in. No further gas bubbles can be detected behind the sludge outlet cover. The mixture is carefully stirred nonetheless and we decide to install a domestic heating blanket to warm the sludge.

FRIDAY 16 SEPTEMBER 2005

The outside temperature is still below 12°C. The electric blanket is tightly wrapped around the fermentation vessel and fixed into place with Velcro strips. The blanket is designed to be installed under a mattress cover and can be set to a maximum of 37°C, the ideal temperature for fermentation to occur.

SUNDAY 18 SEPTEMBER 2005

The first lamp test is carried out. In spite of the heating blanket, the fermentation of *Luminaire no. 2*

1.120 Dung table showing the amount of methane gas produced by a variety of feed stocks

1.121 *Luminaire no. 1* fermenting outside the workshop

1.122 Cropped image of *Luminaire no. 2*. The image was sent to Blackpool Council, to arrive coinciding with the second invoice. This was to show progress and, to give the council confidence to release the funds. The overall photograph of *Luminaire no. 1* (Figure 1.121) was taken at the same time, but it was not issued to the client so that a high degree of anticipation would be maintained

has not produced any methane yet, and a butane–propane mix from a camping-gas bottle is used to test the lamps instead. Each *Luminaire* is fitted with a special gas inlet connector with a gas tap. I have also made an adaptor to connect the gas cylinder outlet to the *Luminaire*'s gas inlet valve. The taps to the fermentation vessels are closed as a precaution against explosion. After inflating the gas pockets, the inlet valve is closed and the gas bottle removed. The gas valve on the lamp is than opened and the gas filament lit. Due to the extremely low pressure of the stored gas, the flame is yellow and smoky. The gas, however, lasts much longer than anticipated. The flame goes out when the gas reserves have burned off. We decide that the lamp test is satisfactory for our purposes and that revisions to the lamp design can be made in a later version of the *Luminaire*.

MONDAY 19 SEPTEMBER 2005

A second invoice of £1,500 is sent to Blackpool Council. Unless any additional funding becomes available, this is the last charge that we can make.

TUESDAY 20 SEPTEMBER 2005

The temperature is still low, and there has only been one day of sunshine since the start of the test fermentation. With the fermentation vessel of *Luminaire no. 2* filled to the top it is immoveable and we will have to empty the vessel and interrupt the fermentation to move the *Luminaires* to Blackpool.

The media, the mayor of Blackpool and a number of local celebrities have already been invited to the lighting of the *Luminaires*. It will be embarrassing if we have to justify spending £3,000 of the council's money on a series of streetlights made from junk that do not work. After a whole week of heating the sludge no methane has been produced.

When looking from the functionalist's point of view, the question of whether the *Luminaires* 'work' or not has a simple answer. Though the functionalist's position enjoys a splendid amount of popularity, it is in fact no more objective than any other perspective. A project that has technically failed can still be viewed as a successful project.

The book *For Clever Scholars, Astronomers and Doctors* (Panamarenko 2001) reproduces the work of Belgian artist Henri Van Herwegen (born in Antwerp in 1940). The artist who operates under the pseudonym 'Panamarenko' has made technical failure the subject of his projects. The book was designed and published by the artist in 2001 and presents his work in five different ways:

1. mathematical calculations and formulas;

2. scientific diagrams;

1.123 Filling the *Luminaire* with camping gas

1.124 Testing the lantern

Camping gas is used to test the lantern. To prevent an explosion, the gas pockets are filled and then the gas bottle removed before the lantern is lit. The gas pressure is low, so the flame is yellow and smoky, blackening the glass of the lantern. This is not considered to be a problem and the lamp works well enough to impress its audience. The realisation of the essential idea takes precedent over technical perfection. For the *Luminaires* it is sufficient that they work in principle

3. technical sketches;

4. photographs of large-scale machines;

5. written narratives describing the manufacture, testing and scientific context of each piece.

1.125 *Luminaire no. 1*: central section and
light

1.126 *Luminaire no. 2*: back-up fermentation
vessel and agitation crank

1.127 *Luminaire no. 2*: lamp and gas storage
detail

Each project makes use of a selection of the above media to communicate itself. Page 26 reproduces a photograph and a technical sketch of *Knikkerbeen*, an electrical walking apparatus. The photograph shows a man, probably the artist, from the back. He is seated on top of *Knikkerbeen* looking at a group of trees on the horizon. There is a pasture in the foreground. The text that accompanies the sketch and photograph reports on the testing of *Knikkerbeen* on a pasture in Flanders. The result was an injured guinea-pig and a flattened 'bronze worm gear'. The report concludes: 'So I stopped the tests to think about

it a little longer elsewhere' (Panamarenko 2001). When reading about Panamarenko's other projects, one realises that what, at first, appears to be an accidental technical shortcoming leading to the break-down of a machine, repeats itself with each completed project. The report on the construction of *Bing of the Ferro Lusto* (1997), a mechanically powered flying saucer, says of the engine design: 'I made a couple but could not make them rotate (silly enough). It could be that they will not work'. Similarly, the report on the *Hazerug* (1997), a 'one-person flyer', concludes:

Although it was not as dangerous as a rocket belt, it sure sounded alarming. There was not a force on Earth that could put the *Hazerug* on my shoulders, even for a brief test, no way! (Panamarenko 2001)

In his introduction to *For Clever Scholars, Astronomers and Doctors*, Jon Thompson explains:

In designing, making and testing his machines, he performs his irony rather than uttering it. If his venture happens ultimately to be futile, as with the imitation of the wing action of the hymenoptera, he is concerned to demonstrate its futility. And as a witness we are expected to accept the attempt in good faith. (Thompson in Panamarenko 2001)

For Panamarenko, technical failure is part of the success of a piece of work, part of the narrative. But how can one establish failure or success of a machine if not by assessing its ability to efficiently and reliably execute the task that it has been designed for?

Thompson writes:

The irony is dressed up in a comedy of consequences which snaps immediately into place as soon as you begin to imagine yourself using one of these machines, zooming up and down, strapped to an elastic-driven gyro, for instance or being propelled through the waves on a cold, wet, solitary journey across the North Sea. (Thompson in Panamarenko 2001)

Thompson's analysis illustrates how to judge the success of Panamarenko's work: it is successful when it is able to engage its audience. The audience will then accept the idea behind the work 'in good faith' in spite of the technical flaws of the prototype. In fact, technical failure makes Panamarenko's dangerous machines snug and vulnerable and thus more believable. In Panamarenko's work, the audience plays an active role, their power of imagination is as important as his storyteller's sense of humour. Their creative thinking as important as his storyteller's skill. This is also true for the *Luminaires*. When proposing a *Luminaire* powered by chewing gum, the prime objective was to engage the audience and not to deliver a technically feasible contraption.

Though his work engages with science and technology, Panamarenko chooses to exhibit it in art galleries and not in science museums. The reasons for this are obvious. As science, Panamarenko's work does not have any monetary value whereas as art it can be sold. Aside from the financial benefit, exhibiting in an art gallery rather than a science museum is less controversial because it is more acceptable to be producing good art than bad science.

The *Luminaires* are being exhibited in the council's Illuminations Department amongst thousands of large-scale lighting installations, where any potential technical flaw has been eliminated by decades of relentless improvement by an army of lighting professionals. Where Panamarenko has frugally aligned himself with the art world, the *Luminaires* will be shown in the context of technology, a context that traditionally seeks a functional response and not a fictional one.

Blackpool Council has given General Design the commission for the *Luminaires* and has paid Jan Kattein Architects' invoices. As a member of General Design, I would be classified as a designer. As a member of Jan Kattein Architects, I would be classified as an architect. It is unlikely that I would be classified as an artist.

The Architects' Code published by the Architects Registration Board in November 2002 sets out 12 standards that define how architects should practice in the UK. Breach of any of the standards can result in disciplinary procedures and suspension from registration. Standard 2 states that: 'Architects should only undertake professional work for which they are able to provide adequate professional, financial and technical competence and resources' (Architects Registration Board 2002). Consequently, it would be illegal for an architect to produce a piece of work that is unfit for purpose. The success of the work of the architect is judged by its ability to fulfil its technical brief: clearly, the *Luminaires* do not.

There is no code to define the work of the designer. Traditionally, however, the role of the designer has been to provide a technical solution to a problem. A design that fails to fulfil its technical brief is flawed. In this context, artists are allowed to make technically inadequate machines, but designers would ruin their reputation if they did so and architects could be prosecuted for technical inadequacy. I decide to write to the client to explain that I am unsure if the *Luminaires* will generate any methane. The issue is resolved when an email instructing us to 'cheat' is received from Blackpool Council. Our client is obviously not concerned about the technical flaws of the project. His concern is related to its performative qualities. The architect-inventor in the *Luminaires* project has failed but was bailed out by an 'artistic license', so long as the architect-activist now works hard to manipulate the gas supply so that the architect-arbitrator can successfully engage his audience.

WEDNESDAY 21 SEPTEMBER 2005

The test fermentation is halted and the vessel emptied of sludge. The sludge is disposed of in some shrubbery. It will be good fertiliser, and the owners of the plants may well be surprised by their accelerated growth over the next year. The switch on date is confirmed for 24 October in No. 01 shed in the Blackpool Council Illuminations Department.

MONDAY 26 SEPTEMBER 2005

With two weeks to go until the lighting ceremony, the funds run out and we have not even transported the *Luminaires* to Blackpool. Our budget has been spent on the site visit and accommodation for five people, drink and food for volunteers on workshop days and on used and new materials for the *Luminaires*. Most materials have been bought, but a few expenses still have to be paid in order to complete the project including travel to Blackpool and accommodation for five people for the duration of the lighting ceremony plus about £150 for diesel for the van we have hired to carry the *Luminaires*.

Blackpool Council requires invoices for all payments to Jan Kattein Architects. Costs for materials and services are subtracted from those payments and the remainder of the sum is a profit on which tax is due at the end of the financial year. Many of our materials are sourced from scrap yards and car-boot sales. These places are often unable to provide receipts for purchases. Not having a receipt means that the outlay cannot be declared as a cost in Jan Kattein Architects' tax return. This made it expensive to purchase used materials. A new equivalent when purchased with a receipt is sometimes cheaper than a used item from a scrap yard.

Jan Kattein

From: <██████████@█████>
To: <j.kattein@ucl.ac.uk>
Sent: 20 September 2005 13:35
Subject: Re: Luminaires

Hi Jan
My advice would be that we "cheat" and have a gas supply to ensure say 2 or 3 work. If they will work in principle I have no qualms doing this. Artistic licence. We obviously don't tell anyone but we need to guarantee they work or it will be a media disaster!! I want to build an evening around the event so it's crucial that there is some light. The 24th is ideal as it's the start of energy saving week so it's when we can get most exposure.
As soon as you can confirm dates I will book rooms although the Hilton will be busy then as it's party conference time.
We can help move the lights. No problem.
I have asked for website to be amended.
Best wishes
Philip

Philip Oakley
Festival Director
Blackpool Illuminations
Rigby Road
Blackpool
FY1 5ES
Mobile: ██████████
Telephone: 01253 476 406
Fax: 01253 476 420
www.festivaloflight.co.uk

1.128 Email from Blackpool Council instructing us to 'cheat'. The registered architect in me was appalled, and I was glad to be operating as a 'General Designer'

To be on the safe side we subtract 22.5 per cent from our £3,000 budget for taxes. This leaves us with an effective budget of £2,325.

SUNDAY 3 OCTOBER 2005
The Swiss preserving jar seals finally arrive by post and are fitted. The rubber is more malleable than the previous seals. The next step is to test the gas transport and storage system that is connected to the fermentation vessels. The original design intended that non-return valves would be fitted to the gas outlets of the vessels. The final design uses water taps instead because the gas pressure in the system is expected to be too low to release the non-return valve. The gas system is again first tested with compressed air. The air inlet valve is attached to the fermentation vessel, the gas outlet taps opened and pressure admitted.

Expandable rubber pockets have been attached to a gas distribution pipe at high level in a row of ten. These rubber pockets are to store the methane and keep it under pressure to push it through the lamp into the filament. When air is admitted, only one of the rubber pockets inflates and then bursts when it has reached its maximum capacity. We had expected that the ten rubber pockets would expand together and thus share the pressure. Further design improvements are required.

To avoid over inflation, we decide to cage the gas storage pockets. A system using nylon nets is tested. The nets are installed over the rubber pockets and tied with string to the copper tubing. The tests give positive results: one pocket after the other inflates to the size of the net. For five *Luminaires* with ten storage pockets each,

50 nets are required. Due to time constraints and a meagre response to a call for net donations, 42 packets of onions are purchased from a supermarket for 79p each. Each net contains three large onions. A total of 126 large onions are purchased for the price of £33.18.

SATURDAY 8 OCTOBER 2005
I have made onion pie with some of the onions that are left over from the purchase of the onion nets. This provides a packed lunch for all volunteers on today's journey to Blackpool. There are still enough onions for another 18 onion pies. The extra expense to obtain the onion bags could, in the end, result in a saving on food expenses because onion pie provides a cheap lunch for the volunteers.

SUNDAY 9 OCTOBER 2005
To discuss the financial situation a meeting is held between Philip Oakley, Veronika Niederhauser, Chrysanthe Staikopoulou and Jan Kattein. The minutes from the meeting state: 'PO said that he would cover the cost of accommodation for three people on Monday night [the night of the lighting ceremony]' and later on: 'PO confirmed that JK can send invoice of £500 to cover transport expenses.' With this extra funding we feel that all expenses have probably been covered, however, a final budget is not made.

The project description states that 'the *Luminaires* are constructed entirely from recycled materials'. This is not the reality of the final products. New and used materials were sourced from skips, scrap yards, plumbing merchants, builder's merchants, specialist suppliers, car-boot sales and charity shops.

Zwiebelkuchen vom Blech
Für Gäste (etwa 20 Stück)

Zubereitungszeit: etwa 70 Minuten,
ohne Gehzeit
Backzeit: etwa 35 Minuten

Für die Fettfangschale (40 x 30 cm)
oder das Backblech mit hohem Rand
(etwa 2 cm):
etwas Fett

Für den Hefeteig:
250 ml (¹/₄ l) Milch
400 g Weizenmehl
1 Pck. Trockenbackhefe
1 TL Zucker
1 gestr. TL Salz
6 EL Speiseöl

Für den Belag:
1 ¹/₂ kg Gemüsezwiebeln
300 g durchwachsener
Speck
4 EL Speiseöl
etwas Salz
frisch gemahlener Pfeffer
1 gestr. TL gemahlener
Kümmel
200 g mittelalter
Gouda-Käse
4 Eier (Größe M)
1 Becher (150 g) Crème
fraîche

Pro Stück:
E: 8 g, F: 24 g, Kh: 19 g,
kJ: 1349, kcal: 323

1 Für den Teig Milch in einem kleinen Topf erwärmen. Mehl in eine Rührschüssel sieben und mit Trockenbackhefe sorgfältig vermischen. Übrige Zutaten für den Teig und die warme Milch hinzufügen und alles mit einem Handrührgerät (Knethaken) kurz auf niedrigster, dann auf höchster Stufe in etwa 5 Minuten zu einem glatten Teig verarbeiten. Den Teig zugedeckt so lange an einem warmen Ort gehen lassen, bis er sich sichtbar vergrößert hat.

2 Für den Belag Gemüsezwiebeln abziehen, vierteln und in dünne Scheiben schneiden. Speck fein würfeln. Speiseöl in einem großen Topf erhitzen, die Zwiebelscheiben hinzufügen, unter Rühren dünsten, die Speckwürfel hinzufügen und kurz mitdünsten, dann mit Salz, Pfeffer und Kümmel würzen. Die Zwiebelmasse etwas abkühlen lassen.

3 Fetten Sie die Fettfangschale oder das Backblech. Gouda reiben und mit Eiern und Crème fraîche unter die Zwiebelmasse rühren.

4 Heizen Sie den Backofen vor. Den Teig leicht mit Mehl bestäuben, aus der Schüssel nehmen und auf der leicht bemehlten Arbeitsfläche nochmals kurz durchkneten. Den Teig in der vorbereiteten Fettfangschale oder auf dem vorbereiteten Backblech ausrollen und an den Rändern etwas hochdrücken. Die Zwiebelmasse auf dem Teig verteilen und den Teig nochmals so lange an einem warmen Ort gehen lassen, bis er sich sichtbar vergrößert hat. Die Fettfangschale oder das Backblech in den Backofen schieben.

Ober-/Unterhitze: etwa 200 °C (vorgeheizt), Heißluft: etwa 180 °C (vorgeheizt), Gas: Stufe 3–4 (vorgeheizt), Backzeit: etwa 35 Minuten.

5 Den Zwiebelkuchen warm oder kalt servieren.

Tipp: Der Zwiebelkuchen lässt sich gut am Vortag vorbereiten. Dafür den Hefeteig mit kalten Zutaten zubereiten, Teig dünn mit Öl bestreichen, damit er nicht austrocknet und in der Schüssel mit Frischhaltefolie zugedeckt im Kühlschrank über Nacht gehen lassen. Am nächsten Tag wie unter Punkt 2 beschrieben weiterverarbeiten.
Sie können den Zwiebelkuchen vor dem Backen mit Kümmelsamen bestreuen.

1.129 Onion pie recipe from Dr Oetker's *Backen Macht Freude* [*German Baking Today*]

Thirty-nine triple packs (a total of 117 onions) were purchased to obtain the onion nets needed for the *Luminaires*. Dr Oetker states that his onion pie can be served warm or cold. This allowed us to make large quantities that could either be re-heated before serving or eaten cold if no heating facilities were available. Faced with a challenging financial situation, the architect-activist had to step in to provide the team with provisions

The structure of the *Luminaires* is made from scrap steel bars and tubing which was available in the Bartlett workshop and from various local skips. Joints are welded and bolted.

The brackets which connect the structure with the fermentation vessels are made from laminated hardwood. Discarded table legs were cut into strips and laminated together to form 40mm thick boards. Waterproof PVA glue was used to avoid de-laminating in damp conditions. The width of the strips and the colour combination was governed entirely by aesthetic decisions.

All the *Luminaires* are fitted with wheels so that they can be moved easily. All wheels used were locally sourced. *Luminaire no. 4* was fitted with the wheels from a postal trolley that the architect-activist recovered from the street in Kentish Town in London. Copper tubing with brass connectors and brass valves was used for the gas connections. The brass connectors are soldered to the fermentation vessels and all copper pipe connections are soldered for gas tightness.

Rubber and latex tubing was used for the flexible connections between the lantern and the valve. The gas storage pockets were chosen for their functional qualities, for their availability and for their charming aesthetic appeal. They are tied to specially made copper connection pieces with embroidery string to avoid gas leakage.

Finishes chosen are maintenance intense, but readily and cheaply available anywhere in the UK. Even though urban designers do not normally resolve their designs to this degree of detail, the choice of finishes is essential for the urban

All members of General Design were encouraged to obtain materials and a petty-cash kitty was available to everybody: this was to diversify the range of materials that were used.

The fermentation vessels were sourced from three different scrap yards in East London. The vessels were chosen for several reasons: they were easy to cut and solder with basic plumbing tools, gas tight and made from copper which does not corrode when exposed to acids. I was also aware of the aesthetic appeal of the shiny surface and how it would appear in photographs of the project. The vessels cost between £18 and £30 depending on their weight.

1.130 Supermarket receipt for onions

1.131 Onion nets installed on *Luminaire*

Zero Emission Luminaires
~~Petty Cash List~~ Expenses
General Designs
15th July 2005

Date	Name	Amount		
15.07	~~Dinner~~	~~200.00~~		
10.08	Jar/Copper vessel	24.00		
10.08	2 Travelcards	10.40		
11.08	Car Hire + Petrol	42.00 + 5.10		
11.08	Congestion charge	8.00		
11.08	Copper Vessels	80.00 + No Pt CETTY		
11.08	Copper Vessels	~~180.000~~		
11.08	Parking	4.30	/354.20 —	
13.08	Lunch for all	15.00		
14.08	Gas lamp	9.00	/20.00 —	
14.08	Brillo	0.50		
16.08	Lunch	8.00		
17.08	Gas Lamp	4.99		
17.08	Taps	9.80		
17.08	Taps	2.98	/26.00 —	
19.08	Gas Lamp	22.48		
19.08	Clamps	10.00		
19.08	Clamps	8.00		
20.08	Plumbing	33.66		
18.08	plumbing	41.10		
19.08	Leyland	1.20	/123.24	//523.44
23.08	London Plumbing	8.91		
19.08	Elson	24.00		
25.08	Thomas BKS	7.33	A1.74	/565.18
18.08	Leyland	1.50		
23.08	Train Tickets	5.75		
23.08	Snacks	5.78		
23.08	Falcons	2.49		
13.08	Leyland	12.51		
	Plumbing	10.53		
	Gates RCA	10.00	/42.81	//607.99
total:				

Train Tickets 121.50
Flights 57.00
Hotel. 26.00 × 4 = 104

Total 282.50

1.132 List of expenses for *Zero Emission Luminaires*. Recording expenses was discontinued on 23 August. To maintain the reputation of the General Designer, the project now had to progress irrespective of budgetary constraints

1.133 Promotional postcard image for *Zero Emission Luminaires*

1.134 *Luminaire no. 5* on site in Caroline Street. The end-user was engaged as soon as the architecture was installed on site as was the press. Figure 1.134 was edited to show the *Luminaire* illuminated. Even though the *Luminaire* was not lit when the photograph was taken, the fact that the lamp had been shown to work during the lamp test justifies the editing of the photograph

significance of the project. Most contemporary urban infra-structure is designed by its contractors to be maintenance-free and vandal-resistant. The *Luminaires* invite the local community to positively contribute towards their surroundings by requiring maintenance and calling for protection. The timber pieces are coated with two coats of Rustin's Yacht Varnish to protect them from de-laminating in moist conditions. All steel parts and copper tanks are coated with two coats of boiled linseed oil to prevent corrosion and to maintain shiny surface qualities. Rubber parts were carefully protected during finishing to prevent the linseed oil accelerating their decomposition.

MONDAY 10 OCTOBER 2005

A test installation on site is made at 2 pm in front of house number 29. We want to rehearse the event in Caroline Street planned for 23 October and to gauge the residents' reaction. We also want to produce photographs to use for publicity.

It does not take long for residents to appear in doors and windows when *Luminaire no. 4* is installed on site. At first children, who have been playing in the neighbourhood, gather and I take a photograph of a girl on a bicycle. Another photograph of a little boy standing just inside the door of his house is taken. These are exactly the pictures I had hoped for to show the adoption of the *Luminaires* by local residents.

Eventually, adults come onto the pavement. We explain that the *Luminaires* are a new type of street light powered by fermenting donkey dung. Residents are curious as to why we have chosen their street to install the *Luminaires*. We explain that we had looked for a suitable site in all of Blackpool and had selected Caroline Street especially because of the intimate relationship between their houses and the street. We also explain that there are, in total, five *Luminaires* which will be installed and lit in their street in two weeks time when fermentation is completed. In the end about 20 residents of all ages gather around *Luminaire no. 4* to have their photographs taken and to use the opportunity to catch-up on some gossip with their neighbours.

TUESDAY 17 OCTOBER 2005

Zero Emissions Luminaires features on the BBC News website accompanied by a photograph of a Blackpool donkey.

WEDNESDAY 18 OCTOBER 2005

Today, an article with the title 'The Blackpoo Illuminations' appears in *The Daily Mirror* claiming that donkey dung could power next year's Illuminations – a claim that is not substantiated by the project description nor Blackpool Council's press release.

FRIDAY 20 OCTOBER 2005

Zero Emission Luminaires is mentioned in *The Guardian* press review of an article originally published in the *Liverpool Daily Post* on 18 October 2005. The Guardian article is a 'comedy of consequences' that imagines the *Luminaires* lined up along all Blackpool pavement edges casting their diffuse yellowish puddle of light onto the entire Blackpool donkey population who devour vast amounts of unripe plums as their keepers shovel the steaming mess into the fermentation vessels!

SATURDAY 21 OCTOBER 2005

We are driving to Blackpool to light the *Luminaires*, first in Caroline Street, and then, on the next day, in the Illuminations Department. Apart from Veronika Niederhauser, none of the volunteers that had originally been involved in the construction of the *Luminaires* are coming to Blackpool for the lighting ceremony. One by one they had stopped attending the workshop sessions. One of them had to go on holiday, two of the other volunteers have started paid jobs and one of them is not available for personal reasons. Instead, our friends Christiane Tombrink and Heini Phillip have agreed to help light the *Luminaires*. Travelling with us is a generous slice of onion pie.

SUNDAY 23 OCTOBER 2005

Preparations for the lighting of all *Luminaires* on Caroline Street start at 8 am in the council's Illuminations Department. We have decided that the event should take place at dusk. This ensures that it will be dark enough to see the gaslights and bright enough to see the entire construction of the *Luminaires*. At 4.45 pm the *Luminaires* are assembled and are rolled out of the gates of the Illuminations Department towards Caroline Street. When we arrive in Caroline Street at 5 pm, none of the streetlights have been turned off as previously agreed, no press has been invited and no help from the Illuminations Department is present. The setting up of the *Luminaires* in front of the houses goes smoothly.

Zero Emission Luminaire

Proposal for the 125th birthday celebration of the electric lightbulb in Blackpool, September to November 2005.

General Designs
London, 10th October 2005

Introduction

125 years ago Edison invented the 1st commercially viable version of the electric light bulb. Since then scientists have not ceased trying to perfect Edison's invention. In the 1st decades after the birth of the light bulb efforts mainly went into extending it's lifespan. The tungsten filament which is still in use today replaced various other inferior filament types and vacuum pumps used in the manufacture of the light bulb were improved to delay the burning of the filament. Today a tungsten light bulb has a lifespan of approximately 1000 hours and costs in average 50 pence.

Only in recent years efficiency has become a major concern to scientists. From the energy which is transformed inside a tungsten light bulb, only 10% are transformed into light, the remainder is transformed into heat. Inspite of the wide availability of compact fluorescents, the widespread use of discharge lamps in street lighting and the invention of new types of LEDs, the domestic energy use in the UK is steadily increasing: Between 1990 and 2000 electricity use for lighting and appliances in British households has gone up from 40 to 48 million tons of oil equivalent per year.

These figures show that the key to reducing energy consumption in the UK may not be the introduction of evermore efficient appliances. To make significant progress in reducing energy consumption, consumer behaviour needs to change.

The Project

To reverse this worrying trend in face of ever greater pressure to address environmental issues, the project proposes a new type of Zero Emission Streetlight. Individual units are displaceable, repairable and upgradeable and constructed entirely from recycled and reused materials. Their fuel is entirely derived from zero emission sources. All Luminaires are 4m high and can hence be constructed under the permitted development order.

I am currently undertaking PhD by design research on large scale sustainable urban development. The research is consistently added to a website for a virtual city called New Mayfair. The growth of the city is entirely based on user intervention and public empowerment. This will accommodate growth and development according to its inhabitants needs.

The Zero Emission Luminaire is part of the infra structure for the city. Plans, assembly instructions and photographs of prototypes will be downloadable and printable on a standard domestic A4 printer when New Mayfair is launched in the winter of 2005. This information can then serve as a blueprint for the construction of locale specific versions of the light.

Building on Blackpool's tradition of boldly displaying the latest inventions in lighting, there are five prototypes specifically designed for the Blackpool Festival of Light:

Each Luminaire has at its base 2 No. copper fermentation vessels. Once one of the vessels has been loaded with kitchen waste and donkey manure, it is sealed airtight. The valve at the top of the vessel is opened and the luminaire is positioned in a sunny spot. Once fermentation starts, methane gas and co2 form. The gas leaves the vessel through the valve and inflates a series of expandable rubber bags. When enough pressure has build up, the Luminaire is wheeled back into its resident position, the gas

valve on the lamp can be opened and the filament lit. The second fermentation vessel can now be loaded, sealed and set to ferment.

Aim

The aim of the project is to introduce a new urban infra-structure which encourages public involvement in its upkeep, maintenance, care and construction: If the fermentation vessel of the Luminaire is not fed regularly with kitchen waste, there is no light in the street at night.

The Luminaires are constructed entirely from reused and recycled materials. It thus sets a radical precedent for the re-use and recycling of waste on a local level.

Because of convenience and ease of use (many electrical appliances do not even have a power switch any more nowadays and are always on standby), today's society has forgotten how precious energy is. The very visible means by which energy is generated in the Zero Emission Luminaires will raise awareness of its preciousness and encourage its conservation.

1.135 Original project description issued to
the press

Donkey dung energy powers lights

The organisers of the famous Blackpool illuminations are using donkey dung to power some specially created lights.

A London-based designer has made several contraptions powered by the waste produced by the resort's donkeys.

The special lights have been put together to mark the start of Energy Saving Week next Monday, to show how alternative forms of power can be used.

Festival director Philip Oakley does not think there are enough Blackpool donkeys to power all the illuminations.

"We are trying to stimulate ideas as to how we can possibly power up the illuminations and other lighting in future years," he said.

The lights are not on public display, but he said they might be used on some local streets for a few days.

Mr Oakley said the dung was loaded into specially-made machines, with the methane gas created being burnt off in lanterns.

Story from BBC NEWS:
http://news.bbc.co.uk/go/pr/fr/-/1/hi/england/lancashire/4348842.stm

Published: 2005/10/17 13:04:44 GMT

© BBC 2014

Blackpool illuminations to harness the power of donkey dung

Oct 18 2005
Daily Post *Liverpool Post*

DONKEY dung could be used to power lights in next year's Blackpool illuminations if a new experiment proves successful.

A London-based design team has developed five prototype machines able to use waste from the resort's donkeys to power lamps.

Together with organisers of Blackpool's Festival of Light, General Designs came up with the idea to mark the start of national Energy Saving Week next Monday.

Although the festival organisers do not believe there are enough donkeys in the town to power all the illuminations, they hope the experiment will "get the ball rolling" in their search for alternative sources of energy.

Festival director Philip Oakley said: "We have one of the biggest light shows in the world and we are trying to come up with some new ideas to see how we might be able to power the illuminations. "At first the designers were going

to power the machines with kitchen waste, but seeing as we have the donkeys on our doorstep we decided it would make more sense to use their waste as well."

He said the Zero Emission Luminaires worked by being loaded with donkey dung and placed in sunlight.

The manure fermented, produced methane and carbon dioxide, and the gas was then burnt off to power lanterns.

The machines can also use household waste.

1.136 Online article from *BBC News*

1.137 Article from the *Liverpool Daily Post*
dated 18 October 2005

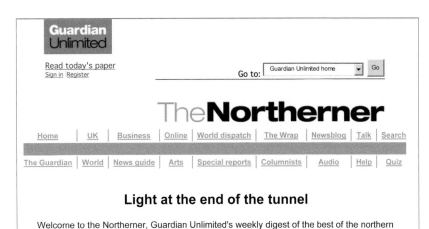

Light at the end of the tunnel

Welcome to the Northerner, Guardian Unlimited's weekly digest of the best of the northern press

David Ward
Thursday October 20, 2005

Talking of Blackpool, the Liverpool Daily Post reports that the town's bright lights could be powered by donkey dung. Or at least partly powered because, unless stuffed with prunes, it seems the resort's donkey herd may not be able to defecate with the volume, frequency and enthusiasm required to light up every bulb during the annual illuminations.

The Daily Post explains that a London-based design team has developed five prototype machines able to use waste from the resort's donkeys to power lamps. They hope the experiment will be a start in their search for alternative sources of energy.

At first the designers were going to power the machines with kitchen waste but then decided to make use of the donkey ride byproduct available on the beach.

The Daily Post goes on to provide a brief explanation of how the prototypes, but not a donkey's innards, work. It seems that the manure ferments, produces methane and carbon dioxide, and the gas is then burnt off to power lanterns. Do not try this at home.

18 October 2005

THE BLACKPOO ILLUMINATIONS

Donkey dung could power next year's Blackpool illuminations if a new experiment proves successful.

A design team has developed five machines which are able to use waste from the resort's donkeys to power lamps.

Print article Email to a friend

1.138 *The Guardian* press review dated 20. Oct. 2005, quoting the *Liverpool Daily Post*

1.139 Online article from *The Daily Mirror* dated 18 October 2005

The story is an integral part of the project. It contextualises the *Luminaires* and stimulates the imagination of its audience. The literary value of the story increases every time it is re-told

We fill the gas pockets with camping gas on site and make preparations for lighting the *Luminaires*.

The entire event is a disaster: *Luminaire no. 2* bursts into flames. When lighting the *Luminaire*, one of the gas pockets catches fire and one by one the gas pockets start to burn off. We do not have a fire extinguisher and are only able to save the *Luminaire* by blowing out the flames. By the time the flames have been extinguished and the other *Luminaires* re-filled, it is too dark to take photographs.

It is fortunate that the press have not been invited. In spite of the disaster, the event is a success for the residents of Caroline Street. Many of them have seen the *Luminaires* on TV before and are amazed to see them again in their street.

MONDAY 24 OCTOBER 2005

Today is the first day of National Energy Savings Week and the official 'Switch On' ceremony for the *Luminaires*. Preparations start in the morning. We have to replace burned nets around the gas-storage pockets and repair various leaks that we noticed during the lighting ceremony in Caroline Street. The programme for the evening lists the following sequence of events:

1. refreshments on arrival and organ music by one of the Tower Ballroom organists;

2. brief introduction;

3. 5-minute silent movie by the Claremount Family Players on how the Illuminations started;

4. reading from some of the original reports in the *Blackpool Gazette* on the very first Blackpool Illuminations in 1879 by actor Moray Watson;

5. switching on the *Zero Emission Luminaires*;

6. performance by Voltini, who will demonstrate his ability to literally eat electricity (<www.voltini.com> is a must see).

At 6 pm the guests arrive. Donkeys are present during the evening. Deck chairs have been arranged in front of a stage inside one of the Illuminations Department's assembly sheds. Drinks are available, and the organ player from the famous Blackpool Tower Ballroom is playing on a portable organ. In the adjacent assembly shed, well out of sight of the guests, we fill the gas pockets of the *Luminaires* with camping gas. The mayor arrives in his limousine while actor Moray Watson is reading his section from the *Blackpool Gazette*. Then the large roller shutter gates of both sheds are open. The *Luminaires* are rolled out of one shed and the audience ushered out of the other to meet on the car park. A wireless microphone is handed to me and I explain how the *Luminaires* function. The camping gas is not mentioned. Then they are lit. Everything goes to plan and the audience applaud before their attention is focused back onto the stage where magician Voltini is eating light bulbs.

This concludes the *Luminaires* project. We will drive back to *London tomorrow.*

The Zero Emissions Luminaires project continues some of the working methods established in previous projects. But, even though these methods can by now be described as tried and tested, they did not prove successful on this occasion. Great effort went into engaging the volunteers by taking them along to client meetings, giving them design responsibility, allowing them to take credit for their work on the *Luminaires* and introducing them to the seasonal delights of German cuisine. But three of them stopped attending after only a couple of weeks. The collaboration with Veronika Niederhauser, a registered architect in Switzerland, was very successful. She took on responsibilities and managed to combine a full-time job with voluntary work on the *Luminaires.* The success of the collaboration was, however, not due to the fact that she is a registered architect. The other projects in *The Architecture Chronicle* show that collaborations can be successful even with non-architects. The part-failure/part-success of the collaboration is probably due to the failure of the architect-arbitrator to fine tune each participant's degree of engagement. Whereas Veronika Niederhauser was perfectly engaged, the other volunteers were overwhelmed by the amount of responsibility that being involved in every part of the project brought. To compensate, the architect-activist had to work much harder to meet the immovable deadline.

Being an architect has given me an advantage in my negotiations with theatres in other

projects. The reason for this may have been the novelty factor of an architect designing for the theatre. More likely, however, is that the reputation of accuracy, knowledge of construction and professionalism ascribed to my profession gave me authority. Stage designers in the theatre, I noted, have a reputation for metanoia (the tendency to change one's mind on regular occasions) and inconsistency. In the *Zero Emissions Luminaires* project the architect existed in denial, hiding behind the veil of General Designer to avoid falling foul of the Architect's Code.

1.140 *Luminaire no. 5* on site in Caroline Street. This picture was originally not published by the council for child protection reasons. Instead the council published the picture with the girl on the bicycle (Figure 1.133), because her face is concealed. This book is published almost a decade after the photograph was taken, hence child protection is no longer an issue

The press clippings and the enjoyment of the Caroline Street residents reveal the real success of the project. The architect-arbitrator had been successful in engaging the audience. The *Luminaires* acted as a catalyst, inspiring those who saw them (or read about them) to speculate beyond the *Luminaire* and to engage in what Thompson calls 'a comedy of consequences'. In their technical inadequacy, the *Luminaires* resemble Panamarenko's projects. In their ability to critically engage their audience, they go further. The site for Panamarenko's work is the art gallery, and consequentially his audience is the art gallery visitor. The site for the *Luminaires* is the city and their audience are primarily the residents of Caroline Street, but the press coverage the project received reached a wider audience. Panamarenko's work is easily classified as art, but, the *Luminaires* avoid classification, making them accessible to a much wider audience. Panamarenko's work has its home in the sterile environment of a the generic, white art gallery, the *Luminaires* are sited amidst the vitality of a city street with an audience of locals who were an essential part of the project. The project consisted of three parts, the narrative, the structure and the performance. This makes it essentially a form of urban theatre realised by a balanced collaboration between the architect-arbitrator, architect-inventor and architect-activist who all contributed in equal parts, levelling out each other's deficiencies.

1.141 *Luminaire no. 1* at Woburn Square Studios. To investigate the urban implications of the project, we had to manufacture several *Luminaires* to install along the entire length of Caroline Street. If there had been only one it would have been all too easy to categorise it as a piece of art. When the *Luminaires* were later exhibited, they were shown in the context of the whole project alongside a video showing their operation, large scale photographs, press clippings, drawings and text

1.142 *Luminaire no. 2* at Woburn Square
Studios. The *Luminaires* were all slightly
different. This was for a number of reasons:
(1.) the availability of materials, (2.) aesthetic
considerations, (3.) the fact that we were
designing while making and learning as we
went along

1.143 *Luminaire no. 3* at Woburn Square
Studios

1.144 *Luminaire no. 4* at Woburn Square
 Studios

1.145 *Luminaire no. 5* at Woburn Square
 Studios

OPERNREIGEN

The press release from Opernhaus Graz GmbH, dated 16 January 2007, describes the aim of *Opernreigen* (Opera Round-Dance) as follows:

> Central to the project is the productive exchange between theoretical and practical work, between young and experienced artists, between teachers and students and between the two institutions Oper Graz and Universität für Musik und Darstellende Künste Graz [Graz University of Music and Performing Arts].

The product of the collaboration was *Opernreigen*. *Opernreigen* was the overall title given to a number of individual compositions written by students from the Universität für Musik und Darstellende Künste Graz. Opernhaus Graz, at the instigation of its director, Dipl. Ing. Jörg Kossdorf, who had committed to fund the staging of *Opernreigen* in the Next Liberty Jugendtheater (Next Liberty Youth Theatre), a small theatre located behind their main stage. Anna Malunat had been asked to direct the production, I had been asked to design the stage and Magdolna Parditka had been asked to design the costumes. As winners of the Ring Award 2005, part of the prize was the commission of the staging of a production 'on one of the stages of Opernhaus Graz GmbH'.

It is interesting to observe that even though the overall title for the four compositions is *Opernreigen* which contains the word *oper* (opera), the composers refer to their compositions as either *Instrumentarium im Raum* (instrumental in space) or *Szenische Installation und vokale Artikulationsform* (scenic installation and vocal articulation form). The word 'opera' does not appear in any of their project descriptions.

The participating composers and the number of compositions to be included in *Opernreigen* kept fluctuating until the project was well advanced. The *Opernreigen* that finally appeared on stage was made up of four different compositions in the following sequence: 'Schatten' (Shadow) by Hannah Eimermacher, 'Myo-e' by Yasuko Ueda, 'Kugelstein' (Stonesphere: near Graz) by Elisabeth Harnik and Olga Flor, and 'Forugh' by Siavosh Banihashemi. The libretti are unrelated. 'Schatten' does not have any spoken or sung words, only vocal sounds, 'Myo-e' is the tale of a Buddhist monk from the 15th century and is written in Japanese, 'Kugelstein' is written in German and tells the story of a car accident on a motorway near the Austrian mountain Kugelstein, and 'Forugh' is written in Persian and recites 'the lyric of the Persian poet Forugh Farrochsad' (Banihashemi 2007).

Our contract with Opernhaus Graz states that it is our job to turn the four compositions into an 'evening-filling performance'.

SUNDAY 8 JUNE 2006

For the past few weeks, Anna Malunat has been negotiating our contracts with Herr Müller from Opernhaus Graz. My involvement begins when I first travel to Graz. I arrive on the 11:10 am flight from Stansted. The purpose of my visit is initially to complete the contract negotiations and sign the contract and thereafter to attend a meeting with six composition students from the university whose compositions have been selected by their tutors for inclusion in *Opernreigen*. Two rooms have been reserved for Anna Malunat and myself in the four-star Romantik Park Hotel near Opernhaus Graz.

During breakfast Anna Malunat recounts the negotiations that she has had with Opernhaus Graz over the past weeks. She has been able to negotiate a salary increase of approximately 33 per cent and a budget increase for stage-set and costumes by 20 per cent. She explains that the reason for Opernhaus Graz accommodating us in the opulent Romantic Park Hotel is their desire to complete the contract negotiations. I believe that employing us to stage *Opernreigen* does not so much indicate an artistic interest in our work by Opernhaus Graz so much as it allows them to discharge their pledge to commission the Ring Award winners and provides their collaboration project with the university with an experienced directing team. Due to the fragmented nature of *Opernreigen* and the ongoing changes of participants, it is a challenging production that not many teams are prepared to take on. They are desperate for us to sign the contract.

Anna Malunat and I meet Herr Müller. After a formal introduction he explains that he does not have the authority to make changes to the institution's standard contract. We say that we are not prepared to sign a contract that does not reflect our agreement. Herr Müller asks whether we do not trust him. Instead of telling the truth, we insist that the purpose of a contract is not to affirm the party's trustworthiness, but to provide for the possibility of a breakdown of trust.

When Herr Müller realises that we are not prepared to sign the contract as it stands, he suddenly identifies a section at the end of the document where additional agreements can be added. The following phrases are appended to my contract:

1. Opernhaus Graz GmbH pays for the cost of max. 9 inner European trips (flight or train) to and from Graz as necessary and as agreed in advance. A train ticket between Liverpool Street Station and London Stansted will also be paid. A taxi will be paid to transport models. Opera Graz GmbH pays for Mr Kattein's accommodation.

2. Due to the tight schedule, the concept presentation will happen concurrently with the test build. ...

3. Mr Kattein will have an assistant employed by Opernhaus Graz GmbH. ...

4. The realisation of this project requires unusual conditions [position of stage and opera, sound, lighting]. The technical department of Opernhaus Graz GmbH will assist, as far as possible to find appropriate solutions.

5. If required, the fee can be paid in instalments, however max. one-third after signing the contract, one third at the start of the rehearsals and one-third after the general rehearsal.

After our experience with *Le nozze di Figaro*, where the working conditions had been very challenging, we feel that these additional agreements are essential to make the contract acceptable. Condition 4 was specifically inserted because we had noticed that the lighting equipment available in Next Liberty Jugendtheater is

inadequate for our purposes, and we will need extra lighting from Opernhaus Graz. These additional clauses contradict some of the phrases used earlier in the contract, but this cannot be rectified because Herr Müller from Opernhaus Graz does not have the authority.

After concluding the contract negotiations, we go through a backdoor that leads us from the administration corridor straight to the stage of the Next Liberty Jugendtheater. This is where we meet the composers.

The Next Liberty Jugendtheater reminds me of a 1980s local council office. The walls of the auditorium are honey-coloured laminate panelling. The seats are upholstered blue meeting-room chairs with chrome legs. The aisle numbers are written on bright yellow stars recessed into the vinyl floor covering. There is a gallery with glass railings held up on round columns. The stage is elevated and roughly square in plan (11×11m). There are four electric pulley systems. There are three light bridges above with a permanently fixed lighting grid. There are more lights on the gallery edge and on some trusses along the ceiling of the auditorium. A room with untreated fibreboard walls and a large number of old suitcases is set up on stage.

Somebody from the university comes to inform us that one of the composers, Penelope Messidi, has dropped out of the project because she cannot cope with the pressure of the September deadline. Yasuko Ueda, another composer, is in the process of having a baby in Switzerland and is also not able to attend. The first composer we meet is Elisabeth Harnik who explains that her opera is composed spatially. The orchestra is seated to the left and right of the audience. She explains that the music will create the illusion of unstable ground, of swinging from right to left, reflecting the state of mind of the protagonist in the aftermath of a car crash.

The next composer we meet is Erin Gee. She has written her composition together with her brother. She is unable to explain what it is about, even though we offer to speak English. All she knows is that her brother, who is a dancer, has to perform in her composition. We explain that we have been employed to combine the six compositions into 'an evening-filling performance' and that it will be difficult to integrate a piece that already has a choreography and stage play. Gee decides that if her brother cannot take part, she does not want to work with us.

Siavosh Banihashemi, who has composed in Persian wants a Persian-speaking singer. His project concerns 'the conscious and subconscious versus inside and outside' (Banihashemi 2007). The music is partly electronic. He understands that we might not be able to have a Persian-speaking singer, but he can imagine working with us anyway.

The last candidate we meet is Peter Jakober who brings along his composing partner Albert Sackl. Their opera, 'Puppet Theatre', 'is located in the field of tension between puppet, machine and man' (Jakober and Sackl 2007). This will be practically realised by Peter Jakober dancing naked on stage in front of three movable screens and a video projection. Instead of telling the truth about our sentiments towards Jakober dancing naked on our stage, we have a tiresome discussion during which we explain, for the fourth time, that we have been commissioned to stage this production and

to design a stage-set and costumes. Peter Jakober and Albert Sackl finally leave. I wonder whether anybody told these composers what their brief was before they asked us to come all the way to Graz to meet them. By the end of the day three out of six composers remain involved: Yasuko Ueda, Siavosh Banihashemi and Elisabeth Harnik. We also meet identical twins that we want to cast. They are sopranos. We will need some sopranos because almost all of the pieces require soprano voices. Thank God we have not signed the contract yet.

WEDNESDAY 11 JUNE 2006

Back in London and Germany Anna Malunat and I compose (by email) a letter to Jörg Kossdorff.

MONDAY 3 JULY 2006

Jörg Kossdorff replies:

> Dear Miss Malunat,
>
> Have thanks for your letter that I will answer swiftly. Gerd Kühr has informed me today that the *Opernreigen der Zukunft* is now after all 'irritations' of the recent past back on a good track as there have been extremely positive conversations with the composition students and we have hence decided to proceed with the originally planned realisation of four to five short-operas. Mr Kühr will contact you about this at the beginning of July. As you know, we are on holiday from 1st July to 20th August but are available thereafter for any questions that yet require resolution. In the hope that we will now come to a good solution for all people concerned, I remain today with hearty greetings from Graz.
>
> Jörg Kossdorff

This response is a collection of words with no meaning. The remaining questions that Mr Kossdorff refers to are of no trivial nature. He neither identifies the 'short-operas' that are to make up *Opernreigen*, nor does he report on the outcome of the conversation that Mr Kühr has had with the composition students. Without this information it is impossible to develop a concept or a design. The submission for plans for the stage-set is scheduled for the end of October 2007. It worries me that we will not be able to make progress with the set until the piece is clearly defined and that we will not be able to do so until Mr Kossdorf returns from his 7 week holiday.

MONDAY 17 JULY 2006

The uncertainties of the commission threaten to break the team apart. The costume designer has taken on another production in Brussels for the period when we had hoped to work together in Graz. Her limited availability to work on the project manifests itself in our email exchange. I feel this could have been avoided with more support from Opernhaus Graz. Surely it would have been reasonable to set a deadline for the submission of compositions to partake in *Opernreigen* before our involvement and to brief composition students properly on the nature of a composition required for staging as an opera. The fact that the composing students refer to their work as 'instrumental in space' and 'scenic installation' rather than opera suggests that they have fundamentally misunderstood their role in an operatic production. Traditionally, the stage designer is responsible for designing the space for a composition and not the composer. The director is responsible for managing the relationship of characters to each other and their position on the stage.

1.146 Letter to Jörg Kossdorff. To establish transparent and well-ordered working conditions before starting a new job is as essential as the arranging, by the architect-activist, of his or her tools prior to beginning any work. Inappropriate tools, a vague brief and a disorganised environment can spoil the final product

(Much honoured Mr Kossdorff,

Last Friday the stage designer Jan Kattein and myself were in Graz for a meeting with the composers of *Opernreigen der Zukunft*. The reason for this meeting for us was to obtain an accurate description from the composers of what they want to say with their pieces. This would then allow us to come up with a concept for the evening that will take account of every piece. One of the composers, Penelope Messidi dropped out before the meeting. During the conversation with Peter Jakober and Erin Gee it became apparent that both of them have already finalised their stage concepts and their design concepts, which are more of an installation. Both of them are not prepared to let go of their individual concepts to allow us a scenic realisation for the entire evening. We do not think that it makes sense to stage only half of originally six pieces and see two possible alternative solutions:

1. The composers declare themselves prepared to submit material and will allow us its interpretation and realisation. This concerns in particular casting and stage design as well as the use of video.

2. Should our creative realisation of a common concept to cover the entire evening not be required, it would not be interesting for us to participate in the project. We are prepared to withdraw from the project so that a production manager can take over. A production manager could organise the scenery changes and the composers can than realise their own pieces. I would ask you to redefine our task in face of these changed circumstances before 19 June so that we can reconsider our participation in the project. Until our task area is clearly defined we are unable to sign our contracts.

With Kind Regards,

Anna Malunat and Jan Kattein)

Jan Kattein

From:	"Jan Kattein" <j.kattein@ucl.ac.uk>
To:	"▓▓▓▓▓▓▓▓▓▓▓▓▓▓▓▓▓▓"
Sent:	11 June 2006 15:28
Subject:	Re: Graz

Liebe Anna,

hiermit die veraenderte Form des Briefes and den Kossdorf. Leider habe ich keine Umlaute und wuerde Dich bitten, den Text noch zu korrigieren. Desto mehr ich ueber Graz nachdenke, desto saurer bin ich auf die Grazer Oper und die Zeitverschwendung, die die uns bereitet haben. Es ist heiss hier und ueberall wir gegrillt. Denk daran auch der Magdi eine Kopie des Briefes zu emailen.

Jan

Jan Kattein Architect
105 Cornwallis Road
London N19 4LQ
+44 (0)20 7272 3241

Sehr geehrter Herr Koßdorff,

Opernreigen der Zukunft

vergangenen Freitag waren der Bühnenbildner Jan Kattein und ich zu einem Gespräch mit den Komponisten von 'Opernreigen der Zukunft' in Graz. Zweck dieses Gespräches für uns war, möglichst genau von den Komponisten beschrieben zu bekommen, was jede/r Einzelne mit seinem Stück erzählen und erreichen möchte, um anschließend ein
Gesamtkonzept für den Abend zu entwickeln, in dem wir jedem Stück gerecht werden können.

Eine der Komponistinnen, Penelope Missidi, stieg kurz vor dem Treffen aus. Bei den Gesprächen mit Peter Jakober und Erin Gee wurde deutlich, daß beide bereits fertige auch räumliche und szenische Konzepte im Kopf haben, die eher in Richtung Installation gehen. Beide sind nicht bereit davon zugunsten der Gestaltung des gesamten Abends abzuweichen und uns die räumliche und szenische Gestaltung ihres Stückes zu übertragen.

Wir halten es nicht fuer sinnvoll nur die Haelfte von urspruenglich sechs geplanten Stuecken aufzufuehren und sehen grundsaetzlich zwei Moeglichkeiten:

1. Die Komponisten erklaeren sich bereit Material zu erstellen und den Umgang damit weitgehend uns zu ueberlassen. Das betrifft insbesondere Besetzungs- und Raumvorgaben sowie den Einsatz von Video.

2. Sollte unsere kreative Umsetzung eines Gesamtkonzeptes fuer den Abend nicht erwuenscht sein, dann waere die Teilnahme an dem Projekt fuer uns uninterressant. Wir sind in diesem Falle gerne dazu bereit, zugunsten eines Produktionsleiters zurueckzutreten. Ein Produktionsleiter koennte die Umbauten organisieren und die Komponisten koennen dann ihre Stuecke selbst verwirklichen.

Ich wuerde Sie bitten, in dieser veraenderten Situation unsere Aufgabe bis zum 19. Juni neu zu definieren, so dass mir dann unsere Teilnahme an dem Projekt neu ueberdenken koennen. Bevor unsere Aufgabe genau definiert ist, ist es uns leider nicht moeglich, die Vertraege zu unterschreiben.

Mit Freundlichen Gruessen,

Anna Malunat & Jan Kattein

09/03/2008

The word 'installation' describes the arrangement of electrical, ventilation or plumbing services in a building. It can also be used to refer to a piece of artwork using a variety of materials. In either context, an installation can be circumscribed as a network or arrangement of components or materials in space. The spatial relationship of the materials or components to each other makes the installation specific to its site. A site-specific installation is a piece of artwork that engages with its site and that would not work on a site with a different spatial or social context. The fact that the composers use the term 'scenic installation' to describe their work suggests that their composition includes the scenic arrangement in space. In an opera, the arrangement of a scene in space is normally the responsibility of the director. To design that space is the responsibility of the stage designer. The expression 'scenic installation' suggests that director and stage designer are superfluous. The fact that several of the composition students dropped out after our meeting in June substantiates the suspicion that their tutors had misinformed them about the role of the director and stage designer when composing an opera.

SATURDAY 29 JULY 2006

The costume designer's inability to confirm her commitment to the production and Anna Malunat's failed attempts to reach her by phone for several weeks in a row leads her to write an email setting out her expectations for a successful collaboration. She particularly emphasises the need for a common concept and design solution where input from every team member is the pre condition for a successful result.

FRIDAY 4 AUGUST 2006

In her response, the costume designer disagrees. She insists on the traditional hierarchy in the theatre where a concept developed by the director is illustrated by the designers. This is a slightly antiquated view. Our production of *Le nozze di Figaro* was the result of a collaborative effort, where stage design had informed concept, concept had informed costumes and vice versa. In *Opernreigen* collaboration in the directing and design team is particularly important because the narrative of the constantly fluctuating contents of the production does not provide many clues to devise a staging concept. Anna Malunat insists on the collaboration of the team, because a concept for the staging can grow out of ideas for costumes and stage design. The costume designer does not acknowledge this opportunity and the potential significance that her costumes could have in this production.

TUESDAY 8 AUGUST 2006

Anna Malunat reports briefly about the meeting she had with Magdolna Parditka. Apparently the outcome was positive. Much more importantly, she has started to establish an approach to *Opernreigen*. The most interesting observation she makes is the importance of the transitions between the four different pieces and how these can be used to introduce a coherent theme. In effect, this means that we would focus our efforts on choreographing the intervals, rather than the pieces, this may be the solution to the limited amount of creative input that the composers have granted us.

Anna Malunat also sends two photographs of the Kugelstein, the mountain that gives its name to Harnik's composition. The photographs are

of no use for the design, but another idea at the end of the email seems critical: 'Something', Anna Malunat writes, 'should reveal itself at the end'.

FRIDAY 22 AUGUST 2006

Anna Malunat reports on her telephone conversation with Mr. Kossdorff:

> Dear Magdi, dear Jan,
> I have today spoken on the phone with Kossdorff and have good news: We will in addition get three actors or dancers, two of whom I will be able to bring along and one of whom would have to come from Graz.
> Kind regards,
> Anna

Expenses for actors have not been factored into the original budget for *Opernreigen*, and any actors are employed at extra cost to Opernhaus Graz. I believe the reason why one of the additional actors has to come from Graz is financial. Actors based in Graz do not incur accommodation nor travel costs. Perhaps the three additional actors have been approved in order to entice us to finally sign our now amended and re-issued contract.

TUESDAY 10 OCTOBER 2006

In preparation for our meeting in Munich (Anna Malunat and Magdolna Parditka live in Munich) next week, Anna Malunat sends an outline of our current thinking about the project, clarifying how the four compositions are linked. The link was discovered in an observation made by Yasuko Ueda, composer of 'Myo-e': 'In the Buddhist ritual, the sound, the spoken word is not simply vibrating air. It is an association of energy. It does not disappear over time but remains in the room' (2007).

The central question, how sounds become visible, became relevant for our production. The novel *Dr Murkes gesammeltes Schweigen* (*Dr Murke's Collected Silence*, 1955) by Heinrich Böell a copy of which Anna Malunat has sent to me, helps to inform the stage designer's answer to this question. The novel is set in the studios of a 1950s radio station. Here, Dr Murke, employee of the culture section, has the thankless task of editing out the word 'God' from a pre-recorded interview with the famous philosopher Bur-Malottcke. Each reference is substituted with the words 'this Higher Being that we worship' and this activity leaves Dr Murke with 28 brown magnetic tape snippets recorded with the word 'God'. He keeps them in an empty matchbox for later use. Dr Murke also has a collection of silence. This collection consists of tape snippets of silence cut out of interviews and reports produced for broadcasting. In contravention of the strict directive of the radio station, Dr Murke has carefully archived these snippets of silence in empty biscuit tins that he keeps on a shelf in his living room.

Anna Malunat's outline captures the spirit of our telephone conversations of the past week on how magnetic recording tape can be used spatially,

> Through the entire room run magnetic tapes that record every single sound and every sung word. They unite on a desk in the centre of the room where a seated man with thick black glasses cuts them apart, winds them up, folds them together, gets caught in them, sorts them, preserves them and uses a pair of tweezers to file them into albums and archive them in drawers and index boxes.

Jan Kattein

From: "Anna Malunat" <█████████████>
To: "magdolna parditka" <█████████████>
Cc: "jan kattein" <j.kattein@ucl.ac.uk>
Sent: 29 July 2006 14:34
Subject: Re: graz

Liebe Magdi,

ich merke, daß ich eine bestimmte ansicht darüber habe, wie man gut zusammen arbeiten und ein gutes ergebnis erzielen kann. ich halte gewisse rahmenbedingungen dafür für unbedingt notwendig:
eine ausgeglichenen kommunikation. damit meine ich, daß ich sowohl über die arbeit als auch über die organisation der arbeit (in unserem fall jetzt termine) in einen dialog kommen möchte. mir ist das im Moment zu einseitig und ich habe sehr stark das gefühl, dir hinterherzulaufen und um arbeitszeit bitten zu müssen. von dir kommen keine konstruktiven vorschläge, was die termine betrifft, sondern nur negatives, was meine und jans vorschläge betrifft.
dazu gehört auch erreichbarkeit, ich finde es sehr schwierig, dich zu erreichen und muß oft sehr lange auf eine antwort warten.
was das inhaltliche der arbeit betrifft, möchte ich mich nicht als 'konzeptliferant' verstanden wissen, sondern das konzept gemeinsam entwickeln.

ich möchte die sache gut machen und dazu ist, finde ich, eine gute zusammenarbeit die voraussetzung.

ich habe im moment sehr stark das gefühl, daß es dich wegen dem zeitlichen druck mehr belastet, an dem projekt teilzunehmen, als daß es dir freude und spaß macht. wenn das so sein sollte, dann akzeptiere ich das. schließlich hattest du das andere projekt auch zuerst. aber dann sag bitte schnell bescheid, damit ich noch jemand anderen finden kann.

wenn nicht, müssen wir einen weg und vor allem ausreichend zeit für die gemeinsame arbeit finden.

viele grüße,

anna

1.147 Email from Anna Malunat to Jan Kattein dated 29 July 2005

(Dear Magdi,

I realise that I have a certain view about how one can work together well and how to achieve good results. I consider certain conditions as essential to a balanced communication. By this I mean that I want to have a dialogue about the work but also about the organisation of the work (appointments in this case). I find our relationship very one-sided at the moment and strongly get the feeling that I have to run after you to ask for work time. There are no constructive suggestions from you concerning appointments, but only negative comments regarding my or Jan's suggestions. There is also accessibility. I find it very difficult to reach you and have often to wait very long for an answer. Concerning the contents, I do not want to be understood as a deliverer of concepts but I want to see concepts developed together. I want to do my work well, and good collaboration is the prerequisite. I have at the moment the feeling that due to the time constraints the project is more of a burden to you than a pleasure and joy. If this should be the case then I accept this. After all you had the other project first. But then please let me know quickly so that I can find someone else. If not, then we have to find a way and especially sufficient time for our work together.

Regards,

Anna)

Jan Kattein

From:	"Anna Malunat" ███████████@█████████
To:	"jan kattein" ███████@██████
Sent:	05 August 2006 15:01
Subject:	Fw: graz

Lieber Jan,

leite Dir auch Magdis Antwort weiter. Ich treffe sie nachher. Bin einfach
müde und habe da keine Lust mehr und versuche, den Schaden zu begrenzen.
Aber natürlich auch ganz schön enttäuscht.

laß uns nochmal telefonieren, bevor ihr in den Urlaub fahrt.

Anna

Anna Malunat
████████████
████████████
████████████
████████████
----- Original Message -----
From: ███████████@██████
To: "Anna Malunat" ███████████@████████
Sent: Friday, August 04, 2006 8:18 PM
Subject: Re: graz

hallo anna!
für dieses projekt wurde ich als kostümbildnerin gefragt und als solche habe
ich das, von dir als regisseurin vorgeschlagenes konzept zu ergänzen,
beziehungsweise weiterzuentwickeln. über die termine, dachte ich, wären wir
bereits im klaren, seit wir am anfang juni telefoniert haben. wie besprochen
komme ich morgen nach münchen. bis dann, magdi

Verschicken Sie romantische, coole und witzige Bilder per SMS!
Jetzt bei WEB.DE FreeMail: http://f.web.de/?mc=021193

1.148 Email from Anna Malunat to Jan
Kattein dated 5 August 2005

(Dear Jan,

I forward Magdi's reply. I will meet her later. I
am simply tired and do not want this any more
and try to limit the damage. But obviously also
extremely disappointed. let us speak before I
go on holiday.

Anna

―――――――

Hello Anna!

For this project I was asked as costume
designer and as such I have to complete the
concept that you propose or to develop it
further. about the appointments I thought we
had reached agreement since we have spoken
on the phone in the beginning of June. as
discussed I come to Munich tomorrow.

see you then,

Magdi)

Attending our concept and design meeting in Munich are Anna Malunat, director; Jan Kattein, stage designer; Magdolna Parditka, costume designer; and Lena Gaetjens, stage and costume design assistant. The following key decisions are made:

1. The setting for the stage-set is an opera house or rather an opera house under construction.

2. All activities on stage contribute towards the construction of the opera house.

3. There are three types of characters on stage who construct the opera house, utter sounds and music, and record, edit and archive the sounds that are produced on stage.

4. We will use the four compositions as a means to generate the sounds that are recorded on stage. The narrative of the individual short operas are subservient to the overall narrative that tells the story of the construction of the opera house.

5. The epilogue reveals to the audience what has been happening on stage. The opera house is activated and suddenly transforms the audience into guests at the premiere night of the newly built opera house. The previously recorded sound snippets are released into the new opera house. Suddenly an explosion occurs that destroys the opera house and sees scraps of recorded sound tapes slowly settle on stage and in the auditorium.

I now have sufficient information to progress the stage design. The deadline for the submission of plans to Opernhaus Graz is 30 October. I am working on the design with my employee Josephine Callaghan. A 1:50 scale model of the existing theatre is made from medium density fibre board that is painted black. The individual elements that we are working on are the recording equipment, a projection screen, a desk for the editor, a chandelier and a base image showing operatic paraphenalia to be arranged on stage. The projection screen will be hung against the rear wall of the stage. A red theatre curtain will be printed onto the screen. At the end, during the epilogue, a video recorded during the audience admission in the main auditorium of Opernhaus Graz will be projected onto the projection screen on top of the printed curtain. The printed curtain is thus suddenly animated. Our model uses a compact slide projector bought from the New Covent Garden Sunday Market and a slide with a digital photograph of the Opernhaus Graz stage curtain. The image of the curtain was taken by Lena Gaetjens in Graz and emailed to London. Printing the digital image onto a transparency with a non-professional ink-jet printer has made the projection slightly blur. The soft image qualities makes the image look less like a projection and more like a very distant reality. We decide that these qualities will be retained for the full-scale projection.

Lena Gaetjens is instructed to produce the video recording of the admission procedure in the main auditorium. The camera will be positioned on the first gallery, directly opposite the stage. It will cover the entire admissions procedure until the members of the audience have taken their seats and the members of the orchestra have tuned their instruments.

The cut will occur the very moment the curtain opens.

MONDAY 23 OCTOBER 2006
Three points of view are selected to photograph the model, plan, front elevation and axonometric.

WEDNESDAY 25 OCTOBER 2006
One of the elements of the stage-set will be an architectural model at 1:50 scale of Opernhaus Graz. The idea behind the model is that it will be used by the characters on stage to plan the full-scale opera house that they are constructing. A stage-extra will be working on the model during the performance. At the end of *Opernreigen*, the tape snippets will be poured into the model using a funnel. This will cause the model to explode.

Lena Gaetjens writes from Graz that she has been unsuccessful in obtaining the plans from the main opera stage for me. These are required so that I can design the exploding model. Unlike in *Le nozze di Figaro*, where elements of the stage-set were irreversibly destroyed, destruction has to be reversible in *Opernreigen* so that the stage-set can be re-used for subsequent performances.

FRIDAY 30 NOVEMBER 2006
The drawings and model photographs are posted to Herr Martin Lipp at Opernhaus Graz on the agreed submission day together with the following cover letter:

> Dear Mr Lipp
>
> *Opernreigen*
> Herewith I am sending you the plans for the stage-set of *Opernreigen* as discussed. I am looking forward to the building rehearsal on 17 November when we will present the

staging concept in further detail. If there are any queries in the meantime, then you can reach me on the number/email below.
With kind regards,
Jan Kattein
encs. drawing nos. 001–007
3 photographs
copy: Anna Malunat, Lena Gaetjens

Drawing no. 001 is a CAD drawing showing the general arrangement in plan at 1:50 scale. The desk with the editor is located on the left. Some orchestra seating is arranged along the back wall of the stage, on the right side is a long shelf that extends from the stage into the auditorium. On top of the shelf are a series of tape recorders. The recording tapes are shown running below ceiling level from the recorders through the auditorium to the editing table. Behind the audience at stalls level a tower is shown that can move from right to left on a track. The stage is covered with furniture items in a more or less random arrangement. The drawing is inaccurate in that we know already that the furniture on stage will not be arranged in the chaotic manner shown in the drawing.

1.149 Model view from lower auditorium level with projection screen in the background

1.150 Elevation view of model from lower auditorium level with recording tapes in the foreground. We feel that an opera house is defined by its ambience rather than its strategic layout. The model was carefully composed to convey this ambience

1.151 Plan view of model. The shallow depth of field, the projection in the model and the furniture cut-outs in the model create an ambiguity of scale. In *Opernreigen*, the line drawings are complemented by the model photographs

Because of their scale, both the drawings and the model photographs look as if the set has already been built. The drawings look as if it has been technically resolved, the model photographs look as if the ambience has already been created

Jan Kattein • Architects
105 Cornwallis Road • London N19 4LQ • UK
+44 [0]20 7272 3241

Notes

Do not scale from this drawing.

Report any discrepancies.

Copyright owned by Jan Kattein Architects.

| 02 12 06 | rev. a | orchestra seating changed, monitors added |

Project Name	**Opernreigen**		
Project Number	**005**		
Drawing Name	**Stage Level Plan**		
Drawing Number	**001**	Revision	**A**
Scale	**1:50**	Date	**10 03 06**
Drawing Status	**Preliminary**		

1.152 Plan drawing no. 001

1.153 Section drawing no. 003

The layout drawings nos. 001, 003 define the position of key elements on stage, but they also serve as an inventory of a production that uses hundreds of individual objects and pieces of furniture that would yet have to be found on site in Graz by the architect-activist. As place holders, the digital drawings of the furniture that make up the audience seating in *Kabale und Liebe* are inserted into the drawing

Since we will not have a curtain, all setting-up of the stage will happen in full view of the audience. To arrange the furniture will be Anna Malunat's task. The architect-inventor has devised the task of the furniture arrangers so that the architect-arbitrator has less work to do. The reason that the furniture is drawn at all at this stage is so that it will be included in the stage-set budget that Opernhaus Graz will base upon our drawings. The position of the recording tapes is random in the drawing. Their exact position will be determined on site and is dependent upon the position of existing fixings on the auditorium ceiling. Even though the stage in the Next Liberty Jugendtheatre is clearly delineated from the auditorium by a change of level, the general arrangement ignores this delineation and uses the entire theatre as a site.

Drawing no. 002 shows the general arrangement of the upper level in plan at 1:50 scale. Its purpose is predominantly to show the position of the musicians, some of whom will be seated in the auditorium gallery.

Drawing no. 003 is a CAD drawing showing the general arrangement in section at 1:50 scale. Drawing no. 004 is a pencil drawing measuring 1.37×0.86m and shows in detail the tape-transport and drive mechanism, which is based upon a series of suspended bicycle wheels fitted with spools of rope that have counter weights at their ends. The system was inspired by the winding mechanism of a cuckoo-clock. Cuckoo-clocks are commonly driven by a bronze weight, in the shape of a pine cone, suspended on a chain that runs across a pulley. The clock is wound by pulling on the opposite end of the chain and elevating the weight towards the clock mechanism. As the weight slowly drops down, it causes the pulley to rotate and power the clock mechanism. Our tape-drive mechanism uses a sash weight and a sash cord run over a wooden pulley attached to a bicycle wheel. When elevating the weight and

releasing the cord, the weight should slowly make its way back down to ground level, transferring the potential energy to the bicycle wheel that pulls on the recording tape, unwinding it from the spool on the tape recorder at the other end of the room.

Drawing no. 005 shows a detail of the shelf with the tape recorders. The edge of the shelf is decorated with pointed plywood tongues arranged in a horizontal row leaving a 2mm gap between each piece of plywood. The plywood is painted matt white. Its function is to hide the structure of the shelf support behind and to make the proportions more pleasing. This design was copied from a detail at Blackheath Rail Station in South London, a 19th-century frieze of vertical timber tongues running along the roof edge to conceal the structure that supports the roof.

Drawing no. 006 shows a 4.5m tall steel tower with wheels that will be installed in the auditorium to run along a track on the floor. The tower will be occupied by the conductor. A wooden lectern is to be installed in front to hold the music. A small glass lamp is suspended from a bar affixed to the side of the tower just above head height. The tower has an official and an unofficial purpose. Its official purpose is to provide a vantage point for the conductor whose orchestra is distributed across stage and auditorium galleries. The unofficial purpose of the steel structure is to remove the conductor from his traditional hiding place at the front of the orchestra pit and to integrate him into the dramatic action. When positioned underneath the suspended lamp the conductor appears to have a halo. The steel tower is wheeled backwards and forwards by a stage-extra dressed as the conductor's assistant. The architect-inventor knows that the structure will be inherently shaky, but the architect-arbitrator ensures that the drawing does not show this to avoid the rejection of the design by the intended occupant.

Drawing no. 007 is a detailed design of the sound collectors. The sound collectors are adjustable so that they can be aimed at a source of sound or music by a group of stage-extras dressed as lab technicians. They are fitted with microphones that are connected to the tape recorders. They are designed like a gramophone horn, made up of a row of trapezoid metal segments connected by folded seams. Our horns, however, will be manufactured from grey cardboard segments pinned together with letter pins.

The photographs included in the submission are the photographs of the model printed on A5, crème and matt ink-jet paper with a 1-inch edge on all sides.

TUESDAY 31 OCTOBER 2006

Anna Malunat sends an email confirming that nine stage-extras have been approved for our production. This is good news. The compositions of *Opernreigen* are very challenging to sing. Even though opera singers tend to have good acting skills, it is unlikely that our singers will be able to act on stage because of the degree of concentration required to perform the music. Neither the composers, nor their teachers, appear to have taken this into account.

1.154 Detail drawing of tape shelf and
transport mechanism

1.155 Detail drawing of conductor high chair

Drawn at 1:2 scale, the stage-set appeared
almost already built, alleviating any concern
from workshop staff over technical feasibility.
Drawing at such intimate scale also allowed
the architect-inventor to study in detail,
the materials that he was proposing to use,
retracing the lines that the original designer
of the gramophone horn, the tape player, plug
socket and electrical junction box had drawn
to prepare the manufacture of these products.
The mechanism of a cuckoo-clock inspired the
tape drive mechanism

It is important that there are actors and stage-extras available that Anna Malunat can direct to realise our concept. Adding the nine stage-extras to the three previously approved actors gives us twelve characters to direct on stage, not counting the singers.

The disadvantage of using stage-extras is that they are not normally able to act convincingly. This limits their usefulness. We decide that we can overcome this limitation by preventing them from acting altogether. Instead, they will be given particular tasks with particular outcomes to carry out while on stage. The stage-set provides the sites for these tasks. In *Opernreigen*, the architect-inventor designs spaces and objects but also tasks. The following tasks are related to the following elements of the stage design:

1. chandelier – beading and raising;

2. furniture – carrying and arranging;

3. projection screen – unfolding and raising;

4. recording equipment – maintaining and repairing;

5. scale model – cutting out and assembling;

6. conductor's tower – pushing and pulling.

FRIDAY 17 NOVEMBER 2006
The building rehearsal at Next Liberty Jugendtheater starts at 10 am. Present are Michael Barobek, production manager at Opernhaus Graz (replacing Herr Müller who has apparently resigned); Michael Brandstaetter, conductor at Opernhaus Graz; Lena Gaetjens, stage design assistant; Elisabeth Kapfer, production manager at Next Liberty Jugendtheater; Anna Malunat, director; Martin Lipp, technical co-ordinator at Opernhaus Graz; Josef Loibner, engineer at Art & Event GmbH; Richy, stage technician at Next Liberty Jugendtheater; Viktor, lighting technician at Next Liberty Jugendtheater; Wolfgang Urstadt, technical director at Opernhaus Graz; and several sound technicians from Opernhaus Graz.

On stage are the plans, the model photographs, the model and the mock stage-set. The rehearsal is opened by the technical director who welcomes all present to the start of *Opernreigen*. Anna Malunat then explains our strategy. She reminds her audience that we have been employed to combine four short compositions with different themes into 'an evening-filling performance'. She explains that this will be done by introducing an over-arching narrative about opera and addressing the question of how to make sound visible. Practically, this will be realised by building an opera house on stage. I then explain that the stage-set comprises eight main elements and I use the scale model to point out the position of the model on stage, the conductor's tower, the recording equipment, the projection screen, the editing table, the tape-transport mechanism, the chandelier and the various operatic furnishings. These elements will become parts of the opera house to be constructed on stage. The events will occur in three phases,

1. Collecting of sounds from singers and orchestra performing the student's compositions using sound collection horns and tape recorders.

2. Cutting, sorting and packaging of sound tape on the cutting table, while at the same time beading the chandelier, bringing in and arranging furniture and furnishing the scale opera-house model. Practically, this means that the set is to be left unfinished by the workshop and will be finished on stage. I mention that this has been done to limit the amount of finishing required from Art & Event. Some people laugh.

3. During the final phase, the opera house set is completed, the chandelier is raised, the projection screen rolled out and the cut sound-tape snippets poured into the scale opera-house model with the help of a large funnel. Conversations, steps, the fussing of the audience, and the tuning of instruments, originally recorded in the main auditorium of Opernhaus Graz, are broadcast, and a projection of the arriving audience appears on the projection screen.

I conclude my presentation to answer questions while the crowd breaks into smaller groups to discuss other ongoing productions. The meeting is formally dissolved and the technicians are given the go-ahead to disassemble the mock stage-set. Someone comes back to roll up my drawings that have been left behind.

The official purpose of the building rehearsal is to provide an opportunity for the opera's various departments to raise concerns, request additional information and provide technical advice to specific problems. The much more important but incidental result is that it provides an opportunity for the team to meet for the first time. In this context, it is essential that the directing team comes across as united, professional, decisive, approachable and ideally also as having a sense of humour. The reason is that there are always numerous sets being built at the same time in a theatre and this creates competition for workshop time. The earlier the directing team engages the technicians, the higher the quality of their set. The better the directing team engages the technical director, the lower the price for the production of the set.

SUNDAY 19 NOVEMBER 2006

Today Anna Malunat sends an email to Lena Gaetjens and myself. She has reviewed the recording of the audience admission to the premiere of *Carmen* on the main stage. The raw data has yet to be edited to cover the entire admissions process from early birds to late comers while consistently increasing anticipation and suspense of the impending performance, all this with an overall duration not exceeding several minutes. Our opera house will have its premiere during the epilogue to *Opernreigen*. This may confuse the audience who will have just witnessed the music ending and will be getting ready to applaud when they will suddenly find themselves immersed in the projected admissions process. Applause will have to be prevented at all costs to avoid the interruption of the narrative. The length of time during which we can keep the audience in their seats depends upon the quality of the projection and other action on stage. Anna Malunat writes that she thinks that we will get away with a 7-minute long projection.

1.156 Model maker at work

Opernreigen aus Papier
1:50

1.157 DIY drawing

Logen links

Sitze Logen

Loge.rechts

Loge links

**Opernreigen aus Papier
1:50**

Logen rechts und links

1.158 DIY drawing (second page)

The DIY drawing enables a stage-extra, without
a detailed understanding of architectural
models, to play the part of a proficient model
maker. An important task of the architect is to
teach the maker of his or her design

I think that 4½ minutes is more likely. The audience reaction, however, cannot be rehearsed. Whereas films often pre-release screening to gauge the audience reaction before a final cut, theatre or opera rehearsals do not normally have an audience to pass comment.

WEDNESDAY 29 NOVEMBER 2006

The tape recorders come from a number of sources. Three of the recorders are found in a storage room belonging to the sound department at Opernhaus Graz GmbH. The remaining seven recorders are purchased from an online auction website. Today I win a Loewe Opta 403 tape recorder for €27.50 and a SABA Hifi Tonbandgerät 543 Stereo. Both tape players are located in Germany and will be posted to Opernhaus Graz.

FRIDAY 1 DECEMBER 2006

We have decided that the recording of the admission at Opernhaus Graz GmbH has to be redone so that it can be filmed from a lower angle. This will ensure that the audience seated in the stalls of the theatre will perceive the projection from the correct angle. Lena Gaetjens writes:

> I will this evening make a test recording with Alex from the lighting department to see whether the thing with the camera lens is working. There is not a single performance at Opernhaus Graz at the moment that starts with the opening of the curtain. All have a prologue or they do not have a red curtain or start with the opening of the fire shutter.

The red curtain has become symbolic with opera and it is essential that it appears in our projection because it identifies the opera house. This is probably the very reason why other directors shun the use of the red curtain.

TUESDAY 12 DECEMBER 2006

A detailed design drawing of the opera-house model (Figure 1.163) is issued to the workshop by email. The model is based upon the plans of Opernhaus Graz that I have been given. The performance specification is as follows:

1. the model has to be at a scale small enough so that an actor can continue its construction on stage during the performance;

2. the model has to be non-combustible;

3. the model has to be collapsible when a string is pulled. I also draw a cut-out template of the auditorium seating and finishes to aid the actor who will continue with the building of the model on stage.

WEDNESDAY 13 DECEMBER 2006

The bill of parts issued today is a spreadsheet with eight columns specifying each item, quantity, description, works to be done, the relevant drawing number with a photograph of the item. The bill of parts is the result of weeks of work by myself and Lena Gaetjens in identifying, cataloguing and photographing items of use for the stage-set. The sites for our search were the many departments of Opernhaus Graz. This is appropriate since the stage set depicts an opera house. Where *Zero Emission Luminaires* used a finding list to specify

1.159 Email message from Anna Malunat
dated 19 November 2006.

The email comments on the video recording
that Lena Gaetjens produced at Opernhaus Graz.
Opernreigen ends with the showing of a film
recorded at the beginning of another production.
Not only are the material elements of the
stage-set found objects, in the construction of
Opernreigen even an opera sequence in the form
of a film is treated as a found object that is then
carefully inserted into the overall assembly

(Dear Lena, dear Jan,

I have just viewed the admissions recording. I
think this will have a very good effect. It would
probably be best to film before a premiere,
because the anticipation comes across in the
film – even without premiere. This is also why
I think that we can make it last five to seven
minutes, we can always cut off a bit at the
beginning if we realise during the rehearsals
that it is too long. (It would be good if we could
test this in the painting studio [the rehearsals
took place in the former painting studio that has
now been converted into a rehearsal room], but
definitely during my three stage rehearsals.

A few things: I think it is good that there are
always people walking in front of the camera.
That the side aisles in the auditorium are filling
up is not noticeable, only when people appear
really big in the recording. Also, that backrests
of seats are visible in the foreground is good
(the print would have to be done accordingly).
In the beginning, when the projection starts,
naturally nobody should be standing in front
of the camera. Also the ticket checking in the
foreground is good, but this is not essential if it
does not work with the perspective. I would in
this case have a real ticket attendant on stage.
And since the boss on the desk is selling tickets
throughout the entire performance ...

The question is whether we should leave the
mobile phone announcement in, I do not
dislike it, it is also funny. It is beautiful if one
can understand a few phrases of what is said.
At the end it gets blurry, because it is getting
dark, so that our projection is not lost – not
only because of the blurredness but especially
because of the intensity and clarity – we have
to think something up. It is nice to have the
tuning and the warm-up in. And unfortunately
the film stops before the curtain opens.
A conductor applause would be nice.

But, as I said it is funny and also relaxing after
all the tiring pieces [the music of *Opernreigen*]
and simultaneously full of suspense, because you
become involved in this anticipating, ceremonial
atmosphere. And I think we can afford up to
seven minutes. Better first too long than too short.

Kind regards,

Anna)

Page 1 of 1

Jan Kattein

From:	"Anna Malunat" <███████████████>
To:	"Lena Gätjens" <██████████████>; "Jan Kattein" <j.kattein@ucl.ac.uk>
Sent:	19 November 2006 16:28
Subject:	Projektion

Liebe Lena, lieber Jan,

ich habe gerade die Einlaßaufnahme angeschaut. Ich glaube, das wird eine sehr gute Wirkung haben, am besten wäre es wahrscheinlich noch, vor einer Premeiere zu filmen, den n die Spannung überträgt sich auch im Film - schon ohne Premiere. Deswegen denke ich auch, daß wir ruhig 5 bis 7 Minuten machen können, wir können ja immer noch vorne ein bißchen abschneiden, wenn wir bei den Proben merken, daß es zu lang ist. (Es wäre gut, wenn wir das im Malsaal schon probieren könnten, auf jeden Fall aber bei einer meiner 3 Bühnenproben).

Ein paar Dinge: Ich finde gut, daß vorne immer Leute vor die Kamera laufen, daß sich die seitlichen Ränge mit Publikum füllt merkt man nämlich gar nicht, erst, wenn die Leute wirklich groß draufkommen.Auch daß Stuhllehnen im Vordergrund drauf sind, gefällt mir gut (entsprechend müßte dann der Druck sein.). ganz am Anfang, wenn die Projektion losgeht, darf natürlich noch keiner vor der Kamera stehen.
Auch das Kartenabreißen im Vordergrund ist gut, muß aber nicht unbedingt da sein, wenn das sich mit der Perspektive nicht ausgeht. Ich würde in dem Fall einen Kartenabreißer auf dei Bühne stellen. Und da der Chef am Schreibtisch ja das ganze Stück hindurch schon Karten verkauft...
Die Frage ist, ob wir diese Handygeschichten drinlassen sollen, also die Ansage, ich finds nicht so schlecht, ist auch ganz lus Es ist ebenso schön, wenn man einige Sätze von dem Gesprochenen versteht.
Am Ende wurde es unscharf, weil es dunkel wird, damit unsere Projektion dann nicht baden geht -nicht nur wegen der Unschärfe, sondern vor allem auch wegen der Intensität und Brillanz- müssen wir uns was überlegen.
Es ist schön, daß Stimmen und Einspielen draufzuhaben.
Und leider hört der Film auf, bevor der Vorhang aufgeht.
Ein Dirigentenauftritt wäre schön.

Aber, wie gesagt, es ist lustig und auch entspannend nehme ich an nach den ganzen anstrengenden Stücken und gleichzeitig spannend, weil man da so reingezogen wird in die erwartungsvoll-feierliche Stimmung. Und ich denke wir können uns bis zu 7 Minuten leisten. Lieber erstmal zu lang als zu kurz.

Liebe Grüße,

Anna

25/02/2007

1.160　Email message from online auction service confirming the purchase of a compact tape recorder of type Lowe Opta 403, dated 29 November 2006

(Subject: You Won eBay Item: Suitcase Tape Recorder Loewe Opta 403

Postage: Insured despatch: 10.00 Euro

Payment details: buyer covers postage costs. Payment can be submitted by bank transfer or on collection.

Postage and packaging 10.00.

International postage and shipping on request

More from this seller: Typewriter by Triumph Matura + Instructions)

1.161　Email message from online auction service confirming purchase of a tape recorder of type SABA 543 Stereo F.

(Subject: Message from an e-Bay member regarding this item

Hello, congratulations for winning the auction! Shipping to the UK for an insured package is 25.00. With kind regards A. Ehringer)

Due to the distance between my workplace in London and the site in Graz, the architect-activist has to find new ways of obtaining materials. Online auction sites are a useful resource that allow for the procurement of materials that can then be shipped straight to Graz. The disadvantage of digital scavenging is that online auction sites only provide a written and photographic description of items. Proportions, texture and weight are not communicated

1.162 Collection of repair and maintenance tools for stage-extras: (a) adhesive tape for joining splices; (b) strong scissors for cutting jammed tape clots; (c) long-nose pliers for freeing-up tape-transport mechanism; (d) precise scissors for splicing; (e) screwdriver for releasing tape spools

materials to be acquired, *Opernreigen* used a found list to specify the location of items identified and the adaptations that have to be executed by the workshop. The prevailing colours of objects found were deep shades of red, brown, gold and ivory. Our bill of parts suggests that the interior of opera houses distinguishes itself from other buildings primarily by a very specific colour palette.

THURSDAY 14 DECEMBER 2006

The main purpose of rehearsals is the testing of each team member's work in the context of others' work. The lyrics are examined in the context of the stage-set, the costumes in the context of the lighting, the actors' behaviour in the context of the director's concept, the make-up in the context of the costumes. Constant assessment of the design is especially important in *Opernreigen* because it is a densely woven collection of objects, activities and spaces found and carefully assembled. Objects are collected from three different sources. Car-boot sales in London and Graz are an important source for smaller objects. Second-hand auction websites are a good source for larger and very specific items, and the Opernhaus Graz furniture store and props archive provide the furniture.

1.163 Detailed drawing of exploding opera-
house model. Every element of the stage-set is a
tool for a very particular activity. The rehearsals
then start to undermine the specificity of the tools
and encouraged their creative use for a number
of activities. This fostered interaction between
characters and added an element of humour to
their activities. A toothbrush for example can be
used for polishing tape-recorder controls, but it
can also be used to brush one's teeth

(Section aa: crack! boom! crack! [explosion
noises], model outside mdf [medium density
fibreboard], model painted black on inside,
hinge and table legs, from furniture store,
newly painted with white gloss. Plan: eyelets
with removable pin on string, 15W refrigerator
bulb, model painted black on inside. Section bb:
aluminium vessel for pyrotechnics)

Often objects are introduced during the rehearsals to test their performance in the overall composition, and they are then exchanged for more suitable alternatives when they become available. The situations that the singers are put in and the tasks that they carried out are appropriated from the world of the theatre. The singers themselves contribute fragments of conversations, behaviours and attitudes based on their observations of colleagues at work.

The compositions from four different composers in four different styles and four different languages integrate well into this eclectic assemblage.

Anna Malunat writes to report that the composition students have complained to Opernhaus Graz that they are not integrated into the rehearsals process. This is incomprehensible, because a composer's involvement in the production ends with the provision of the music score and libretto. It is further evidence that they fail to understand the essential principle of apportioning creative responsibility.

WEDNESDAY 20 DECEMBER 2006

The quotation from Art & Event to build the stage-set totals €21,781.46. This amount does not include the tape recorders, the model opera house and the bicycle-wheel tape-transport system. The stage-set budget is €11,000. The architect-arbitrator obviously did not manage to sufficiently engage the workshop staff during the building rehearsal. Maybe the estimate (extortionate for a very modestly scaled stage-set that relies heavily on existing furniture and objects) is a political move designed to put Art & Event in a strong negotiating position with regard to design changes. During *Le nozze di Figaro*, the costume department employed the same technique, but we were able to outsource tailoring instead. Because of the high transport costs for a stage-set, we are dependent on the local firm to produce the set. However, I prepared for a high estimate and have built into the design a certain number of extras which can be omitted or changed to show good will.

1. The original drawings show nine shelf supports in excess of 2.5m in height. The detailed drawing shows these supports as turned wooden legs with a steel core for stability. Actually, the decorated legs are not necessary for the design and are replaced with square section steel legs instead.

2. The tape-transport mechanism, for which I had made a prototype, makes a distinct clicking noise when wound up. Ten of these are part of the stage-set. I have already agreed with Anna Malunat that the noise would significantly disturb the performance and that an alternative solution has to be found. A re-design of this element is now proposed as a means of cutting costs.

3. I propose that the cardboard sound collectors are replaced with real antique gramophone funnels to save workshop time.

These proposals are sufficient to demonstrate good will and the design is approved by Opernhaus Graz.

FRIDAY 22 DECEMBER 2006

I have an appointment with the owner of The Talking Machine, a phonograph shop in Finchley, North London.

1.164 Furniture selected from the Opernhaus
Graz furniture store

1.165 *Opernreigen* colour palette. The very
specific colour palette for *Opernreigen* gives
the stage design the recognisable character of
an opera house

1.166 Excess baggage ticket dated 2 January 2007. In spite of the vast stage-set construction costs, the €250 excess baggage ticket was reimbursed by Opernhaus Graz without quibbles. Maybe the stage-set budget was repeatedly corrected upwards to keep the directing team sweet while the conflict with the composers was bubbling under the surface, undermining the entire production

He does not have ten gramophone speaker horns at his shop, instead I meet him at his house where we have to clear out his garage to get to his horn collection. I select ten beautiful horns in a variety of colours and sizes. Most of them have become rusty while in the back of the garage, but this is desirable for the aesthetic appeal that I am trying to achieve.

TUESDAY 2 JANUARY 2007

I travel from London to Graz with a large cardboard box that contains the gramophone horns. The horns cost £20 each and the airline charges £250 excess baggage. This is still cheaper than having cardboard horns made by Art & Event.

SUNDAY 21 JANUARY 2007

The composition students are still trying to interfere. Anna Malunat writes to Jörg Kossdorff to inform him that she will no longer allow the composers to be present during rehearsals.

SATURDAY 27 JANUARY 2007

Today the lighting rehearsal is cancelled by Anna Malunat. We have been trying to light the stage using all available equipment supplemented by a group of 2kW halogen lamps borrowed from Opernhaus Graz. Unfortunately, it is impossible to get the stage bright enough. The primary reason for this is that nearly 100 lectern lamps have been installed throughout to illuminate the music scores for the musicians. The action on stage disappears amidst this visual disturbance. The lighting technicians do not know how to solve the problem.

SUNDAY 28 JANUARY 2007

I receive a quotation from a stage equipment hire company in Vienna for the rental of 2kW HMI (hydrargyrum medium-arc iodide) lamps. HMI lamps are arc lamps that provide a gleaming brightness with a colour balance similar to natural daylight. The quotation is forwarded to the production manager at Opernhaus Graz.

TUESDAY 30 JANUARY 2007

Three HMI lamps are delivered from Vienna. The lamps cannot be connected to the theatre's lighting controls, because they do not have an automatic ignition. Instead, the performance is adapted so that one of the actors manually switches the light. Even though this is a rather last minute intervention, the operation of the light controls by the characters on stage gives the performance a welcome moment of realism.

WEDNESDAY 31 JANUARY 2007

Today a meeting takes place between Jörg Kossdorff, Michael Brandstaetter, Anna Malunat and myself. The purpose of the meeting is to settle the ongoing conflict between the composers and the directing team. The composers have complained about alleged noise created by the action of one of the dancers on stage during the first part of the opera. One of the composers in particular, is concerned that her composition was distracted by 'shuffling paper'. The conductor supports the composer's argument. A conductor and a director have equal say in an opera production, and, since no agreement between the two factions can be reached, the director of Opernhaus Graz intervenes. During the scene referred to, the singers drop sheet music from the gallery while singing.

These sheets are then collected by the dancer below and stacked neatly for the next scene. Normally, singers in an opera do not use sheet music. In our production, the compositions are so difficult that, in all but one of the four scenes, the conductor has requested that the singers refer to the paper score. Singing from sheets severely

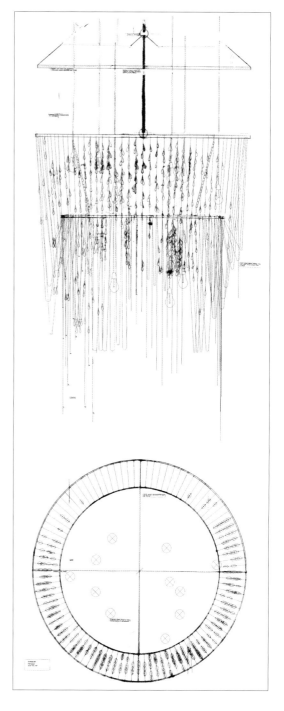

1.167 Final drawing of chandelier issued to Opernhaus Graz

Jan Kattein

From:	"▓▓▓▓▓▓▓▓▓▓▓▓▓▓▓_▓▓▓▓@▓▓▓▓▓▓▓▓
To:	<▓▓▓▓▓▓▓▓▓▓▓▓▓▓▓▓▓@▓▓▓▓▓▓▓▓▓▓
Cc:	<mail@jankattein.com>
Sent:	21 January 2007 17:19
Subject:	Bitte um Kenntnisnahme

Lieber Herr Kossdorff,

ich moechte Sie darueber informieren, dass es am Samstag auf der Probe einen Konflikt mit den Komponisten gab.
Eine von ihnen stoerte die Probe, alle halten sich zum wiederholten Male nicht an Absprachen, sie wollen noch immer mitinszenieren und respektieren nicht die Grenzen. Ich war aus diesem Grund immer sehr vorsichtig, sie das noch Unfertige sehen zu lassen und sehe mich leider im Moment in meinen Befuerchtungen bestaetigt.
Ich moechte daher die Komponisten von meinen wenigen verbleibenden szenischen Proben ausschliessen, um in Ruhe arbeiten zu koennen, nicht natuerlich von den musikalischen (BOs, 2. HP usw.).

Ich bin zur Zeit im Ausland und ab Dienstag Morgen um ca. 10.00 Uhr wieder in Graz, wenn Sie mich erreichen wollen.

Mit herzlichen Gruessen,

Anna Malunat

Ihr Blog. Ihre Fotos. Ihre Erlebnisse. Jetzt auf MSN Spaces. - Jetzt anmelden!

1.168 Email from Anna Malunat to Jörg Kossdorf dated 21 January 2007. The email is the response to a physical clash between Hanna Eimermacher and Anna Malunat on the rehearsals stage. The composer intentionally interrupted the rehearsals by walking on stage. Hannah Eimermacher was the least engaged composer because her composition had been introduced at the last minute, just before rehearsals started. The inability of the composers to comprehend and respect disciplinary boundaries led to physical violence

(Dear Mr Kossdorff,

I would like to inform you that there was a conflict with the composers during the rehearsal on Saturday. One of them interrupted the rehearsal, all of them repeatedly do not comply with our arrangements. They still want to co-direct and do not respect the boundaries. I have for this reason always been very careful not to show unfinished work and unfortunately see my concerns confirmed at this moment. I want to exclude the composers from the few remaining rehearsals, to be able to work in peace, not obviously from the musical rehearsals (orchestra rehearsal 2 and dress rehearsal). I am currently abroad and back in Graz at approx. 10 am on Tuesday morning in case you do want to reach me. With kind regards,

Anna Malunat)

impedes any scenic action unless – as we urge – the sheets become part of the stage-set and the shuffling of the paper becomes part of the action on stage. The scene has been rehearsed many times and has become a key part of the story that we narrate on stage. The premiere is now only a few days away, and it is not possible to change the design so quickly.

The meeting starts with both factions stating their position. The director of Opernhaus Graz then asks whether changes to the staging can be made. Anna Malunat explains that changes have already been made to accommodate the composers concerns and also to accommodate all the special requirements of the composition team and that no further changes can now be made. The director of Opernhaus Graz then decrees that the scene with the paper must be changed. Anna Malunat says that, in this case, we will withdraw our names from the production. The director of Opernhaus Graz becomes very angry. Anna Malunat ignores this and inquires about payment arrangements for the final instalment of our fee.

It is agreed that we will complete our work on the production and that the final instalment of our salaries will then be paid according to our contract. Our names will not appear in any literature or advertisement about the production. Our decision will be foremost an embarrassment to Opernhaus Graz who have so advocated the collaboration with the composition class.

We also expect that our decision will be communicated to the Ring Award jury. But we do not withdraw our names to disadvantage Opernhaus Graz. We withdraw our names because we feel that we have made a huge number of compromises throughout the production to accommodate the special requirements of music and composers and that no more compromises can be made without a serious detrimental effect on the stage design and directing concept.

An email is sent to the director of Opernhaus Graz confirming the arrangements. Another email is sent to the local press informing them of the decision to withdraw our names.

Peter Konwitschny, a well-known opera director operating in opera houses in Austria and Germany was one of the jury members of the Ring Award. When consulted prior to our decision to withdraw our names from the production, he comfortingly asserted us that there are distinct advantages in working with the material of a dead composer.

FRIDAY 2 FEBRUARY 2006

Today is the dress rehearsal. Completing our contractual duties after the withdrawal of our names is much more pleasant than our work on the production has been in previous weeks. Anna Malunat and I feel strongly that Opernhaus Graz, our client has shown little interest in our contribution to the project. Withdrawing our names makes us feel less precious about the end result.

It is surprising that the project did not fail much earlier. The reason is that many of the employees of the constituent companies that make up Graz Opera gave their spare time to the project and diverted resources from other projects to aid its realisation: the lighting technician who brought his private camera to film *Carmen*, the project co ordinator at Art & Event who swallowed a €10,000 loss for our production and the directing assistant who came in to clean the stage before the start of her 16-hour shift.

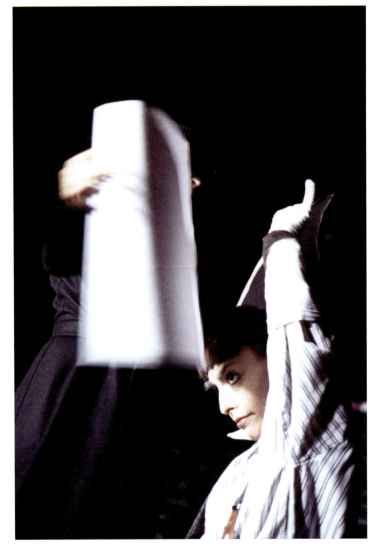

1.169 Rehearsal photographs of the game
 with paper

1.170 Rehearsal photographs of the game
 with paper

1.171 Rehearsal photographs of the game with paper

1.172 Rehearsal photographs of the game with paper

1.173 Rehearsal photographs of the game
with paper

Isabelle, a dancer from Munich is our most
skilled performer. Her character is constructed
around the game with the printed music

During the dress rehearsal I realise that *Opernreigen* is not easily photographed. There are two reasons for this.

1. The stage-set and actors are very much in keeping with their site. The set is reminiscent of the rough functionality of the back-stage, and many actors have costumes that resemble the uniforms of the stage technicians. Thus, photographing *Opernreigen*, the actors and stage-set become invisible in front of the theatre background.

2. Action occurs on stage, in the auditorium and on the gallery. The camera lens can only be directed at one point of view at any one time. *Opernreigen* is viewed from multiple points that are in constant competition to each other. The audience is prompted to perpetually re-adjust their focus to follow the action that occurs behind, above, in front and beside them (as the original concept for *Le nozze di Figaro* had intended). To take a good photograph in low-light conditions an extended exposure time is necessary and the camera has to be kept very still.

SATURDAY 3 FEBRUARY 2006

During the course of the day visitors arrive from Bonn, Hamburg and London. Anna Malunat and

1.174 Rehearsal photograph during scene 4. Paper was everywhere and had informed every scene of *Opernreigen*. Removing the printed music from the scene damaged the performance to such a degree that it could not be repaired within the limited rehearsal time which now remained before the premiere. To have the singers read from sheets without scenic justification would make them look unprofessional and the composers inadequate.

Thus, insisting on the elimination of the scenic use of the paper, the composer made her composition appear unfit for operatic performance

myself do not attend the premiere. Instead we cook, to a Greek recipe, a beautiful piece of pork fillet that we have bought at the Graz farmers market.

The costume designer did not withdraw her name from the production, claiming that the costume design is not affected by the imposed changes. Even though this is true, she does in the end stay away from the customary appearance on stage of the directing team during the applause. The real reason why she did not withdraw her name, is that she has arranged an appointment to meet Jörg Kossdorff to offer her services as a costume and stage designer to Opernhaus Graz. Business aspirations appear to prevail over artistic considerations. Opernhaus Graz posts

a notice cancelling two of the scheduled future performances of *Opernreigen* 'due to a lack of audience interest'.

We were commissioned to create 'an evening-filling performance' from six separate compositions by the students from Graz University. In fact the number of compositions and their authors fluctuated until the last moment. The musical contents were widely different and the libretti entirely unrelated. Unlike in *Herr Gevatter*, where six composers had joined forces to write one opera in six acts, *Opernreigen* used four different orchestras, in four different positions in the room and four different libretti written in three different languages. Musically, *Opernreigen* was a bricolage of styles

1.175 Collection of tools and materials for the chandelier maker: (a) revolving punch pliers for piercing edges of water bags; (b) scissors to cut string; (c) zip-up plastic bags constituting crystals once filled with water; (d) strong cotton thread for beading; (e) bucket with clean water

and instruments cobbled together from a number of sources including student projects, extracts from full-length operas, some using traditional orchestra instruments and some electronically generated sounds.

The unifying theme is their genre, opera. We made opera the subject of our production. Our overarching narrative was the story of a group of people making an opera house, architecturally, technically, musically and managerially. *Opernreigen* means 'opera round dance'. The title given to our production by Opernhaus Graz suggests that our narrative is appropriate.

An audience member buying a ticket for *Opernreigen* might expect to see a production about opera. *Opernreigen* addresses the composition, management and procurement of opera. It deals with the professions that are involved in producing opera, from the director to the musicians down the hierarchy to the technicians and ticket controllers.

Though the payment of the final instalment of our salary is evidence of Opernhaus Graz being satisfied that we have delivered our contractual obligations, the conflict with the composers and the intervention by the director of Opernhaus Graz was unpleasant. With hindsight, it was also inevitable.

1.176 Detail photograph of sound tape cutting table with projected opera curtain in the background

1.177 Actors at the cutting table

1.178 Chandelier being strung with water beads

1.179 Sound tapes being poured into the opera-house model

1.180 When the lights come on a disillusioning occurs as the opera curtain reveals itself as a projection onto a white screen

Opernreigen cannot be captured in one view, a multitude of views and scales is necessary to even begin to capture the complexity of the operatic assemblage

A production that deals with the very genre of art that the institution where it is performed delivers is challenging. The *Deutsches Wörterbuch* (German Dictionary, Wahrig 2000) defines the German (and Austrian) word *Nestbeschmutzer* (*Nest* = 'nest', *beschmutzen* = 'foul') as 'someone who through unfaithful behaviour brings disrepute to one's own family, party or similar'. The online dictionary Wikipedia considers the cultural and historic context of the word and defines the word, historically used in Nazi propaganda (and more recently by the Austrian press with reference to the Nobel Prize winner Elfriede Jelinek) as: 'people who criticise and highlight deficiencies in the social and political system in which they live. Often the revealer of such deficiencies is thus calumniated rather than the originators.'

Clearly, the composers and the opera director felt questioned in their roles and hence inclined to intervene. Our job description was impossible to fulfil, because, to do our job right, we would necessarily be inclined to criticise the very organisation who employed us. It was foolish to believe that our activities would go unnoticed. It is only surprising that the intervention and the ultimate failure of the project's central aim of 'productive exchange', occurred at such a late stage. The architect-arbitrator in *Opernreigen* worked overtime to engage audience and theatre staff. The architect-inventor devised a new set of working

175

methods that helped the architect-arbitrator to engage the characters on stage. But the architect-activist stepped over the line, critically involving himself with the very structures of the institution that was feeding him.

THE CHARACTERS OF THE ARCHITECT

In his book *Words and Buildings*, Adrian Forty refers to an essay written by the 17th-century author John Evelyn. John Evelyn's text is titled 'Account of Architects and Architecture' and it is appended to a translation, also by John Evelyn, of a discussion about the classical orders written by the French author Freart de Chambray. De Chambray's text, in its English translation, and John Evelyn's essay are published in a book titled *A Parallel of the Ancient Architecture with the Modern ... Made English for the Benefit of Builders. To Which is Added, An Account of Architects and Architecture by John Evelyn* (Evelyn and de Chambray 1707). Evelyn was an intellectual and member of the Royal Society who is best known for his diaries, which give detailed insight into life during the middle of the 17th century. Forty sums up the substance of the essay as follows.

> Evelyn asserted that the art of architecture was embodied in four kinds of person. First was architectus ingenio, the superintending architect, a man of ideas, familiar with the history of architecture, skilled in geometry and drawing techniques, and with a sufficient knowledge of astronomy, law, medicine, optics and so on. Secondly, the architectus sumptuarius. 'with a full and overflowing purse' – the patron. Thirdly, architectus manuarius, 'in him I comprehend the several artisans and workmen'. And fourthly, architectus verborum – in whom he classed himself – the architect of words, skilled in the craft of language, and whose task was to talk about the work and interpret it to others. (Forty 2000)

What is interesting about John Evelyn's essay is the assertion that the architect can be understood as a number of distinct characters:

Evelyn's personification of the parts of architecture expressed an important idea, that architecture consisted not just of one or two of these activities, but of all four of them in concert. (Forty 2000)

Words and Buildings investigates the relationship between *architectus verborum* and the other architect-characters. *The Architecture Chronicle* endorses the idea that architecture is the result of the collaboration between a number of different architect-characters who all contribute towards the success of the project. This reality stands in apparent opposition to the public view of the profession. Forty writes,

> There is a modern tendency to identify architecture primarily with the mental work of creative invention – with Evelyn's architectus ingenio – at the expense of its other constituents.

Evelyn's text is a welcome dissolution of this limited view of architectural practice and is a useful model to understand that the profession is made up of a number of characters. His implied hierarchy, however, where *architectus ingenio* presides over *architectus manuarius* 'who should not trouble himself with much learning' (Evelyn and de Chambray 1707) is antiquated. It does not correspond to the realities of architectural practice in *The Architecture Chronicle* where inter-disciplinary exchange and cross-disciplinary practice are essential to progress the work. Using Evelyn's idea that architecture consists of a number of distinct characters 'in concert' we can identify and consider three characters that constitute the architect in *The Architecture Chronicle*: the architect-inventor, the architect-activist and the architect-arbitrator.

The Architecture Chronicle is written by an architect, but it reports on five theatre projects and one urban design project. The reason for this is not coincidental. Jan Kattein Architects completed a number of building projects during the period covered by *The Architecture Chronicle*. However, these only feature as background information. *The Architecture Chronicle* deliberately reflects upon the role of the contemporary architect from outside the discipline.

Looking at the work of Rem Koolhaas and his practice OMA, the benefit of investigating a discipline from the outside becomes apparent. In 1995 OMA, Rem Koolhaas and Bruce Mau published *S,M,L,XL*, a 'novel about architecture'. The book has 1,344 pages and weighs 2,840g, a size more common for an encyclopaedia than a novel. The book appears like a scrapbook, reproducing drawings, graphs, sketches, photographs and texts in a sequential order by project size. *S,M,L,XL* is a book by an architect and a graphic designer about OMA's architectural practice.

The authors explain the format of the book: 'Architecture is by definition a chaotic adventure'. The introduction rejects coherence as 'self-censorship'. This is a strange observation when considering the book in relation to the buildings it reproduces on its pages. Koolhaas' Kunsthal, for example, is neither incoherent nor chaotic. Even though constructed from a wide variety of materials, the drawings and photographs of the Kunsthal show a well-ordered and purposeful building. If incoherence and chaos define architecture, does this mean that the Kunsthal is not architecture? And if not, why is it then reproduced in 'a novel about architecture'?

One possible explanation is that Koolhaas distinguishes between architecture as practice and architecture as a product with the former being incoherent and chaotic and the latter ordered and purposeful. But if *S,M,L,XL* is trying to make an argument about architectural practice (rather than product), why then reproduce photographs of a completed building (the Kunsthal) in the book? The more likely explanation for the chaotic nature of *S,M,L,XL* is that Koolhaas has fallen victim to the same conundrum that he ascribes to movie stars in *Delirious New York*. The inability of movie stars to reflect upon their practice observed by Koolhaas-scriptwriter in the earlier book is also symptomatic of Koolhaas, now a star architect, writing about his own practice. Koolhaas' 'ghost writer', who gives 'coherence' to 'mountain ranges of evidence' in *Delirious New York*, rejects the notion of coherence in *S,M,L,XL*. This book publishes 'a mountain range of evidence' and rejects coherence.

Evelyn sees himself as *architectus verborum*. In *Delirious New York*, Koolhaas' describes himself as architectural 'ghost writer'. Both terms describe the same activity, the explanation of the architect's work to others. In the space of four centuries, *architectus verborum* has been rebranded architectural ghost writer.

S,M,L,XL does not explain, it is a collection of the work of *architectus ingenio*, published in the absence of *architectus verborum*, leaving the reader to draw his or her own conclusions. The book illustrates how difficult it is to discover patterns and express intentions within one's own discipline.

Delirious New York reveals parts of architecture normally hidden from public view.

2.1 Elevation of the architect's desk. *S,M,L,XL* by OMA, Rem Koolhaas and Bruce Mau is an essential constituent of every architect's library. Because of its size it is especially useful as a screen prop giving an entire 72mm viewing height advantage. Even the colour scheme of the book cover is co-ordinated with that of the monitor stand

It is innovative because it is written by a ghost writer with an intimate interest in architecture who is looking at the discipline from outside. Innovation in *Delirious New York* is the result of cross-disciplinary practice. This is also true for *The Architecture Chronicle*. Such dissociation allows for a critical assessment.

Koolhaas' has re-branded Evelyn's *architectus verborum*. To understand the particularities of the contemporary role of *architectus ingenio*, *The Architecture Chronicle* needs to undertake a further re-branding. The architect-inventor describes the contemporary version of *architectus ingenio*.

THE ARCHITECT-INVENTOR

In a chapter titled 'The Influence of Imagination in Architecture' in his book *The Image of the Architect*, Andrew Saint gives an account of a lecture given by John Ruskin at the Architectural Association in 1857.

> Ruskin's message was as clear and thrilling as a clarion's; [architects] must imagine. Industry alone he proclaimed, would never avail to make an architect great; practicality and utility could not raise him above the level of a mere builder; mathematical skill would be perceptible to few among future generations. Human imagination and sympathy alone would make his work endure. (Saint 1983)

Their ability to imagine beyond the boundaries of their discipline is what sets architects apart from other building professionals. Imagination, according to Saint, is the key to leadership. Evelyn's definition of the 'superintending' *architectus ingenio* matches Saint's idea of leadership through imagination. Founded in 1834, the Royal Institute of British Architects is the UK 'body for architecture and the architectural profession'. It is the first point of call for many potential clients in search of an architect. A section under the headline 'Why use an Architect' on the Royal Institute of British Architects' website, uses the term 'creativity' to advertise its members' ability to imagine. Interestingly, creativity, an ability Saint considers central to the status of the architect, is only listed in third place on the website's 12-bullet-point list. In first place, is the architect's ability to 'see the big picture' and in second place the ability to 'design flexible buildings'.

An important consideration for a client commissioning a piece of architecture is the financial returns the investment will yield after completion. Maybe creativity only appears in third place because its financial benefit to potential clients is less easily quantifiable than that of 'seeing the big picture' or the immediate financial benefit of a flexible building.

In *The Architecture Chronicle*, the character that represents the architect's ability to imagine is the architect-inventor. The architect-inventor enters the project by challenging the brief to let the client know what they do not yet know they want. He or she is always a step ahead, socially aware and technologically advanced. The architect-inventor exceeds the client's expectations, regardless whether the client wants it or not, as an interview with Ray Hood, reproduced in Frank Lloyd Wrights' autobiography, illustrates,

> H: All right then, how do you get your houses built? By telling the owner what he's got to do? Or do you hypnotize him?
> W: Yes, I hypnotize him. There is nothing so hypnotic as the truth. I show him the truth about the thing he wants to do as I have prepared myself to show it to him. And he will see it. If you know, yourself, what should be done and get a scheme founded on sensible fact, the client will see it and take it, I have found.
> H: But suppose he wouldn't take it?
> W: But, by God, Ray he would take it. (Wright 1977)

To realise the innovative project, the architect-inventor questions social conventions. He or she knows that to have talented people working for you, they have to work for something bigger than themselves. The architect-inventor inspires with a vision that engages the design team by challenging members to exert themselves. To avert disillusion of other team members during an often lengthy process and to maintain his or her vision, the architect-inventor is a perpetual designer. He or she is brimming with ideas that are consistently refined as the project progresses.

Forty ascribes the origin of the contemporary architect to his or her ability to draw and to write. Acquired during the Italian Renaissance, these skills allowed architects to remove themselves from the site of construction and to upgrade their status from manual labourer to artistic creator. Through his command of drawing, the architect was able to pre-figure the building and to claim authorship for its design. As mentioned, the word 'design' comes from the Italian word *disegno* (drawing).

2.2 Pages 28–9 of *Words and Buildings* by Adrian Forty with photograph by John Maltby. The caption to the photograph reads: The architect and his clients, photograph by John Maltby for *Modern Woman*, July 1958. In a visual convention going back to the Italian Renaissance, the architect is identified by the drawing he holds. It is architects' command of drawing that has customarily distinguished them from the other professions involved in building

Today, architects face a dilemma similar to that experienced by pre-Renaissance architects: they have limited authorship of a design. Buildings are designed by a design team that includes architects, engineers, interior designers and specialist contractors. Contemporary procurement methods and an increased specialisation in the building industry threaten to degrade the architect to one anonymous designer amongst others. Forty observes that in spite of the common presumption amongst architects that designing and drawing are inseparable, an architect's occupation is hardly restricted to drawing and that buildings during the middle ages were generally designed without drawings. During the Italian Renaissance an architect's ability to draw distinguished him from other building professionals. This advantage is lost in contemporary practice where drawings are produced by a multitude of professionals including engineers, draughtsmen and even contractors.

The pre-Renaissance architect relied on his own hands to execute his design, translating the virtual image in his mind to appropriate operations on site. The translation from idea to built space was direct. The architect was able to adjust and vary the design to adapt to a change of circumstances on site, to his client's changing financial situation or the availability of building materials, and most importantly, having completed part of his building, the architect was able to learn his lesson

and adapt his methods accordingly. The pre-Renaissance architect was self-sufficient. Innovation occurred as a result of trial and error: sections of cathedrals sometimes repeatedly collapsed during construction until the structure was adapted to suit its purpose and to support the required loads.

The price for removing himself from the site of construction was that the Renaissance architect surrendered his self-sufficiency. He was suddenly reliant on contractors and builders to realise his design. This development brought about a whole new problem: an architectural idea had to be communicated from the architect's mind to the mason's hands on site. Forty suggests that his ability to draw and to write distinguished the Italian Renaissance architect from the men on site. In his essay 'Architectural Practice in the Italian Renaissance', James S. Ackerman observes, however, that 'the High Renaissance Architect managed without a firm and without even an office because he did so little detailed designing' and that 'very few drawings were intended to be used in constructing a building' (Ackermann 1991).

The Renaissance architect produced three types of drawings: the presentation drawing, the construction drawing and the architectural sketch. The presentation drawing was prepared for the benefit of the client. It was carefully rendered and did not have any measurements, it was therefore not useful for construction. Just like the conviction drawing in *The Architecture Chronicle*, the presentation drawing often differed significantly from the building that was finally constructed. Its primary role was to engage the client and to verify the skill and conviction of the architect. Construction drawings were limited to plans. Dimensioned plans were used to set out the building's outline at the beginning of the works, sections and elevations were not normally issued to site. The third category of drawing is the architectural sketch. Sketches were used to advance the design in the early stages of a project and again during construction to develop details, often in collaboration with the masons on site. Technical innovation, according to Ackerman, was predominantly left to the masons who were much more experienced in technical matters than architects.

The lack of scale drawings suggests that construction was a perpetual process of oral negotiation illustrated by sketches that seized spatial opportunities that became apparent on site as the project progressed. Innovation occurred during construction. Failures, a necessary by-product of innovation, were rectified by adding additional supports or by re-building what had previously collapsed.

Today, presentation drawings still play an important role for architects to secure a commission or to win a competition. The importance of the construction drawing has increased significantly since the Renaissance, and the architectural sketch has lost its previous meaning. The reason for this, as Forty observes, is that an architectural drawing is precise and a sketch is vague. When facing a choice between precision and vagueness, architects tend to choose precision. Innovation during the construction process is rare because failure, a necessary ingredient for innovation, is not deemed acceptable on a building site, partly because of the necessity of financial returns. Where an innovative design needs to be studied at full scale, the architect in *The Architecture Chronicle* resorts to the use

of prototypes, templates and large scale models. This is particularly evident in the design for *Herr Gevatter* where an innovative material required the manufacture of a large number of prototypes.

Architects who design without the intention of building retain their self-sufficiency, as their projects are complete when they have completed their drawings and models. Innovation occurs through drawing and model making. Their products are often publications or exhibitions that contribute towards a theoretical discourse about architecture.

Evelyn ascribes *architectus ingenio*'s ability to innovate upon his knowledge and study of 'history, geometry, drawing techniques, astronomy, law medicine and optics' (Evelyn and de Chambray 1707). His definition suggests that in architecture, even 400 years ago, cross-disciplinary practice was the key to innovation. However, Evelyn clearly situates *architectus ingenio* in the realm of science. What sets *architectus ingenio* apart from the architect-inventor is the architect-inventor's ability to speculate. Knowledge of science and history is important to his or her practice, but the ability to speculate is what advances the discipline. In the eyes of *architectus ingenio* the *luminaires* are flawed. In the eyes of the architect-inventor, they are innovative.

THE ARCHITECT-ACTIVIST

There are architects who design with the intention of building and those who design with no intention of building. We will now look into the architect who designs and makes, the architect-activist. Architects who design and make have returned to the practice of the pre-Renaissance architect to regain their self-sufficiency. Actively participating in the construction process in the workshop is the most direct way for the architect to take control. Designing and making occur concurrently. The architect-activist combines manual and intellectual labour in a dialogue between hands and mind that progresses the work step by step. The three groups of architects (architects who design with the intention of building, architects who design without the intention of building and the architect who designs and makes) influence each other. A natural desire to innovate causes some architects to combine the practices of building, not-building and making. This is the case in *The Architecture Chronicle*.

In their book *Adhocism: The Case for Improvisation*, Charles Jencks and Nathan Silver advocate a practice which combines simultaneous designing and making as a means to innovate. Adhocism relies on the belief that contemporary innovation is the result of combining already existing systems. The introduction of the book explains,

> Adhocism is a term coined by Charles Jencks and first used by him in architectural criticism in 1968. It can also be applied to many human endeavours, denoting a principle of action having speed or economy and purpose or utility. Basically it involves using an available system or dealing with an existing situation in a new way to solve a problem quickly and efficiently. It is a method of creation relying particularly on resources which are already at hand. Incidentally, the word adhocism has the property of itself being ad hoc. (Jencks and Silver 1972)

The advantage of adhocism versus engineering is that it relies on trial and error to solve a problem.

(199) Piranesi: *Portico of Octavia*. The ruins are used as dwellings

(200) Piranesi: *Castel Sant'Angelo* (Hadrian's Tomb) in one of its interim stages of use

(201) Gloucester Cathedral, 1332–77. A *post-hoc* tower buttress added for additional support makes its nonchalant way diagonally through levels of galleries in the transept

cause those communities were spared the aggressive ministrations of the ugly architect. The architect became necessary when choices and techniques in building became complicated. In a technologically developed culture the architect is delegated the adhocist job of sorting through and simplifying the contending means of building.

If vernacular building using only traditional skills, resources and formal archetypes amounts to a pure, accepting sort of practical adhocism, there is a more sophisticated and accommodating sort in buildings that are left standing after redevelopment. There the *ad hoc* impulse remains, but the culture meanwhile has changed or is changing. Within cities of the world that have been lived in for thousands of years, succeeding cultures absorb, adapt and reintegrate the ruins left by previous civilizations (199).

Piranesi made many engravings of ancient Rome as taken over by the later Romans, who built new hovels among the imperial ruins. In some parts of Rome the roofless vast interiors of public buildings became exteriors, as squares with shacks or new buildings added to the outsides: architecture inside out. Roman temples were routinely cannibalized through the centuries by the Popes, their columns, arches and vaults recycled in Christian churches. Vanished Roman landmarks left their evocative shadows in patterns of squares and streets. The shape of Domitian's stadium be-

came the Piazza Navona; Rome's Castel Sant'-Angelo first was Hadrian's mausoleum. In the Middle Ages the mausoleum became a fort. Apartments for the Pope were added; now it is a museum (200). From tomb to fort to papal flats to tourist attraction—in Charles Tomlinson's words, this was essential Rome:

. . . Walls built of walls, the run-down
Etruscan capital is a town
Of bars and butchers' shops
Inside the wreck of palaces.[27]

Likewise, the growth of medieval towns often was a characteristic demonstration of sheer, receptive practical adhocism, with each building added onto and modified by the next. Houses were often built around urban cathedrals, then cleared away later in accommodating practical adhocist urban renewal. And the building of the medieval cathedrals itself reveals striking adhocism, both in intentional precept and practical commission.

In precept, work was taken in hand under the assumption that generations of canons, with varying abilities and (sometimes opposing) ideas would work out the details. There might occasionally be one *inceptor* given credit, like Peter Quivil or Alan de Walsingham, but that title reveals the limits placed on a single construction manager's creative authority.

27 Charles Tomlinson, "Tarquinia," *The Listener*, 14 January 1971.

In commission, the failure to achieve original objectives and the substitution of others were rationalised in ways that we might find funny if they didn't result in the Gothic functionalism so admired by Ruskin and others. If something went wrong, for example, supernatural causes might be cited; this was as much as to say if the building can't be made to fit the original program, change the program. In this sense, it can be said that just as the Gothic dispensed with Greek and Roman ideal rules of formal purism (it was the first conscious eclecticism), it also was indifferent to functional purism (201). Gothic building was classic full adhocism.

As adhocism had its *classic* period in Gothic architecture, classicism had an *ad hoc* period. The classicism of the Greeks and Romans was always being reworked, so in that sense it was a language whose parts could be used *ad hoc*, as Jencks notes. Then in the 18th century a small but influential school of French architects proposed visionary projects that emitted the strongest vibrations of classical purity and were adhocist as well. Two visionaries were Claude-Nicolas Ledoux (1736–1806) and Étienne-Louis Boullée (1728–99). They believed that architectural form needed to re-establish itself and regenerate itself through geometry, and so they projected pyramidal and spherical buildings and a circular ideal city. There was nothing particularly *ad hoc* about

any of these. However, along with like-minded contemporaries, they also sought an *architecture parlant*. Translated, this amounted to virtual mimesis: the imitation of forms as a manner of expression; for example, their colleague Lequeu seriously intended a stable in the shape of a cow. Hence when Ledoux proposed a house for a Director of Waterworks, it was shaped like a cylinder on its side pouring water; a classic bit of geometry applied *ad hoc* through circumstances and symbolic appropriateness (more or less).

Boullée's project for a Temple to Nature was an almost complete microcosmic sphere, enclosing an interior hemisphere made of unworked stone that represented raw nature, like an eaten half-grapefruit below a rounded heaven. Both Ledoux and Boullée designed projects for bridges with the bridge abutments disconcertingly taking the form of boats. External metaphors strictly irrelevant to function were repeatedly introduced *ad hoc* (a woodcutter's house done as a pyramid of stacked wood). Practical projects weren't overlooked: a visionary brothel of Ledoux's was to be shaped in plan like a penis with testicles (204), although—and this is the wit of his adhocism—the perspective only reveals a composition of columns, half-cylinders and pitched roofs.

Ledoux's and Boullée's symbolic adhocism is important because it implied that a building could be expressive *in toto*, the most important lesson to be read today in contemporary architecture. Coming down from their designs (fig-

2.3 Pages 160–61 of *Adhocism: The Case for Improvisation*, by Charles Jencks and Nathan Silver. The image on the right shows what Nathan Silver calls 'a post-hoc tower buttress' in Gloucester Cathedral (1332–77). The buttress was initially inserted to remedy structural failure but reveals the structural limits of masonry construction and is hence much more significant to advance constructional knowledge during the 14th century than the otherwise faultless symmetry of the building

This makes the practice universal and multi-disciplinary. Where the engineer applies the skills that he or she acquired during theoretical training, the adhocist learns on the job. Adhocism is doing.

Silver distinguishes between three types of adhocism. Practical adhocism brings 'together various, immediately-to-hand resources in an effort to satisfy a particular need'. Retrieval adhocism is preoccupied with recycling materials or finding new uses for leftovers. Intentional adhocism has an 'interest in ad hoc goals or ends rather than in ad hoc procedures or means' (Jencks and Silver 1972).

The nature of a design executed through practical or retrieval adhocism is in equal parts determined by the materials that are at hand and the skill of the adhocist engaging in the practice. The skilful adhocist combines his or her experience with a natural desire to innovate. It is conceivable that there are adhocists by birth and adhocists by experience, the former having a greater natural desire to innovate, the latter a greater degree of craftsmanship.

For Jencks, the key to streamlining the material acquisition process is his proposal for a national database with a performance specification of all available materials and products. Silver proposes a 'hardware supermarket' operating as a bazaar, service depot and information centre in the middle of Soho in London. The 'hardware supermarket' combines intellectual resources with physical resources, the exchange of experience with the exchange of materials. In *The Architecture Chronicle*, flea markets and car-boot sales serve as a resource for materials but also for ideas. The Holloway Road Sunday Market provides a wall clock for *Kabale und Liebe* and an idea about

materiality and surface texture conveyed by the book *The Doubtful Guest* for *Herr Gevatter*. Jencks' 'materials database' now exists in the form of the internet, primarily a resource for ideas, but through online auction sites also a bazaar for materials. In *Opernreigen*, online scavenging was a key part of the material acquisition process.

Silver identifies Charles Eames' house as the 'first polemical example of adhocism in architecture' using 'standard catalogue industrial windows, open-web steel joists, corrugated metal decking [and] structural members originally made up for another job' (Jencks and Silver 1972). In the design for his house, Charles Eames combined the appropriation of ideas with the appropriation of materials. The idea of large uninterrupted internal spaces, made possible through modern open-web steel joists brightly illuminated through a transparent facade, is appropriated from industrial architecture. The structure of the house is made from materials left over from another project.

The use of materials in Koolhaas' Kunsthal is similarly ad hoc. One can identify practical adhocism, retrieval adhocism and intentional adhocism. Practical adhocism has to do with the appropriation of ideas, retrieval adhocism with the appropriation of materials and intentional adhocism with the appropriation of an aesthetic.

The Architecture Chronicle combines all three forms of adhocism. The walls in *Herr Gevatter* are a particularly explicit example of practical adhocism. The book, *The Doubtful Guest* does not feature physically in the stage-set, but the idea behind its illustration manifests itself in the wall surface. *Kabale und Liebe* uses retrieval adhocism by appropriating a refrigerator, previously used to cool beer, into a stage

door. The *Luminaires* are a product of both 'retrieval adhocism' and intentional adhocism. The intentional adhocism of the *Luminaires* engages the public by inviting contribution towards their maintenance and upkeep.

Jencks compares the practice of the adhocist with the practice of the bricoleur. Both adhocist and bricoleur are 'intent on undertaking [a] job immediately, with whatever resources are available' (Jencks and Silver 1972). Adhocist and bricoleur both engage in a practice with an uncertain outcome, learning by doing, guided by the materials that become available and the joining techniques that come to mind as the job progresses. What distinguishes the two practices is their end product. Bricolage is necessarily ad hoc, but adhocism does not necessarily result in a bricolage. Adhocism can manifest itself in a variety of other disciplines including: architecture, photography, theatre, painting, literature, product design and revolution. I want to discuss bricolage because it is a strain of adhocist practice particularly relevant to the activities of the architect-activist.

The word bricolage comes from the French and has its origin in the context of (ball)games to describe the running off-course, straying or digression of a ball. In a contemporary colloquial context, the French word is used to describe small-scale building work or even home-based craft. In English we distinguish bricolage from do-it-yourself (DIY). Whereas DIY often has derogatory connotations, referring to self-motivated home improvements by unskilled laymen, bricolage is used in a rather more artistic context and refers to creations involving a variety of materials. In his book *The Savage Mind*, Lévi-Strauss describes the bricoleur's activity:

His universe of instruments is closed and the rules of the game are always to make do with whatever is at hand, that is to say with a set of tools and materials which is always finite and is also heterogeneous because what it contains bears no relation to the current project, or indeed to any particular project, but is the contingent result of all the occasions there have been to renew or enrich the stock or to maintain it with the remains of previous constructions or destruction. (Lévi-Strauss 1997)

The Architecture Chronicle shows that the bricoleur's system for material acquisition is not nearly as closed as Lévi-Strauss sets out. Material acquisition is a complex three-stage process involving a high degree of skill and mental activity. Stage 1 relies on the bricoleur's trained magnetic gaze that focuses his or her attention on any abandoned materials left out on the street. The magnetic gaze cannot be disengaged and will activate at any time of day or night. Stage 2 comprises the mental insertion of any identified object or material in an ongoing bricolage. Scale, colour, suitability for the job at hand and compatibility with other materials are all considerations that are tested by the mental eye. Once mentally inserted in the design, the desirability of the find rises exponentially, making its acquisition unavoidable. Lévi-Strauss' observation about the activities of the gatherer in the wilderness is also true for the scavenging bricoleur: 'animals and plants [objects and materials] are not known as a result of their usefulness; they are deemed to be useful or interesting because they are first of all known' (Lévi-Strauss 1997). During the acquisition stage, stage 3, the line between stealing and finding can fluctuate. The only limitation to the progress of stage 3 is the physical strength of the bricoleur who

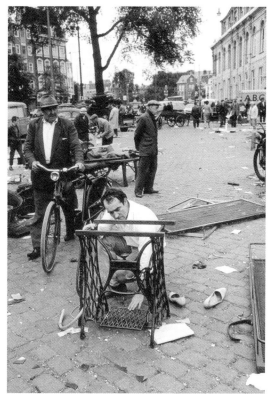

2.4 Jean Tinguely scavenging on the Waterlooplein, Amsterdam. *L'Esprit de Tinguely* edited and published by Kunstmuseum Wolfsburg (2000). Scavenging is an integral part of the bricoleur's job description

In his book *The Appliance House (1990)*, Ben Nicholson describes the practice of the collagist. He divides collage into three distinct stages. The first stage involves the acquisition of materials. This is followed by the ordering, combining and temporary fixing of the collected items, which are then permanently glued into place. Where the term 'collage' puts particular emphasis on the final work-stage (the gluing down of the pieces), the term 'bricolage' puts particular emphasis on the first work-stage (the acquisition and the moving out of context of materials).

Nicholson describes three advantages of his practice, he is himself a collagist, empowering the maker, engaging the audience and making mistakes as a means to advance the work. He writes: 'Collage making, allows anyone to hold a view on any subject' (1990). Collage empowers the architect-maker to take control of the finished piece, because he or she procures the project from start to finish. He or she acts as the patron, offering up dog-eared magazines and fresh scalpel blades, as the designer, selecting and combining the materials found and as the constructor assembling, laminating and adhering.

'The activity of collage ... can profoundly alter the way things and places are viewed' leading to 'both haunting and surprising' results. Collage empowers the architect-maker to engage his or her audience by dislocating objects from their known context and re-combining them to 'disturb or negate the status of the individual elements'. The key to this is that the 'original objects are virtually unrecognisable' (Nicholson 1990). This strategy of 'obfuscation' is used consistently throughout *The Architecture Chronicle*. The jam-jar lid becomes a tank-cover, the balloon finds its new identity as a gas-storage tank

can occasionally be observed exhaustedly dragging large objects through the city.

The practice of the collagist is comparable to the practice of the bricoleur. Both rely on materials immediately at hand to execute their job in an ad hoc manner. The main difference is the end product of the two practices. Collage comes from the French word *coler* (to glue). Even though the word *coler* is contained within the word *bricoler*, their origin is unrelated. Bricolage can create three-dimensional spaces and objects, whereas a collage by definition is a two dimensional laminate of cartridge paper, newsprint, torn books and magazine pages.

inside a protective cover sleeve that had a previous life as an onion net. The castor wheels added to the sofa reincarnate it as a merry-go-round, a race car or a battering-ram, depending on its movement which is carefully controlled by the actors.

The potential of the collage lies in its mistakes because 'making requires living with something that is knowingly incorrect. It is this anti-idealistic in-correctness which mysteriously permits the work to advance' (Nicholson 1990). The work does not only advance from collage to collage as Nicholson suggests, but it also advances from collage to viewer's mind. The mistakes that occur as the architect-activist progresses the design are its potential. Lévi-Strauss, who elaborates on the creative use of a plank of pine to wedge-up an inadequate cube of oak, would probably agree. *The Architecture Chronicle* also proves the point. The rose wallpaper has a greater ability to engage its audience because of the 'inaccurate' printing process. The *Luminaires* are more interesting because they are technically inadequate.

The weakness of Nicholson's practice is, as the name collage (coler (fr) = gluing) suggests, its inherently predictable outcome, a two dimensional laminate of paper. Nicholson highlights the potential for the transformation of the finished collage into a paper relief by pealing the various layers back off the collage base paper and ultimately 'into the construction of a building'. In reality, the translation of a drawing into a building is more complex than this.

The comparison between bricolage and collage is still helpful. Nicholson observes that the collagist 'cannot fully control what occurs in the juxtapositions' (1990). Bricolage and collage are means to empower the maker, who learns as the work advances;

both engage the audience by altering the way a site is viewed and rely on mistakes as a means to advance the work.

Lévi-Strauss describes the bricoleur as 'someone who works with his hands and uses devious means compared to those of a craftsman' (1997). This description stands in opposition to Nicholson's likening of the collagist's practice with that of the surgeon, requiring precision, decisiveness and skill. *The Architecture Chronicle* sides with Nicholson because it shows that a high degree of craftsmanship is essential for the successful completion of the work.

To return to the subject of adhocism, Silver distinguishes between adhocism and eclecticism. Their main difference lies in their intentions. Whereas adhocist thinking does not care about perfection when trying to achieve an optimum whole; eclectic thinking would only choose the best components to attempt a perfect whole. This does not mean that adhocist architecture is crude

2.5 Octave Matthew, Le Corbusier and Louis Houriet working on the sgraffito decoration on the Villa Fallet. The dust coat protecting the black suit identifies the architect-activist designing and constructing concurrently

THE CHARACTERS OF THE ARCHITECT

and eclectic architecture perfect. The adhocist, however, knows that apparent mistakes and imbalances are essential to engage the viewer, whereas the eclecticist strives for a balanced and seamless composition. Or specifically, in relation to *The Architecture Chronicle*, the apparently unfinished edges of the stage-set are essential to engage the audience who are suspended between their experience of the domestic space displayed by the set and the real space, the theatre.

The product of the architect-activist's effort can be drawings and models but, ultimately, it will be a full-scale built structure. The disadvantage of this practice is that the scale of the finished product is limited by the physical ability of the architect-activist, and the quality of the final project is only as good as the architect's skills in the workshop. Silver, however, recognises inventive potential in this practice.

> In place of experts, an emergency team, ad hoc committee, or voluntary brigade can do the work instead – sometimes using bizarre methods that notoriously prove a lesson later to those with special skills or training. (Jencks and Silver 1972)

The output of the architect in *The Architecture Chronicle* is varied, comprising full-scale built structures, drawings, models, text, stories but also tea parties and onion pies. *Kabale und Liebe* was predominantly designed in the workshop. The product of the architect's effort was a full-scale built structure. *Herr Gevatter* was designed in the architect's studio in London and translated into templates that were used in Saarbrücken to manufacture the set. The products of the architect's

effort were prototypes and templates. In *Le nozze di Figaro*, the architect's products included a miniature theatre, drawings and individual elements of the stage-set. Designing *Kabale und Liebe* while making gave the architect substantial insight into workshop techniques. Like during an apprenticeship, the architect-activist was able to work alongside and acquire the language of the professional maker, gaining intimate insight into his or her working methods. Learning the language of the professional maker has aided communication in all other projects and has allowed the architect-activist to gradually withdraw from the workshop without compromising design quality.

Instead of undertaking full-scale procurement by making, the architect-activist addresses much more specific problems in some of the later projects. In both, *Herr Gevatter* and *Opernreigen*, a well-crafted prototype or fragment helped the architect-inventor to convince the makers of the technical feasibility of an innovative process or construction method. Making as a means to an end ultimately limits the scale and complexity of the architect-activists' projects. Making as a means of communication and learning allows the architect-arbitrator to engage and convince the maker. To realise the projects in *The Architecture Chronicle* making is increasingly supplemented by other outputs. K. Michael Hays calls a practice resulting in a wide variety of outputs a 'polyvocal' practice, evidence of which he discovers in John Hejduk's work:

> A unique body of theoretical work: publications ... and small-scale constructions – 'masques' – whose identities lie in the interstices of architecture, scenography, sculpture and poetry. (Hays 1996)

Hejduk's work is polyvocal because it cannot be easily classified. It neither clearly situates itself in the realm of architectural practice nor in that of theory. Hejduk is an academic, but he designs with the intention of building. Hays writes: 'Hejduk's refusal to settle (to posit a solution, to colonize a place, to arrive at an answer, to quiet our nerves) is perhaps a plea for more time to practice' (1996). Following Hays' logic, one can deduce that architectural practice in itself is an activity that comprises the drawing and re-drawing of the line between theory and practice. Once this line has been established, architectural practice becomes irrelevant.

Lévi-Strauss sees artistic creation at this very intersection between thought and practice and, importantly, science. Panamarenko's work supports this definition. Hejduk's refusal to settle is an insistence on the desire to innovate. The architect in *The Architecture Chronicle* also operates in this polyvocal context. Architecture for Detlef Mertins is 'thought embodied in things'. Mertins writes about Hejduk's practice:

> Hejduk's sketches reveal how he works with objects, shaping and combining physical elements in a way that may be likened to language; and yet, language remains inadequate to their expression. (Mertins 1996)

The projects in *The Architecture Chronicle* have a given narrative that can be written down or deduced from the dialogues on stage. But it is the role of the built structures to give expression to that which is inexpressible in words. It is this that engages the viewer. Mertins writes:

> The lesson taught by Hejduk's architecture rests in his unsurpassed skill in constructing such mysteries and in leading the viewer into a state of contemplation about society ... a critical and distanced contemplation that has neither beginning nor end and that defies logical progression, taking instead a myriad of detours and digressions that circumnavigate, but never quite locate, truth or meaning. (Mertins 1996)

Lévi-Strauss calls this type of viewer engagement 'mythical thought'. He writes: 'Mythical thought appears to be an intellectual form of bricolage' and 'it builds ideological castles out of the debris of what was once social discourse' (Lévi-Strauss 1997). The viewer is not a silent observer of the work but a necessary and active participant in intellectual activity surrounding the work. The theatre projects in *The Architecture Chronicle* engage the audience, the *Luminaires* engage local residents and, through the media, can reach society in general. Key to this intellectual engagement is bricolage, the practice of the architect-activist.

THE ARCHITECT-ARBITRATOR

The architect-inventor is commonly found amongst architects who design without the intention of building. The architect-activist builds his or her own design (or designs while building). The architect-arbitrator is the third architect-character that appears in *The Architecture Chronicle*. His or her role emerges from the specific requirements of designing with the intention of having a building built by others. The architect-arbitrator is common to architectural practice. But what exactly is architectural practice?

ROLL ON FRIDAY

'OUR NEW OFFICE IS BUILT AROUND THE KITCHEN, WE EVEN HAVE A BARISTA'
Practice HTA
Location Kentish Town, London
Size 130 people

One of the core things that HTA has always done is have a daily lunch for all the staff. When I joined the practice 24 years ago, there were 14 staff and we all ate together. Now there's 130 staff and we still make a point of all eating together.

We have a very wide range of skills and backgrounds in the practice, so eating together is a fantastic opportunity for the staff to talk to people from all parts of the company and catch up on what's going on.

Our new office is built around the kitchen. We even have a barista, so in the morning the first thing you'll see when you come in is people collecting their coffee and croissants.

After breakfast is over, the decks are cleared and our two cooks start lunch. There's lots of clattering of equipment and the staff have to endure the mouth-watering smells of the food being cooked all morning, but it's always worth the wait.

People find jobs to do near the kitchen at about five to one so that they can strategically position themselves to be first in the queue. The food is so good, one of our thoughts for our 40th birthday next year is to bring out a cookbook.
Mike De'Ath, director

HTA staff enjoy their freshly cooked free lunch.

2.6 Engaging the team with free lunch at HTA architects in London. Entertaining is a key activity of the architect-arbitrator

Dana Cuff's book *Architecture: The Story of Practice*, which compiles her research on architectural practice in the USA during the 1980s, summarises it as follows: 'architectural practice emerges through complex interactions among interested parties, from which the documents for a future building emerge' (1991). Three controversial observations can be deduced from Cuff's definition:

1. Architectural practice occurs through interaction: it happens in a team.

2. Architectural practice occurs before the construction of the building (note Cuff's use of the word 'future').

3. The products of architectural practice are 'documents'.

The interested parties that Cuff refers to include, the client (patron or Evelyn's *architectus sumptuarius*), specialist consultants, engineers, public authorities and local stakeholders. Their interest in the project can be financial, can concern the implementation of law or policy, or can involve attaining prestige or recognition. Cuff's observation on teamwork may seem obvious, but it stands in stark contrast to the portrayal of the architect as lone 'genius and hero' in the film *The Fountainhead* directed by King Vidor based on a novel by Ayn Rand. The lead character, architect Howard Roark, defines his practice as follows.

> No work is ever done collectively, by a majority decision. Every creative job is achieved under the guidance of a single individual thought. An architect requires a great many men to erect his building. But he does not ask them to vote on his design. They work together by free agreement and each is free in his proper function. An architect uses steel, glass, concrete, produced by others. But the materials remain just so much steel, glass and concrete until he touches them. What he does with them is his individual product and his individual property. This is the only pattern for proper co-operation among men. The first right on earth is the right of the ego. (Rand 1993)

2.7 New York architects dressed as their buildings at the Society of Beaux-Arts annual ball of 1931. From left to right, Leonard Schultze as the Waldorf-Astoria, William Van Alen as the Chrysler Building, Ely Jacques Khan as the Squibb Building, Ralph Walker as the Wall Street Building, Arthur J. Arwine as a low-pressure heating boiler, A. Stewart as the Fuller Building and Joseph Freelander as the Museum of the City of New York. In this theatrical performance the body of the architect itself becomes the canvas for his conviction drawing

Saint investigates Cuff's and Rand's understandings of the architect throughout history and identifies periods where one or the other took precedent. Following a period of individualism in architecture, Saint observes that 'today the entrenched isolationism of the profession is starting to crumble' and that architects must 'reconstruct their professional ideology in the light of their true position' and 'accept a smaller architectural profession, in which imagination and artistic ability are more evenly balanced with technical and managerial experience, in which collaboration with other specialists takes on a more realistic, less high-handed meaning' and in which 'sound building' is valued above 'high art' (1983).

The Architecture Chronicle endorses these propositions. More than 20 years have passed since the publication of Saint's book, and there are indications that the contributions of other team members to the design of buildings are acknowledged more widely. One indication of this is the so-called 'partnering contract', a building contract which emerged during the 1990s that abolishes the architect's dominance of traditional building contracts and puts all members of the design team on an equal footing. If design is in fact the result of collective action procured as a team activity, what does this mean for the status of the architect? In his essay 'The Rise of the Professional Architect in England', John Wilton-Ely states that by means of his inter-disciplinary training the architect is uniquely equipped to organise a variety of specialised and disparate functions into an intellectually and visually coherent expression. In Wilton-Ely's view, it is through his ability to co-ordinate that the architect can assert his position and avoid marginalisation (1977). Jeremy Till disagrees. In his book *Architecture Depends*, Till observes that architecture is a wholly dependent profession and that practising architects are in denial of their real situation. Till thinks that acknowledging their dependency is the key to resisting marginalisation. The architect, in Till's book, becomes a 'transformative agent' who seizes arising spatial opportunities as the project progresses and contributes by realising new spatial possibilities as an ongoing concern. The key to enabling transformative agency is what Till calls 'contingency'. In construction contracts, a contingency is a reserved percentage of the construction budget set aside for unforeseen expenditures. Till's transformative agent operates in this contingent space to realise new ad hoc spatial opportunities while letting go of previous moves that have become an obstacle to the progress of the project. Or in other words, in the same way that mistakes are the key to advancing a collage, mistakes are the fodder for transformative agency. The role of the transformative agent is not so much to correct mistakes as to turn them into positive features that realise new spatial potential.

Decisions today are made by the team. This is partly due to the degree of expertise that is required to master the complexity of contemporary building techniques. The main reason for this, however, is that designers in the construction industry are expected to take liability for their work. Architects practising in the UK are required by law to carry professional indemnity insurance and to maintain this insurance even into their retirement. An equivalent insurance exists for engineers and other design-team members. The pre-Renaissance architect was able to rectify design faults on site as the building work progressed. To rectify design faults in contemporary construction can be very costly. Designing in the team provides a convenient apportionment of liability. The success of the contemporary architect is largely based upon his or her ability to convince other team members to take responsibility for his or her ideas. I call an architect-arbitrator that part of the architect's personality which convinces and engages the other team members.

The Architecture Chronicle provides substantial evidence to support Cuff's observation that 'the design of our built environment emerges from collective action' (1991). However, the idea that architectural practice stops when building starts as suggested by Cuff's definition of architectural practice has little to do with contemporary forms of practice. In *Words and Buildings*, Forty describes the construction and design of the *CDLT House in Silverlake, California* by Morphosis Architects:

> At the end of each day the contractor left lights pointed at areas on which he had been working but that needed resolution. Significantly, though, the architects added, the builder had degrees in literature and musical composition, so it was possible to talk ideas with him. (Forty 2000)

Forty continues, 'the project must be treated as an experiment with an unknown outcome'. The architect in the *CDLT House* operates like an architectural bricoleur, seizing opportunities that arise as a result of the changing needs of the client, the availability of materials and the skill of the constructor to incorporate new configurations as the spatial construct of the building on site progresses. What distinguishes Morphosis' practice from the architect-activist's is that, even though both practices are ad hoc, the architect-activist produces a finished structure, whereas the product of Morphosis' efforts are oral instructions to the builder who then translates these into built form. One could say that the *CDLT House* is a built example of Till's 'transformative agency' gone haywire. Cuff's observation that the outcome of architectural practice is documents is disproven by the examples of the *CDLT House* and the *Kabale und Liebe* stage-set, which were built entirely without drawings.

Most building activity in the UK requires planning permission. The purpose of the architect's drawing during the planning process is to dispel any doubts about the outcome of the building process. To build without planning permission would be an illegal activity in the UK and could result in planning enforcement action being taken for any part of the building not constructed in strict accordance with the planning drawings. A planning application is submitted at the beginning of a project, when detailed technical and structural knowledge of the project is still very limited. A successful practising architect has the skills to produce planning drawings

that are at the same time explicit and vague. They are explicit to give the impression that the building design has already been considered in detail and vague to accommodate changes during later design stages. Planning drawings are full of contingency.

Some small structures, temporary structures or highway works are exempt from planning. The *Luminaires* were realised under so-called permitted development rights. In planning terms, stage designs would be classified as internal alterations, which are not restricted by law (except for listed buildings or where the internal alteration changes the function of the building).

Forty rightly observes that the artistic qualifications of the builder who built the *CDLT House* are significant for the final outcome. Most builders would approach construction in a rather more technical or practical manner. Their job satisfaction attained by a technically or practically satisfying resolution of a construction problem, not necessarily an artistic one. Architects in professional practice refer to the start of construction, prior to the production of detailed assembly drawings as 'fire-fighting'. The term is used when architects talk amongst themselves, but an architect would never admit to their client or the builder that they are fire-fighting. The term means to surrender control to the builder and is an expression that can be used at the same time in a derogatory and a macho context because it refers to a practice considered by architects not only as undesirable but also as daring and dangerous. When talking about fire-fighting, architects do not normally refer to the creative potential which Silver, Jencks, Till and Morphosis associate with a practice that has an unknown outcome.

I have previously discussed the role of the architect during the Italian Renaissance. It is interesting now to look in more detail at the architectural drawing specifically in relation to the role of the architect-arbitrator. In his essay 'Architectural Practice in the Italian Renaissance', Ackerman discusses the role of the architectural drawing as an instrument of communication during the 15th and early 16th centuries. Two types of drawing were produced to serve very particular stages of the design and construction process of the building: the rendered drawing and the architectural sketch. The rendered drawing was prepared for the benefit of the client or patron, to communicate the design prior to construction and to entice him to commit to the substantial expenditure necessary to raise the building. This type of drawing was not used during construction. Ackerman observes that generally, rendered drawings differed, sometimes substantially, from the design that was ultimately built. Three types of architectural sketches were common. The sketch initially served the education of the up-and-coming architect allowing him to record and study existing buildings and, during the early Renaissance, also to speculate on the reconstruction of Roman ruins. Secondly, the sketch served as an important tool for the architect to develop the design, studying different options and fixing the fluctuating picture in the mind's eye. Finally, the sketch was used as a means of communication between the architect and the men on site. In this case, sketching was used by the architect and the mason alike as a means to conduct a two-way conversation and to resolve a design problem in collaboration.

Forty looks in detail at the role of the architectural drawing. He defines both language and sketching as vague activities but orthogonal drawing as precise. The architectural sketch expresses an intention; but, whereas the hard lines of the orthogonal drawing try to limit the number of options, the architectural sketch, in its vagueness, increases the options. During the Italian Renaissance, measured construction drawings were very rare or non-existent. The rendered drawings that were produced to communicate the building to the client show great skill and precision and could easily have been translated into dimensioned construction drawings. The reason that orthogonal construction drawings were not used is neither from a lack of skill nor resources on the part of the architect, but a conscious decision The role of the conviction drawing in *The Architecture Chronicle* suggests a possible explanation for the preference of the architectural sketch. Whereas the conviction drawing is essential to engage client and maker during the early stages of the project, the final built structure differs substantially from the original drawing, in the same way that the Italian Renaissance building differed from the architect's rendered drawing. The reason that the conviction drawing is not used for construction is that it lacks contingency. Whereas the conviction drawing is essential to communicate an initial vision, it is too precise to incorporate the expertise of the maker and the particularities of construction materials available during later project stages. The sketch allows the architect to communicate a design intention while also engaging the maker in its technical resolution, taking account of the fluctuating realities on a building site. The Italian Renaissance architect engaged the maker in the resolution of the details, consciously choosing vagueness over precision. Whereas, as Forty observes, the contemporary architect chooses precision over vagueness. In his book *The Seven Lamps of Architecture* John Ruskin explains why he considers that it is crucial to engage the maker.

> I believe that the right question to ask, respecting all ornament, is simply this: Was it done with enjoyment – was the carver happy while he was about it? It may be the hardest work possible, and the harder because so much pleasure was taken in it; but it must have been happy too, or it will not be living. (Ruskin 2005)

Ruskin makes two important observations. Firstly, the significance of a happy maker as a pre-requisite for high quality work. Ruskin's statement refers to ornament in particular, but *The Architecture Chronicle* shows that this applies also to fixing down carpet tiles, printing wallpaper patterns, assembling cardboard walls and threading buttons and beer bottle tops onto chandeliers. Secondly, exertion or challenge ('it may be the hardest work possible') is the key to the satisfaction of the maker. Just like the architect-inventor, the architect-arbitrator also knows that to have talented people work for you, they have to work for something bigger than themselves.

I once taught design to a student from Portugal who was a trained and practising town planner in his home country. Out of interest, I asked him what his tasks were at work on a day-to-day basis, presuming that they would include the drafting of master-plans and the design of new towns. Carlos responded that, in Portugal, town planners do not draw master-plans

because the problem with a master-plan is that it is already out of date by the time that it comes to be implemented. Maybe a master-sketch is a more contingent form to develop a city, accommodating the changing needs of its users, the expertise of its builders and the availability of construction materials at a time of depleting natural resources. This position is supported by Colin Rowe and Fred Koetter's book *Collage City (1995)*, which argues that the domineering attitude of the modernist city erodes the citizens' freedom rather than increases it. Silver ascribes the need to adopt more flexible approaches to urban planning to changes in society.

> To meet the complex needs of an increasingly pluralist society, social, economic and physical plans must become contingent and resourceful. Public planners, including legislators, will have to adopt looser methods. and discard the border mentality encouraged by fixed compartments of authority. (Jencks and Silver 1972)

Cuff writes: 'According to the most popular management theory in architecture today, a firm can do good work in various ways, it can be strong in ideas, service or delivery' (1991). *The Architecture Chronicle* shows that the three architect-characters operate 'in concert' (to use Forty's words) to deliver a good project. For this concert of architecture to be harmonious, the architect needs to be a balance of inventor, activist and arbitrator and to adapt ad hoc as demanded by the site and the specific project. A project run as a solo or duet will most probably either remain uninventive, unbuilt or unsuitable.

Contingency allows the three-fold architect in *The Architecture Chronicle* to adapt ad hoc to the changing needs of the user and the site, the availability of objects, stories and social opportunities all of which are carefully integrated into the overall design. It also allows the design to improve along with the growing knowledge of its architect as the project advances. Till writes: 'The key ethical responsibility of the architect lies not in the refinement of objects as static visual product, but as contributor to the creation of empowering spatial, and hence social, relationships' (2009). Till is correct in asserting the spatial and social responsibility of the architect; however, *The Architecture Chronicle* shows that refinement and the empowering of social relations are not mutually exclusive. Refinement is an essential tool to communicate an architectural intention. *Delirious New York* advances the understanding of architecture, because it makes a refined argument. *S,M,L,XL* does not advance architecture, because the author puts precedent to chaos over refinement.

Koolhaas' statement that architecture is, or should be, chaotic is questionable. Till goes so far as to assert that 'mess is the law'. Conversely, Lévi-Strauss ascribes the advancement of science to the imposition of classification. Classification, a primitive form of order, allows us to 'understand forms of thought' and to critically evaluate their implications. False classification can only be rectified, if there is a system of classification in the first place. Levi-Strauss argues that scientists must not tolerate disorder because all systems in nature are based upon a profound order.

The Architecture Chronicle shows that it is the role of the architect to use his or her intellectual capacity to classify and order. Chaos can be controlled. It is the architect's task as an ongoing concern to turn disagreements into ad hoc

collaborations, mistakes into a driving force to advance the project and uncertainties into new spatial opportunities. In contemporary practice, it is often the architect's ability to engage and direct that asserts his or her status.

Architecture is profoundly tied up with existing systems of order (laws of physics, materials, construction laws, cost-and-usage patterns, to name a few examples). To allow chaos to prevail would simply mean to surrender control of the project to other design-team members and to allow them to impose their own systems of order on the project. Conversely, to impose a fixed solution alienates site, maker and user. Silver rightly observes that 'to an unprecedented extent we now try to master-plan and control changing aspects of culture and society. What's wrong with the World has become not it's disorder, but it's repressive order' (Jencks and Silver 1972).

To encourage flexible and responsive design, the public has to appreciate architecture as a process with an unpredictable outcome rather than expecting an off-the-shelf product. To avert chaos and to encourage innovation, the architect-inventor, the architect-activist and the architect-arbitrator need to operate as a well-balanced trio that accepts contributions from non-architects and encourages other team members to excel in their areas of expertise.

Bibliography

Ackerman, James S., 1991. 'Architectural Practice in the Italian Renaissance', in *Distance Points: Essays in Theory and Renaissance Art and Architecture*. Cambridge, Mass.: MIT Press.

Architects Registration Board, 2002. *Architects Code: Standard of Conduct and Practice*. London: Architects Registration Board.

Banihashemi, Siavosh, 2007. 'Forugh'. Unpublished contribution to *Opernreigen* (collaborative opera project).

BBC News. <bbc.co.uk/news>, accessed 10 October 2008.

Benjamin, Walter, 1997. *One-Way Street, and Other Writings*, trans. Edmund Jephcott and Kingsley Shorter. Verso: London.

Berheide, Hauke, Ulrich A. Kreppein, Bjoern Raithel, Anno Schreier and Raphael D. Thoene, 2004. *Der Herr Gevatter: Ein Hausmaerchen*. Unpublished opera.

Blackpool Council. <www.blackpool.gov.uk>, accessed 10 October 2008.

Blei, Franz (ed.), 1923. *Geist und Sitten des Rokoko*. Gütersloh: Bertelsmann.

Boell, Heinrich, 1955. *Dr. Murke's Gesammeltes Schweigen und andere Satiren*. Koeln: Kiepenheuer und Witsch, 1996.

Brady, Dan and Jan Kattein, 2005. 'Welcome to Slowtown'. Unpublished student briefing notes for a degree course module in design at the Bartlett School of Architecture, London.

Carter, John, 1971. 'St. Catherine's College Oxford'. *Architects' Journal* (November), 1105–18.

Cuff, Dana, 1991. *Architecture: The Story of Practice*. Cambridge, Mass.: MIT Press.

Diller, Elizabeth and Ricardo Scofidio, 2002. *Blur: The Making of Nothing*. New York: Harry N. Abrahams.

Dr Oetker, 2002. *Backen macht Freude*. Bielefeld: Dr. Oetker Verlag KG.

Eimermacher, Hanna, 2007. 'Schatten'. Unpublished contribution to *Opernreigen* (collaborative opera project).

Evelyn, John and Freart de Chambray, 1707. *A Parallel of the Ancient Architecture with the Modern ... Made English for the Benefit of Builders. To Which is Added, An Account of Architects and Architecture by John Evelyn*. London: D. Brown.

Forty, Adrian, 2000. *Words and Buildings: A Vocabulary of Modern Architecture*. London: Thames & Hudson.

Furjan, Helen, 2002. 'John Soane's Spectacular Theater', in Mark Rappolt (ed.), *AA Files 47*. Architectural Association: London.

Gorey, Edward, 1998. *The Doubtful Guest*. London: Bloomsbury.

Gold, Tanya, 2005. '2020 Vision'. *The Guardian* (10 September), 8.

Harnik, Elizabeth and Olga Flor, 2007. 'Kugelstein'. Unpublished contribution to *Opernreigen* (collaborative opera project).

Hegemann, Carl (ed.), 2004. *Das Schwindelerregende Kapitalismus und Regression*. Berlin: Volksbuehne am Rosa Luxemburg Platz and Alexander Verlag.

Hays, Michael K., 1996. 'Hejduk's Chronotope (An Introduction)', in Michael K. Hays (ed.), *Hejduk's Chronotope*. New York: Princeton Architectural Press.

Jacobs, Jane, 1996. 'The Use of Sidewalks: Safety', in T. LeGates and Frederic Stout (eds), *The City Reader*. Routledge: London.

Jakober, Peter and Albert Sackl, 2007. 'Puppet Theatre'. Unpublished contribution to *Opernreigen* (collaborative opera project).

Jencks, Charles and Nathan Silver. 1972. *Adhocism: The Case for Improvisation*. Garden City, NY: Doubleday.

Koolhaas, Rem, 1978. *Delirious New York: A Retrospective Manifesto for Manhattan*. London: Academy Editions.

Kunstmuseum Wolfsburg, 2000. *L'Esprit de Tinguely*. Wolfsburg: Kunstmuseum.

Lévi-Strauss, Claude, 1997. *The Savage Mind*. Chicago: University of Chicago Press.

Loos, Adolf, 1924. 'On Thrift (1924)', in *On Architecture*, ed. Adolf Opel and Daniel Opel. Riverside, California: Ariadne Press, 2002.

Mertins, Detlef, 1996. 'The Shells of Architectural Thought', in Michael K. Hays (ed.), *Hejduk's Chronotope*. New York: Princeton Architectural Press.

Metrohistory.com. <http://www.metrohistory.com>, accessed 10 October 2008.

Mozart, Wolfgang Amadeus and Lorenzo da Ponte, 1786. *Die Hochzeit des Figaro: Komische Oper in vier Akten* [libretto]. Berlin: Staatsoper unter den Linden, 1999.

Nicholson, Ben, 1990. *The Appliance House*. Chicago: Chicago Institute for Architecture and Urbanism.

OMA. <www.oma.eu>, accessed 10 October 2008.

—— Rem Koolhaas and Bruce Mau, 1995. *S,M,L,XL*. Rotterdam: 010 Publishers.

Orgel, Stephen and Roy Colin Strong, 1973. *Inigo Jones: The Theatre of the Stuart Court*. London: Sotheby Parke Bernet; Berkely and Los Angeles: University of California Press.

Panamarenko, 2001. *For Clever Scholars, Astronomers and Doctors*. Amsterdam: Ludion, 2nd edn.

—— <www.panamarenko.be>, accessed 10 October 2008

Peacock, John, 1995. *The Stage Designs of Inigo Jones: The European Context*. Cambridge: Cambridge University Press.

Petzet, Michael and Achim Bunz, 1995. *Gebaute Traeume: Die Schloesser Ludwigs II von Bayern*. Munich: Hirmer Verlag.

Rand, Ayn, 1993. *The Fountainhead*. New York and London: Signet.

Ring Award. <www.ringaward.com>, accessed 10 October 2008.

Rowe, Colin and Fred Koetter, 1995. *Collage City*. Cambridge, Mass.: MIT Press.

Royal Institute of British Architects. <http://www.architecture.com/Home.aspx>, accessed 10 October 2008.

Ruskin, John, 2005. *The Seven Lamps of Architecture*. Boston, Mass.: Adamant Media Corporation.

Saint, Andrew, 1983. *The Image of the Architect*. New Haven: Yale University Press.

Schiller, Friedrich, 1784. *Kabale und Liebe*. Berlin: Goldmann, 1996.

Till, Jeremy, 2009. *Architecture Depends*. Cambridge, Mass.: MIT Press.

Ueda, Yasuko, 2007. 'Myo-e'. Unpublished contribution to *Opernreigen* [collaborative opera project].

United Nations Economic and Social Commission for Asia and the Pacific 1984. *Updated Guidebook on Biogas Development*. New York: United Nations.

Van Schaik, Leon, 2005. *Mastering Architecture: Becoming a Creative Innovator in Practice*. Chichester: Wiley.

Voltini. <www.voltini.com>, accessed 10 October 2008.

Wahrig, Gerhard, 2000. *Deutsches Wörterbuch*. Gütersloh and Munich: Bertelsmann.

Wikipedia. <www.wikipedia.de>, accessed 10 October 2008.

Wilton-Ely, John, 1977. 'The Rise of the Professional Architect in England', in Spiro Kostof (ed.), *The Architect: Chapters in the History of the Profession*. New York: Oxford University Press.

Wright, Frank Lloyd, 1977. *An Autobiography*. London: Quartet.

Index

Illustrations indexed in **bold** type